Gustav .

The Green Face

Translated by Mike Mitchell
with an Afterword by
Franz Rottensteiner

Dedalus

Published in the UK by Dedalus Ltd, Langford Lodge,
St Judith's Lane, Sawtry, Cambs, PE28 5XE
email: info@dedalusbooks.com
www: dedalusbooks.com

ISBN 0 946626 92 8

Dedalus is distributed in the United States by SCB Distributors,
15608 South New Century Drive, Gardena, California 90248
email: info@scbdistributors.com web site: www.scbdistributors.com

Dedalus is distributed in Australia & New Zealand by Peribo Pty Ltd,
58 Beaumont Road, Mount Kuring-gai N.S.W. 2080
email: peribo@bigpond.com

Dedalus is distributed in Canada by Marginal Distribution,
695, Westney Road South, Suite 14 Ajax, Ontario, LI6 6M9
email: marginal@marginalbook.com web site: www.marginalbook.com

First published in Germany in 1916
First published by Dedalus in 1992, new edition in 2004

Translation and Afterword copyright © Dedalus 1992

Printed in Finland by WS Bookwell
Typeset by Cygnus Media Services

A C.I.P. listing for this book is available on request.

The elegantly-dressed foreigner standing somewhat undecided on the pavement in the Jodenbreetstraat gazed at the strange inscription in remarkably ornate white letters on the black sign outside a shop diagonally opposite:

CHIDHER GREEN'S
HALL OF RIDDLES

Out of curiosity, or merely in order to get away from the jostling of the crowd, who were commenting with typical Dutch frankness on his frock coat, his gleaming top hat and his gloves, all things which seemed to have rarity value in this quarter of Amsterdam, he crossed the road between two greengrocer's carts drawn by dogs. He was followed by a couple of street-urchins with hunched shoulders, cavernous stomachs and low-slung backsides who slouched along behind him, their hands stuffed deep into the pockets of their incredibly baggy blue canvas trousers, thin clay pipes sticking out through their red neckerchiefs.

The building with Chidher Green's shop occupied the space between two narrow streets and had a glassed-in veranda running right round the front and up the alleys on either side. From a glance through the dusty, lifeless windowpanes, it seemed to be some kind of warehouse which probably backed onto a *Gracht*, one of the many canals used for goods traffic. The squat cube of the edifice looked like the upper part of a dark, rectangular tower, which over the years had sunk into the soft, peaty soil right up to the glass veranda.

In the middle of the shop window a dark-yellow papier-maché skull sat on a pedestal covered with red cloth. It was a rather unnatural-looking skull: the upper jaw beneath the nose aperture was far too long and the eye-sockets and shadows at the

temples had been painted in with black ink. Between its lips it held an ace of spades. Above it was written: "The Oracle of Delphi, or the voice from the spirit world."

Large brass rings, interlocked like the links of a chain, hung down from the ceiling carrying garlands of gaudy postcards: there were warty-faced mothers-in-law with padlocks on their lips, or wives with a rolling pin raised threateningly; other cards were done in transparent coloured paper: well-endowed young ladies in negligées modestly clutched together over their breasts, with the instructions, "Hold up to the light to view. For the connoisseur."

Handcuffs labelled "The Infamous Hamburg Figure-of-Eights" lay amid rows of Egyptian dream-books, imitation bed-bugs and cockroaches ("to be dropped into the glass of the man next to you at the bar"), rubber nostrils that could waggle, glass retorts filled with a reddish fluid ("The Love Thermometer – irresistible to the Ladies!"), dice-shakers, bowls full of tin coins, "The Terror of the Compartment (never fails to break the ice on a railway journey – essential for travelling salesmen!)" consisting of a set of wolf's teeth that could be fixed below a moustache, and giving its blessing to all this splendid display was a wax female hand projecting from the matt black rear wall, a lacy paper frill around the wrist.

Less because he was interested in buying anything than to get away from the fishy smell emanating from the two young locals who insisted on remaining in close attendance, the stranger entered the shop.

A dark-skinned gentleman, close-shaven, purple-jowled and hair glistening with oil, was sitting in an armchair in the corner, one foot in an ornately-patterned patent leather shoe resting on his knee. The characteristically Balkan features looked up from the paper they were immersed in and shot the foreigner a razor-sharp glance of appraisal. At the same time a window, not unlike those in railway carriages, clattered down in the head-high partition separating the customers from the interior of the shop, and in the opening there appeared the upper portion of a young lady in a low-cut dress with a blond page-boy hairstyle and provocative light-blue eyes.

It took her no time at all to realise from his accent and halting Dutch – "Buy, some thing, not matter what" – that she was dealing with an Austrian, a fellow-countryman, and she spoke in German as she began her explanation of a conjuring trick involving three corks which she had immediately produced. As she did so she brought the whole range of a practised feminine charm into play, from the breasts deliberately displayed to the male, to the discreet, almost telepathic scent given off by her skin which she intensified by occasionally lifting her arm to send a supplementary blast from the armpit.

"You see the three corks here, sir? I put one and then a second in my right hand, which I close. So. The third I put" – she smiled and blushed – "into my pocket. How many are there in my hand?"

"Two."

"No. Three."

Three it was.

"The trick is called 'The Flying Corks' and only costs two guilders, sir."

"Fine. Show me how the trick is done."

"Could I ask for the money first, please? It's our normal practice."

The foreigner handed over two guilders and was treated to a demonstration of the trick, which was merely a matter of sleight of hand, plus several further waves of feminine scent and, finally, given four corks, which he pocketed with admiration for the commercial acumen of the firm of Chidher Green and the absolute conviction that he would never be able to do the trick himself.

"Here you see three iron curtain rings, sir", the young girl began again. "I put the first ..." – her demonstration was interrupted by loud drunken bawling from the street mixed with shrill whistling; at the same time the shop door was violently opened and then flung to with a crash.

The foreigner started and, turning round, saw a figure whose bizarre attire astonished him.

It was a gigantic Zulu with thick lips and a dark, curly beard, dressed only in a check raincoat and a red ring around his neck.

His hair dripped with mutton-fat and had been brushed up in an extravagant style, so that he looked as if he was carrying an ebony bowl on top of his head.

In his hand he held a spear.

Immediately the Balkan gentleman leapt up out of his armchair, gave the savage a deep bow and insisted on taking the spear from him and putting it in an umbrella-stand. Then, pulling aside a curtain with an obsequious gesture, he ushered him into an adjoining room with many polite How-goes-it-sir's and If-you-please-Mijnheer's.

"Perhaps you, too, would like to come in and sit down for a while?" The young lady turned back to the foreigner and opened the door in the partition. "At least until the crowd has quietened down a little." She hurried to the glass door and, with a flood of Dutch oaths – "Stik, verreck, god verdomme, val dood, steek de moord" – pushed a burly fellow, who was standing in the doorway spitting in a broad arc into the shop, out into the street and bolted the door.

The interior, which the foreigner had entered meanwhile, was divided into sections by cupboards and bead curtains, with chairs and stools in the corners and a round table in the middle at which two portly old gentlemen, to all appearances merchants from Hamburg or Holland, were sitting by the light of an oriental lamp staring intently into peepshows, small cinematographic machines, by the humming sound that came from them.

Through a passage between shelves filled with goods one could see into a small office with windows of frosted glass giving onto the side street. There an old Jew, looking like an Old Testament prophet with his caftan, long white beard and ringlets, a round silk cap on his head and his face hidden in the shadows, was standing motionless at a high desk making entries in a ledger.

"Tell me, Fräulein, who was that strange negro just now?" asked the foreigner when the shop assistant returned to continue her demonstration of a trick with the three curtain rings.

"Him? Oh, he goes by the name of Mister Usibepu. He's an artiste, one of the troupe of Zulus that's appearing at the Carré Circus just now. A fine figure of a man", she added, her eyes

shining. "In his own country he's a doctor of medicine."

"Oh, I see, a medicine man."

"Yes, a medicine man. And he's over here to learn from us, so that when he returns home he will be able to impress his fellow-countrymen and maybe win himself a throne. Professor Arpád Zitter from Bratislava, Professor of Pneumatism, is teaching him at the moment" – with two fingers she pushed apart a slit in the curtain and let the foreigner look into a closet that was papered with playing cards.

With two daggers sticking crosswise through his throat, so that the points protruded at the back, and a blood-stained axe deep in a gaping wound in his head, the Balkan gentleman was just swallowing an egg whole, which he proceeded to take out of the ear of the astonished Zulu, who, having taken off his coat, was dressed only in a leopardskin.

The foreigner would have liked to have seen more, but the girl quickly let the curtain fall when the Professor shot her a reproachful glance. A shrill ringing sent her rushing to the telephone.

'Strange how colourful life can be if you take the trouble to look at it from close to and turn your back on the so-called important things, which only bring vexation and suffering', the foreigner mused to himself. From a shelf with all sorts of cheap toys he took down a little open box and gave it an absent-minded sniff. It was full of tiny carved cows and trees, whose foliage was made of green-painted wood shavings.

For a moment he was overwhelmed by the evocative smell of resin and paint – Christmas! Childhood! Waiting breathlessly at a keyhole, sitting on a wobbly chair upholstered in red cotton rep with a greasy stain on it; the Pomeranian – Durudelbutt, yes, that was his name – was under the sofa growling and bit the mechanical sentry in the leg and then came crawling along to him, one eye half-closed and somewhat annoyed: the spring of the clockwork motor had come loose and smacked him in the face; the crunch of pine needles and the long drips of wax on the red candles burning on the tree ...

There is nothing that can revive the past so quickly as the smell of paint on wooden Nuremberg toys. The foreigner shook

himself free from the spell. 'Nothing good comes from memory: Life starts sweetly enough, then suddenly one day it is looking at you over a headmaster's spectacles and it ends up as a gargoyle dripping with blood ... No, no, I refuse to be drawn back.' He turned to the revolving bookcase next to him. 'Nothing but books with gilt edging?' With a shake of the head he deciphered the strange titles on the spines, not at all appropriate to the surroundings: Leidinger G. *History of the Bonn University Choral Union,* Aken F. *An Outline of the Study of Tense and Mood in Greek,* Neunauge R.W. *The Treatment of Haemorrhoids in Classical Antiquity* – 'Well, at least there seems to be nothing on politics' – and he took out Aalke Pott *On the Growing Popularity of Cod Liver Oil, vol 3* and leafed through it.

The poor paper and wretched print were a bewildering contrast to the expensive binding. 'I must be mistaken? It doesn't look like a hymn to rancid oil?' The foreigner found the title page and was amused to read:

Sodom and Gomorrha Series
A Collection for the Discerning Bachelor
(Jubilee Edition)

Confessions of a Depraved Schoolgirl

Second part of the celebrated work *The Purple Snail*

'Really, isn't that just the twentieth century in a nutshell: all scientific mumbo-jumbo on the outside and inside: money and sex', muttered the foreigner to himself in a gratified tone and then laughed out loud.

One of the two stout businessmen (not the Dutchman, he was unmoved) looked up apprehensively and, muttering a few embarrassed words about 'marvellous views of historic cities', tried to make his escape. He was endeavouring to bring his facial

expression, which the visual delights he had just enjoyed had given a somewhat swinish look, back under control, and resume the demeanour of the solid businessman with nothing on his mind but the blameless pleasures of double-entry bookkeeping. But the demon who leads the sober-minded astray had not finished with him. It was just an unfortunate little accident, a chance occurrence, but it laid bare the soul of the respectable member of the Hamburg Chamber of Commerce and trumpeted abroad the dubious nature of the establishment he had allowed himself to be enticed into.

The worthy merchant was in such a hurry to put his coat on that he knocked against the pendulum of a large clock hanging on the wall, setting it in motion. Immediately the door, decorated with scenes of family life, flew open and instead of the expected cuckoo there appeared a scantily dressed woman with an extremely saucy expression on her wax face. As the chimes solemnly struck twelve she sang in a husky voice:

"John Cooper was boring

A great piece of timber.

He bored and he bored

But his tool was too limber –

Limber, limber, limber –" it suddenly repeated, changing to a croaking bass. Either the demon had relented or a hair was stuck in the gramophone mechanism.

Determined no longer to suffer the teasing of the impudent sprite, the captain of industry squawked, "Disgusting!" and fled.

Although he had come across the moral strictness of the Northern races before, the foreigner still found it difficult to explain the extreme embarrassment of the old gentleman until it began to dawn on him that he must have met him somewhere before and had probably been introduced to him in rather different company. A fleeting memory of an elderly lady with sad, delicate features and a beautiful young girl seemed to confirm his suspicion, but he could bring neither name nor place back to mind.

There was no help from the face of the Dutchman who stood up now, looked him over contemptuously from head to toe with

his cold, watery blue eyes and then waddled slowly out. That cocksure, brutal face was completely unknown to him.

The assistant was still on the telephone. To go by her answers, it must be a large order for a stag night.

'I could go now', the foreigner thought to himself; 'what am I waiting for?'

He suddenly felt weary, yawned and collapsed in an armchair. A thought wormed its way into his mind, 'With all the mad things destiny leaves lying around, it's a surprise your head doesn't sometimes explode, or something like that! And why should you feel sick in the pit of your stomach when your eyes devour something ugly?! What has that to do with the digestive system, for God's sake? – No, it's not the ugliness that does it', he span out the thread of his thought, 'you can get a sudden attack of nausea by staying too long in an art gallery as well. It must be some kind of illness – museumitis – unknown to medical science. Or could it be the air of death surrounding all things man-made, whether beautiful or ugly? There must be something in it; I cannot remember ever having been made to feel sick by the sight of even the most desolate landscape. Everything that bears the sign 'man-made' has a taste of tinned food: it gives you scurvy.' He gave an involuntary laugh at the sudden memory of a rather baroque reflection of his friend, Baron Pfeill, who had invited him that afternoon to the café 'The Gilded Turk', and had a deep hatred of anything to do with perspective in painting: "The Fall did not begin with eating the apple, that is base superstition. It was hanging pictures in houses that did it! Scarcely has the plasterer made the wall sheer and smooth than the Devil appears in the guise of an "artist" and paints you a "hole" in it with a view into the distance. From there it's only one step to the bottomless pit where you're hanging in full fish and soup on the dining-room wall yourself next to Isidor the Handsome or some other crowned idiot with a pear-shaped head and a Cro-Magnon jaw, watching yourself eat." – 'Well, yes', the foreigner continued his musing, 'you have to be able to laugh at anything and everything. The statues of the Buddha all smile, and not without reason, whilst the Christian saints are all bathed in tears. If people would smile more often, there would probably

be fewer wars. I've been wandering round Amsterdam for three weeks now, deliberately ignoring all the street names, never asking what this or that building is, where this or that ship is coming from or heading for; I've not read any newspapers: there's no point in having the same thing served up as the latest news as has been going on for donkey's years; I'm living in a house where every single object is foreign to me – I'll soon be the only 'private' person left that I know; whenever I come across something new I no longer ask what it does, nothing does anything any more, everything has something done to it! And why am I doing all this? Because I am fed up with playing my part in the old game of civilisation: first peace to prepare for war and then war to win back peace etc., etc.; because I want to see a fresh, unknown world, I want a new sense of wonder such as must strike an infant if he were to become a grown man overnight; because I want to be a full-stop rather than eternally a comma in the punctuation of time. I'd quite happily relinquish the 'tradition' of my ancestors which subjected them to the state; I want to learn to see old forms with new eyes rather than, as up to now, seeing new forms with old eyes – perhaps it will give them eternal youth! I have started well; now all I have to do is to learn to smile at everything instead of gawping in astonishment.'

Nothing is so soporific as the sound of whispering voices when you cannot make out what is being said. The soft and hurried conversation between the Balkan gentleman and the Zulu behind the curtain hypnotised the foreigner with its unceasing monotony so that for a moment he fell into a deep sleep.

When, a second later, he jerked back awake he had the feeling that he had been granted an amazing number of insights, but all that remained lodged in his consciousness was one meagre sentence, a fantastic hodgepodge of recent impressions and the continued thread of his philosophising, 'It is more difficult to master the eternal smile than to find the skull that one bore on one's neck in a previous existence from among the millions of graves on earth; we will have to cry the eyes out of our heads before we can look on the world with new eyes and a smile.'

'However difficult it is, I will seek out that skull!' The foreigner continued to worry at the idea that had come to him in his dream, firmly convinced that he was wide awake, whilst in fact he had dropped off again. 'I will force things to speak clearly to me and reveal their true meaning, I will force them to speak in a new language instead of whispering in my ear old chestnuts such as: Look, a medicament! Take this to make you well again when you have overindulged; or: See! a delicacy; now you can overindulge and take your medicine again. – I have just seen the point of my old friend Pfeill's saying that everything chases its own tail, and if life has nothing better to teach me, I will go into the desert to eat locusts and clothe myself in wild honey.'

"You want to go into the desert and learn higher magic, nebbich, when you are stupid enough to pay good silver for a silly trick with corks, cannot distinguish a Hall of Riddles from the real world and do not even suspect that the books of life contain something other than what is written on the spine? It is you that should be called 'Green', not me." – The foreigner suddenly heard a deep, tremulous voice answering his reflections and, on looking up, he saw before him the old Jew, the owner of the shop, standing there and staring at him.

The foreigner stared back in horror; the face before him was like nothing he had ever seen before. It was smooth, with a black strip of cloth tied over its forehead, and yet it was deeply furrowed, like the sea, that can have tall waves but not a wrinkle on its surface. The eyes were like dark chasms and yet they were the eyes of a human being and not empty sockets. The skin was a greenish olive colour and looked as if it were made of bronze, such as the races of ancient times may have had of whom it is said they were like dark-green gold.

"I have been on earth", continued the old Jew, "ever since the moon, the wanderer of the skies, has been circling the heavens. I have seen men who looked like apes and carried stone axes in their hands; they came from wood and" – he hesitated for a second – "returned to wood, from the cradle to the coffin. They are still like apes, and they still carry axes in their hands. Their eyes are cast downwards; they want to fathom the infinity that lies concealed in small things.

They have discovered that in the stomachs of worms there are millions of tiny creatures living and further billions within these, but they still have not realised that there is no end in that direction. I cast my eyes downwards, but I also cast them upwards; I have forgotten how to cry, but I have not yet learnt how to smile. My feet were soaked by the waters of the flood, but I have still not met anyone who had reason to smile. Perhaps I did not notice him and went by on the other side.

Now my feet are threatened by a sea of blood and someone appears who thinks he might smile? I doubt it. I shall probably have to wait until the sea turns to fire."

The foreigner pulled his top hat down over his eyes, so as to blot out the sight of the awful face that was etching itself onto his senses and making him catch his breath, and so he did not see that the Jew had returned to his accounts and the salesgirl had tiptoed to his place, taken a papier-maché skull, similar to the one in the window, out of the cupboard and put it on a stool.

When the foreigner's hat suddenly slipped off his head and fell to the floor, she scooped it up like lightning, before its owner could put out a hand for it, and began her patter:

"Here, sir, you can see the so-called Oracle of Delphi. Through it we can at any time see into the future and even receive answers to questions that lie deep in our hearts;" – for some reason she squinted down into her cleavage – "please think of a question, sir."

"Yes, yes, all right", grunted the foreigner, still quite confused.

"You see, the skull is already moving."

Slowly the skull opened its jaws, chewed a few times and then spat out a roll of paper which the young lady quickly snatched up and unrolled, then blew out a sigh of relief.

> Will thy heart's longing
> be fulfilled? Take a firm
> grip on your life and do
> instead of merely desiring.

was written on it in red ink – or was it blood?

'Pity I can't remember what the question was', thought the foreigner. "It costs?"

"Twenty guilders, sir."

"All right. Please will ...", the foreigner was wondering whether to take the skull with him. 'No, impossible, they would take me for Hamlet out in the streets', he said to himself. "Send it to my apartment, please; here is the money."

He glanced involuntarily at the office by the window. The old Jew was standing at his desk, motionless, suspiciously motionless, as if he had spent the whole time doing nothing but write entries in his ledger. Then the foreigner wrote his name and address on the piece of paper the girl handed to him:

<div style="text-align:center">

Fortunatus Hauberrisser
(Engineer)
47 Hooigracht

</div>

and, still somewhat dazed, left the Hall of Riddles.

Chapter Two

For months now Holland had been flooded with people of all nations. Since the war had ended, giving way to growing inner political conflicts, they had left their homes, some to seek permanent refuge in the Netherlands, others to stay there temporarily whilst they made up their minds about which corner of the earth to choose for their future home.

The common forecast that the end of the European war would produce a stream of refugees from the poorer sections of the population of the worst-hit areas had proved completely mistaken. Even if all available ships to Brazil and other parts of the earth considered fertile were full to overflowing with steerage passengers, the outflow of those who earned their living by the sweat of their brow was infinitesimal compared to the number of wealthy people who were tired of seeing their fortunes squeezed by the pressure of higher and higher taxes: the so-called materialists. They were joined by members of the intelligentsia, whose professions, since the enormous rises in the cost of living, no longer brought in enough to keep body and soul together.

Even in the far-off days of the horrors of peace, the income of a master chimney-sweeper or a pork-butcher had far outstripped that of a university professor. Now, however, European society had reached that glorious stage where the old curse, 'In the sweat of thy face shalt thou eat bread' was to be understood literally and not just metaphorically. Those whose sweat appeared behind, rather than on their brows fell into penury and starved to death.

Muscle-power reached for the crown, whilst the products of the human brain were trodden underfoot. Mammon still sat on his throne, but with a look of uncertainty on his ugly face: the piles of dirty money building up around him offended his aesthetic sense.

And the earth was without form and void; and darkness was upon the face of the deep, only the spirit of the travelling salesman could no longer move on the face of the waters as it had done before.

And so it came to pass that the great mass of European intellectuals were on the move, crowding the harbours of those countries that had been more or less spared by the war, gazing westwards, like Tom Thumb climbing a tall tree to spy out the fire from a hearth far away.

In Amsterdam and Rotterdam the old hotels were full to the very last attic, and every day new ones were being built; the streets of the more respectable districts resounded to a pot pourri of languages. Special trains were arriving hourly at the Hague, filled with stony-broke or stony-hearted politicians of all races who were determined to say their immortal piece at the permanent peace conference which was discussing the securest way to bar the stable door now that the horse had bolted for good.

In the better restaurants and chocolate houses people sat shoulder to shoulder reading overseas newspapers – the local ones were still wallowing in officially-prescribed enthusiasm for the current situation – but even the overseas ones contained nothing that did not boil down to the old adage, 'I know that I know nothing, and I'm not even sure of that'.

"Baron Pfeill still not here?", the middle-aged lady snapped furiously at the waiter in 'The Gilded Turk', a dark, smoky café, full of odd little nooks and crannies, hidden away from the traffic in the Kruiskade. With her sharp features, wet hair, pinched lips and pale, nervous eyes she was a perfect example of a certain kind of woman you find without a man; at forty-five they start to resemble their bad-tempered pugs and at fifty they are already yapping at the rest of humanity. "A scandal for a lady to have to sit all by herself in a filthy tavern like this, exposed to the stares of all these men."

"Baron Pfeill? I'm afraid I don't know the name. What does he look like, Mevrouw?" asked the waiter, unmoved.

"Clean-shaven, naturally. Forty to forty-five. Or forty-eight. Not sure. Didn't ask to see his birth certificate. Tall. Slim. Aquiline nose. Straw hat. Brown hair."

"But he's been sitting outside for ages, Mevrouw", the waiter extended a languid arm towards the open door, through which

one could see out onto the terrace between the street and the café with its ivied trellis and sooty oleanders.

"Prawns, lovely prawns", droned the bass of a crab-seller passing the window; "Bananas, ripe bananas" screeched a female descant.

"Nonsense. He's blond. And a moustache. Top hat, too. Nonsense." The lady became angrier and angrier.

"I mean the gentleman next to him, Mevrouw; you can't see him from here."

The lady descended on the two gentlemen like a vulture, loosing a storm of reproaches at Baron Pfeill, who stood up with an embarrassed look and introduced his friend Fortunatus Hauberrisser. She insisted she had rung him up at least a dozen times and had eventually had to go round to his apartment, without finding him in, and all this trouble because – "a scandal" – he had, of course, been out once again. "I would have thought that at a time when everyone has his hands full consolidating the peace, advising President Taft, persuading refugees to return to their places of work, trying to get rid of international prostitution and put a stop to the white slave trade, giving the weak in spirit some moral support and organising a collection of bottle tops for the war-wounded of all nations" – in her indignation she tore open her reticule and then throttled it with its silken string – "I would have thought one would stay at home instead of ... instead of drinking spirits." She shot a venomous glance at the two slim glass tubes on the table full of a rainbow mixture of liqueurs.

"Madame Germaine Rukstinat, widow of Consul Rukstinat, is interested in doing ... good", explained Baron Pfeill to his friend, concealing the ambiguity of his words behind an apparently clumsy manner of expression, "and the good that she does shall live after her ... as Shakespeare has it."

"How can she not notice?" wondered Hauberrisser, shooting a covert glance at the Fury, but to his surprise she was giving a mollified smile. "My friend Pfeill is all too right. The plebs revere Shakespeare but do not truly know him. The more he is misquoted, the more they feel they understand him."

"I'm afraid, Mevrouw", Pfeill turned to the lady again, "that

in your circles my alltootruism is exaggerated. My supply of bottle tops, which the war-wounded so urgently need, is considerably smaller than would appear. Even if I did once – unknowingly, I assure you – affiliate to a charitable association which brought me the odium of public Samaritanism, yet I fear my moral backbone is insufficiently steely to cut off international prostitution from its source of revenue; perhaps I might remind you of the well-known saying, *Yoni soit qui mal y pense*. And as for putting a stop to the white slave trade, I'm afraid I have no contacts at all with the captains of this industry, nor have I had the opportunity to become intimately acquainted with senior officers of foreign vice squads."

"But you must have some useless articles for the war orphans, mustn't you, my dear Baron?"

"Is there such a great demand for useless articles among the war orphans, madame?"

Madame did not notice the ironic question, or ignored it. "But my dear Baron, you must take a few tickets for the grand charity ball we are organising in the autumn. The net proceeds, which will be distributed in the spring, will go to support all those who have suffered through the war. It will be a sensation: the ladies will all be masked and any gentleman who has bought more than five tickets will be decorated with the Order of Charity of the Duchesse de Lusignan."

"Such a grand ball has many attractions indeed", admitted Baron Pfeill reflectively, "especially as at such charitable functions the commandment to love thy neighbour is often interpreted in such a liberal manner that thy left hand knows not what thy right hand doeth. And it must give the rich great pleasure to know that the poor will benefit from the great distribution – eventually. On the other hand, I am not enough of an exhibitionist to go round with the evidence of my quintuple charity hanging from my buttonhole. Of course, if you insist, madame -"

"So I can put you down for five tickets?"

"Only four, if you please, Mevrouw."

"Sir, sir, Baron, sir", breathed a voice, and a grubby little hand

18

tugged shyly at Pfeill's sleeve. When he turned round he saw a shabbily-dressed girl with sunken cheeks and white lips that had squeezed her way between the oleander tubs to us and held out a letter to him. He immediately fumbled in his pocket for a coin.

"Grandfather says to tell you -"

"Who are you, my child?" asked Pfeill in a low voice.

"Grandfather, Klinkherbogk the cobbler, says to tell you I am his little girl" – the girl was mixing up her answer and the message she was to deliver – "that you made a mistake, Baron, sir. Instead of the ten guilders for the last pair of shoes there were a thousand -"

Pfeill turned bright red, tapped somewhat violently on the table with his silver cigarette case to drown the girl's words and said in a loud, brusque voice, "There you are, there's twenty cents for your trouble", and added in softer tones that it was all in order, she should go home and not lose the letter on the way.

As if to explain that the girl had not come alone, but for safety's sake had been accompanied by her grandfather so that she would not lose the envelope with the banknote on her way to the coffee house, for a second between the ivy bushes there appeared the face of an old man. It was deathly pale, for he had obviously heard what Pfeill had just said and was so moved that he was incapable of saying a word; his tongue was paralysed and his jaw trembling, and all that came out was a babbling wheeze.

Without paying any attention at all to the little scene, the charitable lady noted down the four tickets in her little book and took her leave with a few polite words of farewell.

For a while the two men sat in silence, avoiding each other's eyes and drumming with their fingers on the arms of their chairs now and then.

Hauberrisser knew his friend only too well not to sense that to ask what the story with the shoemaker was would have so embarrassed Pfeill that he would have let his imagination run riot to invent some story, any story, to allay the suspicion that he had helped a poor cobbler in great need. He was therefore racking his brain to find some topic of conversation that – naturally – would have nothing to do with charity or a shoemaker, but on the other hand, did not sound too far-fetched.

It seemed an easy enough task, but as the minutes passed, it became more and more difficult.

'Coming up with an idea is a confounded thing', he thought to himself. 'We think our brain produces them, but in reality they do what *they* like with our brain and are more unbiddable than any living creature.' He pulled himself together. "Tell me Pfeill", (the face he had seen in his dream in the Hall of Riddles had suddenly come back to mind) "tell me, you spend so much time reading, doesn't the legend of the Wandering Jew have its origin in Holland?"

Pfeill gave him a suspicious look, "You mean because he was a cobbler?"

"Cobbler? What do you mean?"

"Well, the story goes that the Wandering Jew was originally a cobbler called Ahashverosh from Jerusalem who, when Jesus wanted to rest by his workshop on his road to Golgotha – the Place of a Skull – drove him away in anger. Since then he has had to wander the face of the earth and cannot die till Christ should return." When Pfeill saw the surprised look on Hauberrisser's face, he hastily continued his explanation so as to get away from the theme of the cobbler as quickly as possible, "In the thirteenth century an English bishop claimed to have met a Jew called Cartaphilus in Armenia who told him that at certain phases of the moon his body rejuvenated itself, and that for a while he had been John the Evangelist, of whom it was well known that Christ had said he should not taste of death till he saw the Son of Man coming into his kingdom. In Holland the Wandering Jew is called Isaac Laquedem. There was a man of that name who was presumed to be Ahasuerus because he stood looking at a head of Christ in stone and then cried out, "That is he, that is he, that is what he looked like!" The museums of Basle and Berne even exhibit a shoe – one right and one left – strange things, made up of various pieces of leather, three feet long and weighing a stone, which were found in different places in the mountain passes of the frontier between Italy and Switzerland and, because they are so inexplicable, were connected with the Wandering Jew. As a matter of fact -"

Pfeill lit a cigarette.

"As a matter of fact, it's odd you should think of asking me about the Wandering Jew just at this moment. Only a few minutes ago I was most vividly reminded of a picture that I once saw many years ago in a private collection in Leyden. It is by an unknown master and represents Ahasuerus: an extremely frightening face of an olive bronze colour, a black cloth round its forehead and the eyes without whites and without pupils, like – how shall I put it? – like chasms almost. For a long time it haunted my dreams."

Hauberrisser started, but Pfeill did not notice and continued,

"The black cloth round his forehead: I read somewhere later on that in the Near East that is considered a sure sign of the Wandering Jew. It is said he uses it to conceal a blazing cross which etches itself on his forehead: every time the skin grows back the cross eats it away again. Scholars maintain these things are merely references to cosmic events involving the moon and for that reason the Wandering Jew is also referred to as Chidher, that is, the Green One – but to my mind that's all nonsense.

This mania of interpreting anything inexplicable from antiquity in terms of the Signs of the Zodiac is becoming widespread again today. It's spread was halted for a while after a witty Frenchman wrote a satire on it: Napoleon never actually existed, he too was an astral myth; in reality he was the Sun God Apollo and his twelve generals represented the twelve signs of the Zodiac.

I believe that the old mysteries conceal much more dangerous things than knowledge of phases of the moon and eclipses of the sun, things that really had to be concealed – but which do not need to be concealed nowadays because the foolish throng would not believe them anyway, only laugh at them – things that obey the same laws of harmony as the stars and which are therefore similar to them. Well, be that as it may, for the moment scholars have thrown away the kernel and kept the husk."

Hauberrisser was deep in thought.

"What do you think of Jews as a whole?" he asked after a long silence.

"Hm. What do I think of them? On the whole they are like ravens without wings: incredibly cunning, black, hooked beaks

and can't fly. But sometimes they throw up an eagle, no question of that. Spinoza, for example."

"You're not antisemitic, then?"

"Wouldn't dream of it. For one thing, because I have no very high opinion of Christians. The Jews are accused of having no ideals. If that is true, then the Christians have only false ones. The Jews take everything to extremes: obeying laws and breaking laws, piety and impiety, working and idling; the only things they don't take to extremes are mountain climbing and rowing, what they call 'Goyim naches' – and bombast, they're not very keen on that. Christians, on the other hand, overdo the bombast and underdo just about everything else. As far as religion is concerned, the Jews study their sacred books too closely, the Christians not closely enough."

"Do you think the Jews have a mission?"

"Of course! The mission of overcoming themselves. All people have the mission of overcoming themselves. Anyone who is overcome by others has failed in his mission; anyone who fails in his mission will be overcome by others. If one overcomes oneself, other people don't notice; if, however, one overcomes others, then the sky turns red and the man in the street calls the phenomenon progress. The feeble-minded think the flash is the important part of an explosion. – But you must excuse me, I'd better stop now." Pfeill looked at his watch, "Firstly I must get home as quickly as possible, and secondly I don't think I could live up to all this clever talk in the long run. So, your servant sir – as people say when they mean the opposite – and if you feel like it, come and see me in Hilversum soon."

He put a coin on the table for the waiter, gave his friend a friendly wave and left.

Hauberrisser tried to get his thoughts back in order.

'Am I still dreaming?' he asked himself in astonishment. 'What was that? Is there a thread of remarkable coincidences running through everyone's life or am I the only person these things happen to? Are events like rings which only link to form a chain when they are not disturbed by people making plans and then charging after them and tearing destiny to tatters, when if they hadn't, they could have woven themselves miraculously

into a continuous chain?'

Out of the habit of generations and from his own experience, which had so far appeared to make sense, he put this appearance of the same thought at the same time in his mind and that of his friend down to the effect of thought transfer, but for once the theory did not seem to correspond to the facts, something which in the past he had merely accepted and then tried to forget as quickly as possible. Pfeill's memory of the face with the olive-green glow and the black cloth over its forehead had a tangible source: a portrait that was supposed to be on a wall in Leyden; but what was the origin of his dream vision of a similar olive-green face with a black cloth over its forehead which he had seen just a short while ago in Chidher Green's shop?

'The reappearance of the odd name Chidher within such a short time as one hour, first of all on a shop sign and then as a legendary designation for the Wandering Jew is strange enough', Hauberrisser mused to himself, 'but there are probably few people who have not had any number of such experiences. How is it that names which one has never heard of before suddenly pour down upon one from all directions? And why is it that one often finds that people in the street start to look more and more like a friend one has not seen for years, until he himself comes round the corner – not just like one's memory, no, a photographic likeness, so similar that one's thoughts automatically turn to one's old friend; where do such things come from? Do people who look similar also have similar destinies? How often have I found that to be true. Destiny seems to be inextricably bound up with one's physique and physiognomy; there seems to be a law of correspondence governing it, right down to minute detail. A ball will roll, and so will a die, though in a different way; why should not a creature with a thousandfold more complicated existence not be yoked according to a law as regular, if a thousandfold more complicated, to *one* pair of shafts? I can well understand why astrology does not die out, perhaps has even more believers than ever before, and that one in ten have their horoscope cast; but people are on the wrong path if they believe the stars they can see in the sky determine the path of their destiny. That comes from other 'planets', from

ones which orbit in their blood and around their hearts and have different periods from the heavenly bodies, Jupiter, Saturn etc. If the place, hour and minute of birth were the sole deciding factors, how could it be that the Blaschek sisters, siamese twins who were born at the very same minute, could have had such different destinies, the one becoming a mother, the other remaining a virgin?'

A man in a white flannel suit, red tie and Panama hat set at a jaunty angle, his fingers laden with showy rings and a monocle stuck in his dark eye had appeared behind the cover of a Hungarian newspaper at one of the more distant tables some time ago and, by changing his place several times, as if he were bothered by the draught, had inched his way closer to Hauberrisser, although the latter had been too deep in thought to notice.

Only when the other addressed the waiter in an overloud voice, asking for information on places of entertainment and other local sights, did Hauberrisser become aware of him, and the intrusion of the outside world sent his profound reflections scuttling back into the darkness whence they came.

A quick glance told him that it was 'Professor' Arpád Zitter from the Hall of Riddles who was so desperately trying to play the innocent who had just got off the train.

His moustache was missing and his hair-oil had been diverted into different channels, but that had not detracted anything from the characteristic features of a Bratislavan 'pigeon-fancier' on the look-out for his prey.

Hauberrisser had been much too well brought up to give even the slightest sign that he knew who the person opposite him was. It amused him, moreover, to match the subtler wiles of the gentleman against the crude tricks of the vulgar, who always assume a disguise is successful simply because their intended dupe does not immediately underline his suspicion with much furrowing of the brow and rubbing of the chin.

Hauberrisser did not doubt for one moment that the 'Professor' had followed him to the café with some Balkan villainy in mind. In order, however, to satisfy himself that he was the object of this pantomime, he made as if to pay and leave. Immediately a cloud of irritation crossed Master Zitter's face.

Hauberriser allowed himself an inward smile of satisfaction; "Hmm. Chidher Green and Co. – assuming the 'Professor' is an active partner – seems to have various means of keeping tabs on their customers: scented ladies with page-boy hair, flying corks, ghostly old Jews and incompetent spies in white suits. Quite an organisation!"

"There must be a bank somewhere near here where one can change a couple of English thousand-pound notes into guilders, surely?" the Professor asked the waiter in a casual tone, but once more in a very loud voice. He made a great display of irritation at the waiter's shake of the head. "Seems to be some problem with the petty cash here in Amsterdam", was his opening gambit as he half turned towards Hauberriser. "I had the same difficulty back at the chotel."

Hauberrisser said nothing.

"Yes, hm, chreat deefficulty."

Hauberrisser did not allow himself to be drawn.

"Fortunately the chotel owner knew the old family seat. Allow me to introduce myself: Ciechonski; Count Wlodimierz Ciechonski."

Hauberrisser sketched a bow and mumbled his name as incomprehensibly as possible, but the Count seemed to have an uncommonly sharp ear, for he jumped up in excitement, rushed across to the table and sat in the seat Pfeill had just vacated with a delighted cry of, "Chauberrisser? Not Chauberrisser the celebrated torpedo constructor? The name is Ciechonski, Count Wlodimierz Ciechonski. May I?"

Hauberrisser shook his head with a smile. "You are mistaken. I was never a torpedo constructor." ('A silly performance', he added silently to himself; 'pity he insists on trying to act the Polish count; I would have preferred Professor Arpád Zitter from Bratislava; at least then I would have been able to quiz him about his partner, Chidher Green.')

"No? Pity? But no matter. The very name of Chauberrisser awakes such, oh, such fond memories", the Count's voice quivered with emotion, "that and the name of Eugène- Louis-Jean-Joseph have close ties with our family."

'Now he wants me to ask who this Louis-Eugène-Joseph is.

That is precisely what I will not do', thought Hauberrisser and silently smoked his cigarette instead.

"Eugène-Louis-Jean-Joseph was my godfather, you see. He died in Africa immediately after I was christened."

'Probably from pangs of conscience', Hauberrisser muttered to himself. "Died in Africa, did he, how very unfortunate."

"Unfortunately, yes, unfortunately. Poor Eugène-Louis-Jean-Joseph! He could have been Emperor of France."

"He could have been what?" – Hauberrisser thought he must have misheard – "He could have been Emperor of France?"

"Assuredly!" Proudly Arpád Zitter played his ace, "Prince Eugène-Louis-Jean-Joseph Napoleon IV. He fell on 1st July 1879 in the war against the Zulus. I even have a lock of his hair", he pulled out a gold pocket watch the size of a steak and of quite fiendish tastelessness, opened the lid and pointed to a tuft of black hair. "The watch came from him, as well. A christening present. A mechanical marvel." He explained, "If you press here it strikes the hours, minutes and seconds and at the same time a pair of mechanical lovers perform on the back. This button starts the stop-watch, this one stops it; if you push it in a bit farther the current phase of the moon is shown; even farther in and the date flips out. Push this lever to the left and it squirts out a drop of musk-oil, to the right and it plays the Marseillaise. A truly royal present. There are only two of its kind anywhere."

"That must be a comfort", Hauberrisser conceded with polite ambiguity. He was highly amused by the combination of brazen effrontery and total ignorance of good manners.

Count Ciechonski, encouraged by Hauberrisser's friendly expression, became even more familiar, told him about his extensive estates in Russian Poland which had unfortunately been devastated by the war (luckily he was not dependent on them for his income, his intimate connections with the American Stock Exchange allowed him to earn a few thousand pounds with speculations on the London market every month), moved on to horse-racing and bribing jockeys, the scores of eligible young billionairesses he knew, to land in Brazil and the Urals going for a song, still-undeveloped oil wells by the Black Sea, and remarkable inventions which were his to exploit and which

were sure to bring in a million a day; then he got on to buried treasures, whose owners had died or fled, to infallible methods of winning at roulette, told Hauberrisser about huge sums for spies that Japan was just itching to pay out to reliable persons (of course one would have to put down a deposit first), prattled on about underground brothels in the big cities to which only those in the know had access, and even went into great detail about King Solomon's golden Ophir, which, as he knew from the papers of his godfather Eugène-Louis-Jean-Joseph, lay in the land of the Zulus.

He was even more versatile than his pocket watch and dangled a thousand hooks, each more crudely baited than the last, in order to tempt his prey. Like a shortsighted burglar who tries a whole set of skeleton keys without ever finding the keyhole, he reconnoitered Hauberrisser's mind without finding an open window to climb in through.

Finally he gave up in exhaustion and asked Hauberrisser in a rather deflated voice whether he would not mind introducing him to some gentleman's gambling club. But even here his hopes were dashed, Hauberrisser excused himself, pointing out that he was a stranger in Amsterdam himself.

The 'Count' took a disgruntled sip of his sherry-cobbler.

Hauberrisser looked at him reflectively. 'Perhaps the best thing would be to tell him straight out that he is a confidence trickster. I would give something to hear the story of his life, it must have been colourful enough. This man must have waded through a sea of filth. But he would deny it of course, and even resort to insults.' A feeling of irritation came over him; 'Life is becoming unbearable with the people and conditions of today: mountains of empty shells everywhere and if you do come across something that looks like a nut worth cracking, it turns out to be a lifeless pebble.'

"Jews, Hasidic Jews!" muttered the confidence trickster contemptuously, pointing at a group of figures in rags and tatters – the men at the front with tangled beards and black caftans, the women behind them, their children in bundles tied to their backs – who were hurrying silently down the street, their wide-open eyes staring wildly into the distance. "Emigrants. Not a cent in

their pockets. They believe the sea will part before them when they come. Mad! Not long ago in Zandvoort a whole crowd of them would have been drowned if they hadn't been pulled out in time."

"Do you mean that seriously or is it just a joke?"

"No, no, I'm perfectly serious. Didn't you read about it? Religious mania is breaking out everywhere you look nowadays. For the moment it is mostly the poor who are infected by it but" – Zitter's irritated expression brightened up at the thought that perhaps the time was coming soon when his chickens would be there for the plucking – "but it won't be long before the rich catch it too. I know about these things." Happy to have found a profitable topic of conversation – he had noticed how Hauberrisser's attention had been caught – his tongue was loosened once more. "Not only in Russia, where the Rasputins and Jan Sergeis and other holy men keep popping out like rabbits, the mad idea that the Messiah is coming has spread over the whole world. Even among the Zulus in Africa things are happening; there's a negro running round there who calls himself the 'Black Elijah' and performs miracles. I know all about that from Eugène-Louis" – he quickly covered up his error – "from a friend who was out there recently hunting leopards. I know one famous Zulu chief myself, from Moscow" – his face suddenly showed a certain unease – "and if I had not seen it with my own eyes, I would not have believed it: the man's a complete ass in all other respects, but, as true as I'm sitting here, he can perform magic, he really can. Magic! Don't laugh, my dear Hauberrisser, I've seen it myself and no trickster can pull the wool over my eyes" – for a moment he completely forgot that he was supposed to be playing the role of Count Ciechonski – "I can do all that to a T myself. Devil knows how he does it. He says he has a fetish and when he calls on it he's fireproof. What is true is that he heats up large stones until they glow red – I've inspected them myself! – and then walks slowly across them without burning his feet!" In his excitement he started chewing his fingernails and muttered to himself, "But just you wait, my lad, I'll find out how you do it." Suddenly worried that he might have given himself away, he quickly assumed the mask of the

Polish count and emptied his glass, "Nazdravje, my dear Chauberrisser, nazdravje, cheerio. Perhaps you will see the Zulu yourself; I have cheard he is in Cholland, appearing in a circus. But shall we not go to the Amstel Room next door for a bite ...?"

Hauberrisser stood up quickly. He was not in the least interested in Arpád Zitter as a count. "Awfully sorry, but I am otherwise engaged for this evening. Perhaps another time. Goodbye. So nice to have met you."

Baffled by his sudden departure, the confidence trickster watched him leave open-mouthed.

Chapter Three

Hauberrisser rushed through the streets of Amsterdam, in a fever of excitement, though he could not say why.

As he passed the circus where Usibepu's Zulus were appearing – it must have been the one 'Professor' Zitter had in mind – he toyed with the idea of going in to see the performance, but then let it drop. What did he care if a negro could do magic tricks! It was not a lust for novelty that was racking his nerves, there was something in the air, something intangible, imponderable that whipped him up into a nervous frenzy: the same noxious fumes which, even before he had come to Holland, he had found so suffocating that his thoughts had automatically turned towards suicide.

He wondered where it came from this time. Had he caught it, like an infection, from the Jewish emigrants he had seen?

He felt it must be the same mysterious influence which had driven him from his home that sent these religious fanatics on a wild chase over the face of the earth; only the individual motivation was different.

It was well before the War when he had first had this eerie sensation, as if something was squeezing his brain, only at that time it had still been possible to suppress it by throwing himself into work or pleasure. He had found various ways of explaining it away: it was wanderlust, it was nervous exhaustion, it was the result of his unhealthy way of life; when war raised its bloody standard over the Continent he assumed it had been a premonition of the carnage. But why, now the War was over, was the sensation becoming daily more intense and driving him to despair? And not only Hauberrisser himself, almost everyone he talked to about it had a similar tale to tell.

They had all confidently assumed that when peace descended on the nations of the world it would also return to the hearts of men. Precisely the opposite had occurred.

As usual the empty-headed were loudest in proclaiming their shallow explanation that the fever raging in the hearts and minds of the survivors was merely the result of the disturbance of their comfortable existence. The cause went much deeper.

Spectres, monstrous yet without form and only discernible through the devastation they wrought, had been called up by faceless and power-hungry bureaucrats in their secret seances and had devoured millions of innocent victims before returning to the sleep from which they had been roused. But there was another phantom, still more horrible, that had long since caught the foul stench of a decaying civilisation in its gaping nostrils and now raised its snake-wreathed countenance from the abyss where it had lain, to mock humanity with the realisation that the juggernaut they had driven for the last four years in the belief it would clear the world for a new generation of free men was a treadmill in which they were trapped for all time.

During the last few weeks Hauberrisser had managed to turn a blind eye to his world-weariness. Against all appearances he had convinced himself he could live the life of a hermit, of an uninvolved bystander, here, in the middle of a city which almost overnight the pressure of events had transformed from a centre of international trade into the place where deranged minds from all over the world gathered to give free rein to their wildest fantasies. He had even succeeded in carrying out his plan to a certain extent but then, triggered off by some slight circumstance, the old tiredness had descended on him once again, more stifling than before; the sight of the giddy crowds around him whirling their senseless way through life only served to increase his weariness.

His eyes were suddenly opened to the shock of the distorted expressions on the faces crowding round him. Those were not the expressions he remembered, the expressions of people in pursuit of pleasure, hurrying to forget their troubles at some entertainment. Their faces were already irrevocably marked by a sense of dislocation.

The struggle for existence carves different lines and furrows on the face of mankind. These reminded him of the old woodcuts depicting frenzied dances in times of plague, and then, again, of flocks of birds which, sensing a coming earthquake, fly round and round in silent, instinctive fear.

Car after car screeched to a halt outside the circus, and the occupants scurried into the tent as if it were a matter of life and

death: bejewelled ladies with delicate features; French baronesses who had become *filles de joie*; slim, refined Englishwomen, the *crème de la crème* and now arm-in-arm with some hyena from the stock-market who had made a fortune overnight; and Russian princesses, every fibre of their bodies twitching with nervous exhaustion: all trace of aristocratic sangfroid had disappeared, washed away by the waves of a cultural deluge.

Like the portent of the approach of an age of doom, there came at intervals from the interior of the tent, sometimes fearfully close and loud, sometimes stifled by heavy curtains, the harsh, long-drawn-out bellowing of wild beasts, whilst an acrid stench of big cats, perfume, raw flesh and horse sweat wafted out onto the street.

A contrasting image was released from Hauberrisser's memory and appeared before his inner eye: a bear behind the bars of a travelling menagerie, chained by the left paw, the embodiment of utter desperation as it danced from one leg to the other, constantly, day after day, month after month – even year after year as Hauberrisser saw when he came across the menagerie in a fairground years later.

'Why didn't you buy its freedom!' The thought reverberated through his brain, a thought he had ignored a hundred times already, but which still ambushed him, still burnt in his mind with a fire of self-reproach as intense and unquenchable as when it first appeared; it was a dwarf of a thought, tiny and insignificant compared with the gigantic sins of omission that form an unbroken chain through a man's life, and yet it was the only one that time could not subdue.

'The shades of all tortured and murdered creatures have cursed us, their blood cries out for revenge.' For a heartbeat Hauberrisser's mind was filled with a confused vision, 'Woe to mankind if, on Judgment Day, there is the soul of one single horse among the council of the accusers: why did I not set it free?' How often had he not bitterly reproached himself for it, and how often had he not stifled the reproach with the argument that the liberation of the bear would have been as inconsequential as the fall of one grain of sand in the desert. But – he quickly surveyed his past life – had he ever done anything that

was of more consequence? He had spent his youth not in the sunshine, but in colleges and libraries, learning how to build machines, and he had spent his manhood building machines that had long since rusted away, instead of helping others to enjoy the sunshine; he had made his own contribution to the pointlessness of existence.

He fought his way through the jostling throng until he came to a less crowded square where he called a cab and asked to be driven out into the country.

He suddenly felt a thirst for all the summer days he had wasted.

How slowly the wheels rumbled over the cobbles! And the sun was already beginning to go down! His impatience to reach the open countryside merely made him more irritated.

There, at last, was the rich green of the fields, cut up as far as the eye could see into a chequerboard by the grid of brown drainage ditches, and on the green squares thousands of speckled cows with a rug on their backs to protect them against the cool of the evening, and among them the Dutch dairymaids with their white caps fastened to their hair by brass spirals and their gleaming pails; when the scene was finally before his eyes it was like the image on a huge, pale-blue soap-bubble, and all the windmills with their sails were like the first black crosses signifying the coming of eternal night.

He wandered along narrow pathways beside the meadows, always separated from them by a strip of water glowing red in the setting sun, and they seemed to him like the dream vision of a land he was destined never to set foot in.

His unrest was calmed by the scent of water and grass, but only to be replaced by a feeling of melancholy and desolation.

Then, as the meadows darkened and a silvery mist rose from the ground so that the cattle seemed to be wreathed in smoke, he began to feel as if his skull were a prison cell and he himself were sitting in it looking out through his eyes on a free world for the last time.

The twilight was thickening as he reached the first houses of the city and the air trembled with the echoing boom of the

numberless bells in their bizarrely shaped towers.

He paid off the cabbie and set out in the direction of his apartment, down narrow alleyways, along canals with clumsy black barges floating on the motionless water, through a flood of rotten apples and decaying rubbish, beneath protruding gables with the iron arms of the hoists reflected in the canal. Outside the doors men in wide blue trousers and red smocks and women mending nets sat gossiping on chairs they had brought out from their houses while hordes of children played in the streets.

He hurried past the open doors, which exhaled a smell of fish, sweat and poverty, and across squares with waffle-stands in the corners, filling all the narrow alleyways with the reek of burnt fat.

The dreariness of the Dutch port settled over him like a pea-souper: the scrubbed pavements and filthy canals, the taciturn inhabitants, the tall, pigeon-chested buildings with their pallid chequerboard pattern of flat sash windows, the narrow-fronted cheese and pickled-herring shops with their smoky paraffin lamps, and the reddish-black gable roofs.

For a moment he was struck by a longing to leave this gloomy city that had turned its back on lightheartedness and return to one of the brighter ones he had known in earlier, happier days. Life there suddenly seemed desirable again, just as everything that lies in the past seems better and more beautiful than the present. But the gentle upsurge of homesickness was immediately stifled by the final memories he had come away with, bitter memories of physical and moral decay, of irreversible decline.

He took a short cut over an iron bridge leading to the fashionable part of the city, crossed a brightly-lit and crowded street with shop windows full of elegant goods, and found himself a few steps later – as if the city had done a lightning-quick change – back in a pitch-dark alley: the 'Nes', the notorious street of pimps and prostitutes in old Amsterdam that had been torn down years ago had reappeared in another part of the town, like a new outbreak of some insidious disease. It was the same yet not the same, it was less coarse, less brutal, but far more terrible.

The dregs of Paris and London, of the cities of Belgium and

Russia, fleeing in panic the revolutions that had broken out in their own countries, had settled in these 'exclusive' establishments. As Hauberrisser walked past, silent, robot-like commissionaires in long blue coats and three-cornered hats with brass-mounted staffs in their hands flung open the padded doors and then closed them again with a flourish. Each time a blinding shaft of garish light fell across the pavement, and for a second the air was torn by the wild scream of a jazz trumpet, the crash of cymbals or the sob of gypsy violins.

There was a different kind of life lurking behind the red curtains of the upper stories of the houses: the brief staccato drumming of fingers on the windowpanes, furtive whisperings, grunts and stifled cries – in all languages of the world and yet immediately comprehensible; a female body in a white slip, the head invisible in the darkness, as if it had been cut off, leaving a torso with waving arms; and then again, empty windows, pitch-black, silent as the tomb, as if death dwelt in those rooms.

The corner house at the end of the alley seemed relatively innocuous, a mixture of music-hall and restaurant, to go by the posters on the walls.

Hauberrisser went in; a room packed with people eating and drinking at round tables with yellow tablecloths met his eye.

At the back was a stage where a dozen or so artistes – singers and comics – were sitting in a semicircle waiting until it was time for their number.

An old man with a spherical belly, a pair of false goggle-eyes, a white handlebar moustache and his incredibly thin legs encased in green tights with webbed feet was sitting, casually waggling his toes, in apparently serious conversation with a French chanteuse in the extravagant costume of the *Directoire*. The audience, meanwhile, was listening in mute incomprehension to a German monologue delivered by a character actor dressed as a Polish Jew in caftan and high boots. Brandishing a small glass syringe for rinsing out the ears such as can be bought at any chemist's, he declaimed his interminable poem, breaking into a grotesque jig between each verse, to which he sang in a nasal voice:

You vant a cure?
Viz me it's schure!
I treat from seven till nine.
For ze best in lotions,
Suppositories, potions,
Ze name is Doktor Pimpelstein.

Hauberrisser looked round for an empty seat; everywhere the diners – they mostly seemed to be respectable locals – were packed tight; only one table in the middle of the room stood out by having a few empty chairs leant against it. Three corpulent ladies of mature years and one old one with an austere look and horn-rimmed spectacles perched on her aquiline nose were sitting around a coffee-pot sporting a gaily-coloured woollen cosy, busily knitting socks, an island of domestic calm amid all the noise and bustle.

With friendly nods the four ladies granted Hauberrisser permission to sit at the table.

His first thought had been that it must be a mother with her widowed daughters, but a second glance told him that they could hardly be related. Although they did not look alike, the three younger ones were similar in that they were all of the Dutch type – roughly forty-five years old, blonde, fat and of a bovine stolidity – whilst the white-haired matron clearly came from the South.

The waiter set his steak in front of him with a half-concealed grin, and the people at the tables around were casting covert glances at the table, grinning and exchanging quiet remarks: what did it all mean? Hauberrisser was completely baffled; he gave the four ladies a quick scrutiny – no, impossible, they were very pillars of society. Their age alone almost guaranteed their respectability.

Up on the stage a scrawny, redbearded man with a star-spangled top hat, tight, blue and white striped trousers, an alarm-clock dangling from his green and yellow checked waistcoat and a strangled goose in his coat pocket, had just split open the skull of the ancient frog-man to the ringing tones of 'Yankee doodle', and now a rag-and-bone couple from Rotterdam were

singing – "with piano accompaniment" – the melancholy song
of the vanished 'Zandstraat':

> When you come home from sea again, lad,
> You'll find you get a big surprise;
> Look around you for the Zandstraat –
> I bet you won't believe your eyes!
> That house you visited so often
> Is being knocked down this very day,
> The girls have all retired from business:
> The Burgomaster's had his way.

As solemnly as if it were a hymn – tears glistened in the eyes
of the three fat Dutch ladies – the audience joined in:

> They're going to tidy up the Zandstraat,
> The notion really gets me down;
> Those inns and quiet little houses
> Have all been bought up by the Town.
> No more dancing down at Nielsen's,
> Charley's girls have taken flight,
> Betty wears a little bonnet –
> She's nursing soldiers day and night.

The programme was a mish-mash of acts, changing con-
stantly like the brightly-coloured patterns in a kaleidoscope:
babyfaced English girls with curly locks and a terrifying in-
nocence, Parisian gangsters with long red scarves, a Syrian
belly-dancer with wobbling intestines, four men imitating bells
and the melodic burping of a Bavarian yodelling song.

This meaningless hodge-podge calmed Hauberrisser's
nerves with an almost narcotic effect; it was not unlike the
strange magic emanating from children's toys, which often
exercise a greater healing power over a heart wearied by life
than the most sublime work of art.

Hauberrisser lost all track of time, and when the grand finale
came and the whole company marched off waving the flags of
all nations – presumably symbolising the return of peace – and

led by a negro dancing the cakewalk and singing:

> Oh Susanna
> Oh don't you cry for me;
> I'm goin to Loosiana
> My true love for to see....

he was astonished to find that the audience had disappeared without his noticing and the room was almost empty.

Even his four ladies had silently vanished, leaving, as a token, a pink visiting card propped up against his wine-glass. It bore a picture of two turtle-doves billing and cooing and the address:

> **MADAME GRISEL HUSSY**
> open all night
> Waterloo Plein No. 21
> 15 charming ladies
> *Private entrance*

So they were, after all!

"Would sir wish to purchase a continuation ticket?" asked the waiter in a soft voice as he deftly replaced the yellow tablecloth with one of white linen, placed a vase of tulips in the middle and laid the silver.

A huge ventilator began to whirr, sucking out the plebeian air. Liveried servants sprayed perfume, a tongue of red carpet unrolled from the door to the stage, leather armchairs were wheeled in.

A crowd of ladies in elegant evening gowns and men in white tie and tails poured in; it was the same cosmopolitan would-be cream of society that Hauberrisser had seen rushing into the circus tent.

In a few minutes every last seat was taken.

The soft jingle of lorgnon chains, muted laughter, the rustle of silk skirts, the scent of ladies' gloves and hyacinths, cascades of pearls and clusters of diamonds, the fizz of champagne, the

dry clink of ice-cubes in the silver buckets, the furious yapping of a lap-dog, white shoulders with a discreet touch of powder, foaming lace, the sweet, spicy smell of Russian cigarettes – the room he had first entered was unrecognisable.

Once more the seats at Hauberrisser's table were taken by four ladies – one older with a gold lorgnette and three younger ones, each more beautiful than the other. They were Russians with slim, nervous hands, blond hair and dark eyes, which did not avoid the stares of the men around, yet seemed not to see them.

A young Englishman, whose faultless evening dress clearly said Savile Row, came and stood for a while at the table, exchanging a few friendly words with them. His delicate, aristocratic features bore a look of immense weariness; the left sleeve of his coat was empty up to the shoulder and hung down limply, making the tall, frail figure appear even slimmer; his monocle seemed to have become part of the bony socket beneath his eyebrow.

All around were people such as the eternal petty bourgeois of all lands eyes with the instinctive hatred of the bandy-legged mongrel for a thoroughbred, beings that will ever remain a mystery to the masses, arousing both contempt and envy, creatures that can wade through blood without batting an eyelid and yet swoon at the screech of a fork across a plate, who will pull out a revolver at the slightest suggestion of a sneer yet calmly smile when caught cheating at cards, for whom vices, the very thought of which makes the ordinary citizen shudder, are commonplace and who would rather go thirsty for days than drink out of a glass another has used, who accept God as a matter of course and yet shut themselves off from Him because they find Him boring, who are considered hollow by people who crudely assume that what, in the course of generations, has become the essence of such creatures, is mere veneer and outward show; they are neither hollow nor the opposite, they are beings who have lost their souls and have therefore become the incarnation of evil for the multitude which will never possess a soul, they are aristocrats who would rather die than crawl to anyone, who, with unerring instinct, spot the plebeian within their fellow-man

and place him lower than the animals and yet fall down before him if he happens to be sitting on the throne, they are lords of the earth who can become helpless as a child at the slightest frown on the face of destiny, instruments of the Devil and at the same time his plaything.

An invisible band had just finished playing the Wedding March from Lohengrin.

A bell jangled shrilly.

The room grew quiet.

On the wall over the stage appeared, in letters made of tiny electric lights, the words:

!La force d'imagination!

and out through the curtains stepped a man in a dinner jacket and white gloves with the look of a French hairdresser: sparse, greasy hair, yellow skin, flabby cheeks, a tiny red rosette in his buttonhole and dark shadows under his eyes. Without a word he bowed to the audience and sat down on a chair in the middle of the stage.

Hauberrisser assumed this would be followed by the usual more or less risqué monologue and turned away in irritation when the artiste – was it in embarrassment or was it the lead-in to some smutty joke? – began to finger his flies.

A minute passed and still silence reigned in the auditorium and on the stage.

Then two muted violins from the band began to play "O fare thee well, It was not meant to be", joined, as if from a great distance, by the soulful tones of a French horn.

Surprised, Hauberrisser snatched up his opera glasses to peer at the stage – then almost let them drop in horror. What was that?! Had he suddenly gone mad? He broke out into a cold sweat; no doubt about it, he must have gone mad! That obscene spectacle on the stage could not really be taking place here, here before hundreds of people, before all these exquisite creatures who until a few months ago had been the cream of society. In a harbour tavern on the Nieuwendijk perhaps, or as an anatomical freak demonstrated at medical school, but here??!

Or was he dreaming? Had a miracle taken place and turned the hands on the clock of time back to the days of Louis XV?

The artiste kept his hands pressed firmly over his eyes, like a man summoning up all the power of his imagination to see something as vividly as possible before his inner eye ... then after a few minutes he stood up, sketched a bow and left the stage.

Hauberrisser glanced at the ladies at his table and the people in the immediate vicinity; not one of them moved a muscle. Only one Russian princess was uninhibited enough to applaud. As if nothing at all had taken place, the assembly resumed its cheerful chatter.

Hauberrisser felt as if he were surrounded by ghosts; he ran his fingers over the tablecloth and sucked in the scent of flowers and musk; the only result was that the feeling of unreality intensified and turned into one of abject terror.

Once more the bell rang and the room was darkened. Hauberrisser took the opportunity to leave.

Once outside in the street he almost felt ashamed of the way he had allowed his feelings to get the better of him. What, after all, had happened? Nothing that did not recur again and again, and much worse, at intervals in the course of human history: a mask had been cast aside that had never concealed anything but intentional or unintentional hypocrisy, lack of vitality posing as virtue or ascetic monstrosities conceived in the mind of a monk! For a few centuries a diseased organism, so huge it eventually came to resemble a temple soaring up into the heavens, had been taken for culture; now it had collapsed, laying bare the decay within. Was not the bursting of an ulcer much less terrible than its constant growth? Only children and fools, who do not realise that the bright colours of autumn are the colours of decay, complain when it is followed by the deathly cold of November, instead of the spring they expected.

However hard Hauberrisser tried to regain control over his emotions by subjecting his hasty instinctive reaction to the cold light of reason, the feeling of terror was not assuaged by rational argument, but remained rooted within him, like a rock that cannot be moved by words because its very being is immobility.

Gradually, as if a whispering voice were letting the words drop syllable by syllable into his ear, it became clear to him that this feeling of terror was none other than his old dull, stifling fear of some shadowy horror, a sudden recognition of mankind's headlong rush towards the abyss.

What sent icy fingers round his heart was the fact that the audience could accept as perfectly natural a performance which only yesterday they would have rejected out of hand as the height of insolence; the world, which normally plodded along with the gait of a contented carthorse, had suddenly broken into a wild gallop as if frightened by a ghost popping up by the roadside.

Hauberrisser felt he had slipped one more step down towards the eerie realm where the things of this world dissolved more quickly into shadowy insubstantiality the cruder they were.

He entered one of the two narrow alleys running either side of the music hall and immediately came upon a sort of glassed-in arcade that seemed familiar. When he turned the corner he found himself facing the metal rolling shutter over the door to Chidher Green's shop; the inn or theatre he had just left was merely the rear portion of the strange, flat-roofed, tower-like building in the Jodenbreetstraat that had attracted his attention that afternoon.

He looked up at the two gloomy windows. Here, too, he was struck by the same disconcerting sense of unreality: in the darkness the whole building had the look of a monstrous human skull with the teeth of its upper jaw resting on the pavement.

As he made his way home he was struck by a parallel between the fantastic tangle of rooms, halls and passageways inside this brick skull and the muddle of thoughts and ideas within a person's mind. He began to feel that behind the dark masonry of the forehead there must be enigmas sleeping such as Amsterdam had never imagined in its wildest dreams, and once more the icy fingers clutched at his heart with a premonition of mortal dangers lurking on the threshold of reality.

Had the vision of the green bronze face in the Hall of Riddles really been only a dream?

Suddenly in his memory it was the motionless figure of the

old Jew at his desk which seemed to become shadowy, hazy, as if that were the dream and not the bronze face

Had the Jew really had his feet firmly on the ground? The more sharply he tried to focus the image, the more he came to doubt that that had been the case. He was suddenly certain that he had been able to see the drawers of the desk clearly through the caftan.

For a brief moment his mind was illuminated, as if by the sudden glare of a flashlight, with a flickering spurt of distrust of the apparent solidity of the world around and of his own five senses. At the same time he remembered something he had learnt as a child at school and which now seemed to supply an explanation for these mysteries: the light of those inconceivably distant stars in the Milky Way takes seventy thousand years to reach the earth; if there were a telescope powerful enough to bring the surface of one into view, the events we could observe, however much they appeared to be taking place before our eyes, would be things that had already been past for seventy thousand years. The idea that shook him with its terrifying simplicity was that in the infinite expanse of the universe every event that had ever occurred must be preserved somewhere, as an image embalmed in light. 'Therefore', he reasoned, 'there must exist the possibility – even if it is beyond the power of man – of bringing back the past?'

As if it was somehow connected with his newly-discovered law of spectral return, the image of the old Jew at his desk suddenly took on a frightening reality. He could sense the phantom, as if it were moving along beside him only an arm's length away, invisible to the physical eye and yet more immediate than that distant star shining down from the Milky Way which everyone could see night after night and yet which could well have been extinguished for seventy thousand years.

He had reached the narrow, old-fashioned house with two windows and a tiny front garden. He stopped and unlocked the heavy oak door. So vivid was the feeling that there had been someone walking beside him that he instinctively looked round before he entered. He climbed the stairs, which were scarcely wider than his own chest and which, as in almost all Dutch

houses, ran straight up, uninterrupted and as steep as a fire-escape, from the ground floor to the attic, and went into his bedroom. It was a long, narrow room with a panelled ceiling; the only furniture, a table and four chairs, stood in the middle; all the rest – cupboards, washstand, chests of drawers, even the bed – had been built into the walls which were covered in yellow silk.

He had a bath and went to bed.

As he switched off the light his eye was caught by a green, cube-shaped cardboard box on the table.

'Aha, the Oracle of Delphi in papier-maché, they've sent it from the Hall of Riddles', was his thought as he subsided into sleep.

A while later he started out of his sleep; he thought he had heard a strange noise, a tapping on the floor, like little sticks.

There must be someone in the room!

But the front door was shut, he could clearly remember locking it.

Cautiously he was feeling along the wall for the light switch when something struck him a swift but gentle blow on the arm; it felt like a small, flat length of wood. At the same time there came a thud from the wall and a soft object rolled down over his face.

The next moment he was blinded by the glare of the light-bulb.

Again he heard the tapping noise; it came from inside the green box on the table.

"There must be some mechanism inside that stupid cardboard skull that has managed to set itself off, that'll be it", he muttered to himself in irritation. Then he felt for the object that had rolled over his face and had come to rest on his chest.

It was some sheets of paper tied up in a roll. As far as he could see with his bleary eyes it was covered with cramped and faded writing. He threw it to the ground, turned out the light and went back to sleep.

'It must have fallen down from somewhere, or I accidentally opened some kind of little trapdoor in the wall when I was feeling for the switch', were his last clear thoughts before they

drifted off into a labyrinth of images at the centre of which stood a fantastic figure, an amalgam of all that he had experienced that day: a Zulu with a red woollen bobble-hat on his head and green frog's feet was holding out Count Ciechonski's visiting card, whilst next to him stood the skull-house from the Jodenbreet-straat, grinning all over its bony face and winking now with one eye, now with the other.

The last manifestation of the outside world that accompanied Hauberrisser's slide into the abyss of sleep was the distant wail of a ship's siren.

Baron Pfeill had intended to catch the late afternoon train for Hilversum, where his villa, 'Sans Souci', was, and had set off in the direction of Central Station. He had managed to fight his way through a maze of stalls and booths, already thronged with workers on their way home, and had almost reached the harbour bridge when, as if at a sign from some invisible conductor, all the bells of the hundred church towers broke out together into an earsplitting din, telling him that it was six o'clock and he had missed his train.

On an impulse, he turned and went back to the old part of the town.

He almost felt relieved that he had missed his train because that gave him a few hours to settle a matter that had been on his mind ever since Hauberrisser had left him.

He stopped outside a marvellous old baroque building of red brick with a pattern of white shaded by the gloomy avenue of elms in the Herengracht, looked up for a moment at the huge sash window that took in almost the whole length and breadth of the first floor and then tugged at the heavy bronze knob in the middle of the door that also operated the bell.

It was an eternity before an old servant in a livery of white stockings and mulberry silk knee-britches opened the door.

"Is Doctor Sephardi at home? – You do recognise me, don't you, Jan?" Baron Pfeill took out a visiting card. "Take my card up, please, and ask whether -"

"The Master is already expecting you, Mijnheer. Follow me, please." The old servant led the way up the narrow staircase which was carpeted with Indian rugs, the walls covered with Chinese embroidery; it was so steep that he had to hold on to the curved brass handrail to avoid losing his balance.

The whole house was filled with an overpowering smell of sandalwood.

"Expecting me? How can he be?" asked Baron Pfeill in astonishment. He had not seen Doctor Sephardi for years, and it was only half an hour ago that he had had the idea of visiting him in order to check his memory of the picture of the Wandering Jew

with the olive-green face, in particular certain oddly contradictory details he remembered and which, remarkably enough, did not seem to fit in with what Hauberrisser had told him in the café.

"The Master sent you a telegram at den Haag this morning, asking you to visit him, Mijnheer."

"At den Haag? But I've been back in Hilversum for ages. It's mere chance that brings me here today."

"I will inform the Master of your arrival immediately, Mijnheer."

Baron Pfeill sat down and waited.

Everything, right down to the last jot and tittle, was in exactly the same place as it had been when he had last been here: the seats of the heavy carved chairs were draped in glistening Samarkand silk; the pair of roofed chairs – southern Netherlandish work – still stood either side of the magnificent fireplace with its columns and jade tiles with gold inlay; Persian carpets still spread their glowing colours over the black and white squares of the floor; the niches in the panelling above the black marble table still sheltered the delicate pink porcelain statuettes of Japanese princesses, and along the walls were arrayed the ancestors of Ishmael Sephardi, portrayed by Rembrandt and other old masters. His forebears, distinguished Portuguese Jews, had had the house built in the seventeenth century by the celebrated architect, Hendrik de Keyser, and there they had lived and died.

Pfeill compared these people from a past age with his memory of Ishmael Sephardi. They all had the same narrow skull, the same large, dark, almond eyes, the same thin lips and sharp, gently curving noses, the same unworldly, almost arrogantly contemptuous look of the Hispanic Jews with their unnaturally narrow feet and white hands, who had little more in common with the ordinary Jews of the line of Gomer, the so-called Ashkenazim, than their religion. These features had remained the same throughout the centuries with no hint of adaptation to changing times.

Then Pfeill was standing up to greet Doctor Sephardi as he came into the room, accompanied by a strikingly beautiful fair-haired woman of some twenty-six years.

"Did you really send me a telegram?" asked Pfeill. "Jan told me —"

"Baron Pfeill is so sensitive", Sephardi explained with a smile to his young companion, "that one only has to feel a need and he will respond to it. He has come without having received my missive." He turned back to Pfeill, "You see, Juffrouw van Druysen is the daughter of a late friend of my father's who has come from Antwerp to seek my advice on a particular matter about which you are the only person who can supply the information. It concerns – or, to be more precise, it might be connected with – a picture that you once told me you had seen in the Ouheden Collection in Leyden, a picture of Ahasuerus."

Pfeill stared at him in astonishment. "That was why you sent me a telegram?"

"Yes. We went to Leyden yesterday to see it, but were told that there had never been such a picture in the collection. Holwerda, the Director with whom I am well acquainted, assured me that they had no paintings at all since the Museum only housed Egyptian antiquities and -"

"Perhaps you will allow me to tell Baron Pfeill why I am so interested in the matter?" the young lady interrupted. "Don't worry, I won't bore you with a long description of my family background. To put it in a nutshell: there was a person, or rather – it does sound a little odd – an 'apparition', that had some influence on my father's life, that would often occupy his thoughts for months on end.

At the time I was too young, perhaps also too full of life, to understand what went on inside my father's mind, although I loved him very dearly (my mother had died long before). But recently this has all started to come back to me, and I am filled with a restlessness to find out about things which I should have come to understand long ago.

You will say that I am being hysterical if I tell you that I would like my life to end today rather than tomorrow. The most blasé libertine cannot be closer to suicide than I am." She suddenly stopped, bewildered, confused, and only managed to compose herself when she saw that Pfeill was listening gravely and seemed very quickly to understand her state of mind. "Oh yes,

the picture or the 'apparition', what is all that about? I know virtually nothing about it. All I know is that whenever I used to ask my father about God or religion – I was still a child then – he would tell me that a time was near when all that mankind had relied on would be torn apart and that a spiritual gale would sweep away all the works of man.

Only those would be safe from the destruction who – these were his very words – could see within themselves the green bronze face of our forebear, the ancient wanderer who will not taste death.

Whenever I pressed him to tell me what our forebear looked like, whether he was a living human being or a ghost or even God Himself, and how I might recognise him if I should happen to meet him on the way to school, he would always reply, 'Calm down, my child, and do not worry your pretty head about it. He is not a ghost, and even if he should appear to you as a ghost do not be afraid, he is the only person on earth who *cannot* be a ghost. Over his forehead he has a strip of black cloth concealing the mark of eternal life. For anyone who bears the Mark of Life openly and not concealed deep within himself, is branded with the mark of Cain: and even if he should appear in glory like a flaming torch, he is a prey to ghosts and a ghost himself. Whether he is God I cannot say; you would not understand, anyway. You can meet him anywhere; he is most likely to come when you least expect him. But you can only see him when you are ready for him. Saint Hubert, you remember, saw the pale stag amid the turmoil of the hunt, but when he raised his crossbow to shoot it ...' " Miss van Druysen paused for a while and then went on, "Then, many years later, when the dreadful War came and Christianity, to its everlasting shame -"

"Do excuse my interrupting", said Pfeill with a smile, "but you mean 'Christendom'; Christianity is the opposite!"

"Of course. That's what I meant, Christendom; – then I thought my father had had a vision of the future and was referring to the great bloodbath -"

"I am sure he did not have the War in mind", now it was Sephardi who broke in. "External events such as a war, however terrible they may be, are as harmless as thunder sounds to the

ears of those who have not seen the lightning strike the ground at their feet. Their only response is, 'Thank God it was nowhere near me.'

The War split mankind into two, and neither half can understand the other. Some have seen Hell open up before them and will bear the image within them for the rest of their lives; for the others it was just so much newsprint. I belong to the latter. I have examined my soul and recognised with horror – I openly admit it – that the suffering of all those millions has made no impression on me whatsoever. Why lie? If others can say the opposite of themselves and tell the truth, I take my hat off to them in all humility. But I find it impossible to believe them; I cannot imagine that I am a thousandfold more despicable than they. But do excuse me for interrupting you, Mejuffrouw."

'A man who is not afraid to lay bare his own shortcomings is an upright soul', thought Pfeill, glancing with warm approval at the proud olive-skinned features of his scholarly friend.

Sephardi's young visitor resumed her narrative. "Then I assumed my father had been referring to the War, but gradually I began to feel what everyone who is not made of stone feels today: the very earth seems to give off a suffocating oppressiveness, which is not at all related to death, and it was this oppressiveness, this inability either to live or to die, which my father meant, I think, when he said that all that mankind had relied on would be torn apart.

When, then, I told Doctor Sephardi about the green bronze face of the one my father called the ancient wanderer who will not taste death, and asked him, as one who has spent much of his life in the study of such matters, to tell me what it all might mean, in the hope that he might reassure me that it was not merely a delusion that had plagued my father, he remembered what you, Baron Pfeill, had told him of a portrait ..."

"... that unfortunately does not exist." Pfeill completed the sentence. "I told Doctor Sephardi about the picture, that is true. It is also true that I was firmly convinced – until about an hour ago, that is – that I had seen it; in Leyden, as I thought.

The truth I must acknowledge now is that I have never seen it, neither in Leyden nor anywhere else.

This very afternoon I was talking to a friend about the portrait and could even picture it in my memory in its frame, hanging on the wall; then, as I was making my way to the station, I suddenly realised that the olive-green face only *appeared* to be surrounded by the frame, which my imagination had added to the portrait. I immediately came to the Herengracht to ask Doctor Sephardi whether I really had told him of the painting, or whether maybe I had dreamed that as well.

How the picture came to be in my head is an absolute mystery to me. It used to plague me in my sleep. Perhaps I might also have dreamed I saw it in a collection in Leyden and then remembered the dream as if it were reality?

What makes the matter all the more confusing for me is the fact that while you, my dear Juffrouw van Druysen, were telling us about your father the face appeared to me again with stunning clarity but different from before, no longer fixed and inert like a painting, but brought to life and movement, with its lips trembling as if it were about to speak -"

He suddenly broke off and seemed to be listening to an inner voice, as if the picture were whispering something to him.

Sephardi and the young woman watched him in astonished silence.

From below in the Herengracht came the rich sound of one of the great barrel-organs which in the evening sometimes make the rounds of the streets of Amsterdam on a pony-cart.

It was Sephardi who broke the silence. "I can only assume that in your case it is the result of what we call a hypnoidal state: once, in a deep sleep and completely without being aware of it, you must have experienced something that later managed to worm its way into your conscious mind under the guise of a portrait, in which it took on the appearance of reality. There is no need to worry that such a condition is a sign of illness or abnormality", he added, when he saw Pfeill raise his hands in horror, "such things occur much more frequently than one thinks. And it is my own firm conviction that if we could discover their origin it would be like the scales falling from our eyes: we would gain entry to a parallel existence that we lead in the depths of sleep; at the moment we are unaware of it because

it is beyond our physical being and is forgotten as we retrace our steps across the dream bridge that connects day and night. The things that the ecstatics of your Christian mystical tradition write about the 'rebirth' without which it is impossible 'to see the Kingdom of Heaven', seem to me to be nothing other than the awakening of the soul, which until that point has been as dead, in a world that exists beyond the range of our external senses, in, to put it in a nutshell, paradise." He took a book down from the shelves and pointed to a picture in it. "I am sure the tale of Sleeping Beauty has some connection with it, and what else could be the sense of this old alchemical illustration of 'rebirth': a naked man rising from his coffin and beside it a skull with a lighted candle on top? By the way, as we have got on to the subject of Christian ecstatics, Juffrouw van Druysen and I are going to a meeting of that kind this evening on the Zeedijk. Oddly enough, your olive-green face haunts that place, too,"

"On the Zeedijk?" laughed Pfeill. "But that's an extremely shady part of town. What humbug have you fallen for there?"

"It's not as bad as it used to be, I hear, there's only one sailors' tavern left, though a pretty rough one at that, called the Prince of Orange. Otherwise the district is inhabited by harmless craftsmen."

"One of them is an aged eccentric who lives with his sister; he's a crazy butterfly collector called Swammerdam, and when he's not collecting butterflies he imagines he's King Solomon. We have been invited to visit them", added the young lady with a laugh. "My aunt goes there every day. She is a Mademoiselle de Bourignon – you see what aristocratic relations I have? And to avoid any unfortunate misconceptions: she is a venerable Canoness of the Béguine Convent and quite formidably pious."

"What?! Old Jan Swammerdam is still alive?" exclaimed the Baron with a laugh, "he must be over ninety by now! Does he still wear those shoes with the two-inch rubber soles?"

"You know him? what kind of person is he really?" asked Juffrouw van Druysen in pleased surprise. "Is he really a prophet, as my aunt maintains? Tell me what you know of him, please."

"With pleasure, if you would like to hear it, my dear. But I am

in a hurry as I don't want to miss my train again. I will say my farewells now so that I can dash off as soon as I have finished. But you mustn't expect any spine-tingling revelations – rib-tickling would be a more appropriate expression."

"All the better."

"Well then: I have known Swammerdam since I was four-teen, though in more recent years I have lost contact with him. As an adolescent I was full of wild enthusiasm for everything except school, and amongst other things I collected insects and kept reptiles. Whenever a bull-frog or an Asiatic toad the size – and approximate shape – of a handbag appeared in any of the pet shops I would snap it up and take it home, where I kept such things in heated terrariums. At night there was such a cronking and croaking that it made the windows rattle in the neighbours' houses. And the stuff the beasts needed to eat! I used to bring it in by the sackload. The fact that there are so few flies left in Holland today is solely the result of my perseverance in col-lecting food for my little charges. Cockroaches, for example, I completely eradicated. The frogs themselves I never actually saw; by day they hid under stones and at night my parents had the strange idea that I ought to be in bed. Eventually my mother suggested it would make no difference and be simpler if I set the animals free and just kept the stones, but I was naturally horri-fied by such ignorance and rejected the suggestion.

My passion for collecting insects gradually became the talk of the town and eventually drew me to the attention of the ento-mological society which, at that time, consisted of a knock-kneed barber, a furrier, three retired engine drivers and a tech-nician from the Science Museum who, however, could not come on collecting expeditions because his wife would not let him. They were all frail old gentlemen, some of whom collected bugs, others butterflies, and the society had a silk flag with the words 'Osiris: Society for Biological Research' embroidered on it. In spite of my young years I was accepted as a member. I still have in my possession the letter inviting me to join which ends, 'Yours biologically'.

I soon realised why they were so keen to have me in the club. All the venerable members were either half blind, and therefore

incapable of spotting a moth hidden in the cracks of tree bark, or their varicose veins made trudging through the inevitable sand-dunes to look for insects a painful process. Others found that whenever they swooped with their net on a lively peacock butterfly they were interrupted by a staccato coughing fit, which naturally allowed their prey to escape.

I suffered from none of these infirmities and walking a few miles to find a caterpillar on a leaf was no problem for me; no wonder, then, that the cunning old men had the idea of using myself and a schoolfriend of mine as tracker-dogs. There was only one who was more than a match for me at finding insects, and that was the aforementioned Jan Swammerdam, who must have been sixty-five, if he was a day. He only needed to turn over a stone and there would be a larva or something equally welcome. There was a rumour that he had earned this entomological clairvoyance by having lived a blameless life – you know how highly virtue is regarded in Holland!

I never saw him other than in his black frock coat with the circular mark of his butterfly net, which he stuffed up inside his jacket, between his shoulder blades, and the end of the green handle sticking out between his coat-tails.

He never wore a shirt collar, tying instead the edge he had cut off an old linen-backed map round his neck, and I learnt the reason once when I went to visit him in the attic where he lived. 'I can't get in', he explained to me, pointing to the wardrobe where he kept his clothes, 'Hippocampa Milhauseri' – a very rare caterpillar – 'has pupated right next to the hinge and it will be three years before it emerges.'

On our excursions we all used the railway; all, that is, with the exception of Swammerdam, who went on foot because he was too poor to be able to afford the ticket; and so that he did not wear out the soles of his shoes with all that walking, he used to smear a secret rubber solution on them and, in the course of time, it hardened into a layer a couple of inches thick. I can still see it today.

He made his living by selling the unusual hybrid butterflies which he occasionally managed to breed, but the amount he made was not enough to keep his wife, who patiently shared his

poverty and bore his quirks with an understanding smile, from falling into a physical decline from which she eventually died. After that Swammerdam neglected the financial side of his existence entirely and devoted his life to the goal of discovering a certain green dung beetle which, some scientists claim, insists on living exactly fourteen and a half inches under the ground, but only in places where the surface is covered in sheep dung.

My schoolfriend and I were extremely dubious about this rumoured beetle, but that did not stop us, young scoundrels that we were, from carrying sheep's droppings around with us and occasionally scattering some over a particularly hard part of the track and hiding, so we could giggle at the sight of Swammerdam digging away like a frantic mole.

One day, however, a miracle occurred that shook us to the core. We were out on one of our expeditions. The greybeards were trotting along in front bleating the club song:

> *Cynthia cardui*,
> Painted Lady,
> Please fly down to me.
> I will keep you nice and warm
> On my pad of chloroform.

and bringing up the rear came Swammerdam, like a beanpole in black with his spade over his shoulder. On his face was an expression of almost Biblical radiancy, and when someone asked him why, he just said mysteriously that he had had a most auspicious dream the night before.

My friend and I surreptitiously dropped a portion of sheep dung onto the path. Swammerdam spotted it, stopped, removed his hat, took a deep breath and, quivering with faith and hope, looked up at the sun until his pupils had contracted to the size of pinheads; then he bent down and began to scrape away at the ground, scattering stones and earth everywhere.

My friend and I stood by watching and the devil within us rejoiced.

Suddenly Swammerdam went deathly pale, dropped his spade and stared at the hole he had dug, his hands clenched tight

55

and pressed against his lips. Then he bent down and with trembling fingers picked up a glistening green beetle from the hole.

He was so moved that for a long time he couldn't speak, two large tears just rolled down his cheeks. Finally he said, 'Last night the ghost of my wife appeared to me in a dream, her face as radiant as a saint's; and she comforted me and promised me that I would find the beetle.'

We two rascals slipped quietly away like two thieves, and neither could look the other in the face for shame. Later on my schoolfriend told me that for a long time he went in awe of his own hand which, at the very moment when he was using it to play a cruel trick on an old man, had perhaps been an instrument of the Lord."

After it was dark Doctor Sephardi accompanied Juffrouw van Druysen to the Zeedijk, a crooked, pitch-black street in the eeriest part of Amsterdam at the corner of two canals, right beside the gloomy church of St. Nicholas.

Above the gables the reddish glow from the booths and tents of the summer fairground, which was already in full swing, illuminated the sky and mixed with the white mist rising from the city and the glistening reflection of the full moon on the roofs to create a mysterious iridescent haze in which the shadows of the church towers hovered like long, pointed triangles of black gauze.

The putter of all the motors driving the roundabouts sounded like the thump-thump of a huge heart. The breathless wail of the hurdy-gurdies, the constant drum-rolls, the shrill voices of the barkers and the whiplash crackle of gunfire from the shooting galleries echoed through the dark streets, conjuring up in the mind a picture of a torchlit crowd milling round stalls piled high with gingerbread, brightly-coloured candy and hairy cannibal faces carved out of coconut shells; gaily-painted wooden horses were whirling round, bobbing up and down, boat-swings rose and fell like giant pendulums, black faces nodded, white clay pipes clenched between their teeth as a target for the air-guns, excited children tried to throw hoops over rows of knives stuck

into rough deal tables, glistening seals honked from their tubs of dirty water, flags fluttered over tents where the flickering light reflected by the revolving globe covered in mirror tiles played on the grotesque antics of the monkeys and the parrots screeching on silver swings; and all around, shoulder to shoulder, stood the tall houses like a silent crowd of dusky giants with white, rectangular eyes.

Jan Swammerdam lived well away from the noisy throng in a room on the fourth floor of a building that seemed to lurch forward over the dark street; in the cellar was the notorious sailors' tavern, the 'Prince of Orange'.

Inside, the whole house was filled with the dusty odour of dried herbs from a little store by the entrance, and a sign proclaiming that 'Spirituous liquors were sold here' indicated where, during the day, a certain Lazarus Egyolk ran a gin-shop.

Doctor Sephardi and Juffrouw van Druysen climbed up some stairs that were as steep as a chicken ladder and were warmly welcomed at the top by an old lady with snow-white hair and round, child-like eyes who greeted them with the words, "Welcome, Eva, and thou, too, King Balthasar, welcome in the New Jerusalem."

As the two of them entered, the six people, who had been sitting in solemn silence round the table, rose with gauche politeness and were introduced by Mademoiselle de Bourignon, "This is Jan Swammerdam and his sister" – a wrinkled old woman with a Dutch bonnet and *Krulletjes*, brass spirals, on her ears who kept on curtseying – "and that is Mijnheer Lazarus Egyolk, who is not actually a member of our spiritual circle, but is 'Simon the Cross-bearer' ("and lives in the same house, your Honours", proudly added the man in question, an ancient Russian Jew in a caftan); "then there is Juffrouw Mary Faatz of the Salvation Army, her spiritual name is Magdalena, and dear Brother Ezekiel" – she pointed to a young man with a puffy, pockmarked face, which looked as if it had been kneaded out of dough, and inflamed eyelids without lashes – "he works in the herb-store below; his spiritual name is Ezekiel because when the time is fulfilled he will judge mankind."

Doctor Sephardi gave his companion a puzzled look. Her

aunt, who noticed it, explained, "We all have spiritual names. Jan Swammerdam, for example, is King Solomon and his sister Shulamite; I am Gabriela, that is the feminine form of the Archangel Gabriel, but usually I am called 'The Guardian of the Threshold', for it is my task to collect the souls that are scattered in the cosmos and lead them back to paradise. You will come to understand all this much better later on, Doctor Sephardi, for you are one of us, although you do not know it at the moment. Your spiritual name is King Balthasar. Have you never felt the stigmata?"

Sephardi was more confused than ever.

"I'm afraid Sister Gabriela is rushing on ahead a little too quickly", said Swammerdam with a smile. "Many years ago a true prophet of the Lord arose in this very house, a simple cobbler by the name of Anselm Klinkherbogk. You will meet him this evening. He lives upstairs.

We are not spiritualists, as you might assume, Mijnheer; almost, I am tempted to say, the opposite, for we have nothing to do with the realm of the dead. Our goal is eternal life. In every name there resides a hidden power, and when we repeat our names, with our lips closed, to our own hearts until it fills our whole being day and night, then we draw the spiritual power into our blood and it circulates through our veins, changing our bodies little by little. This gradual transformation of the body – only the body must be transformed, the spirit is perfect and complete from the very beginning – is expressed in all kinds of feelings which are the harbingers of the state known as 'spiritual rebirth'. One such feeling, for example, is the sensation of a gnawing pain that comes and goes without our being able to explain why. At first it just affects the flesh, but then it begins to bore into the bones and penetrates the whole body until, as a sign of the 'first baptism' – that is the baptism of water – the crucifixion of the first degree appears; that is, on the hands there appear inexplicable wounds with water coming out." He and the others, except for Lazarus Egyolk, lifted up their hands to reveal deep, circular scars, as if made by nails.

"But that is hysteria!" cried Juffrouw van Druysen in horror.

"You are welcome to call it hysteria, Mejuffrouw; our hys-

58

teria is not an illness. There are different kinds of hysteria. Only hysteria which is associated with trances and mental imbalance is a sickness and leads downwards; *our* hysteria, on the other hand, is a matter of mental *balance,* the achieving of clarity, and is the way upwards, from insight through rational thought to knowledge through direct contemplation.

In the scriptures this goal is called 'the inner voice', and just as ordinary men and women think by letting words run through their brain without being conscious of it, so within those who are spiritually reborn there is another, mysterious language with new words, which are beyond error or even uncertainty. Then thought becomes a new manner of thought, becomes magic and no longer a tool of our paltry understanding, becomes a revelation of the truth in the light of which error vanishes because our thoughts are rings that are no longer separate, but have linked together to form a chain."

"And have you reached that state, Mijnheer Swammerdam?"

"If I had reached that state I would not be sitting here, Mejuffrouw."

"You say that ordinary people think by letting words run through their brain", said Sephardi, whose interest had been aroused. "How is it with someone who is born deaf and dumb and has never learnt a language?"

"He thinks partly through images and partly in the primal language."

"Me let speak, Swammerdamleben", shouted Lazarus Egyolk in his grotesque Dutch mixed with Russian and Yiddish; he had obviously worked himself up into an argumentative mood, "Now, you have Cabbala, but I have Cabbala, too. 'In the beginning was the word' is not the right translation. 'Bereshith' means 'head-thing', not 'in the beginning'."

"The head-thing", murmured Swammerdam and then, after a moment's silent reflection, "I know. But the meaning is the same."

The others had listened in silence and gave each other significant looks.

Eva van Druysen felt instinctively how at the word 'head-thing' the olive-green face came into her mind and she shot an

inquiring glance at Sephardi who gave her a faint nod.

He it was who eventually broke the silence, since no one else looked as if they were going to speak. "In what manner was the gift of prophecy granted to your friend Klinkherbogk and in what way does it appear?" he asked.

Swammerdam started, as if waking from a dream, "Klinkherbogk?" He collected his thoughts, "Klinkherbogk sought God all his life until eventually it completely occupied his whole mind and for many years he was so consumed with longing that he could not sleep. One night when he was sitting as usual by his globe – you know, I'm sure, that shoemakers use globes filled with water that they place in front of the candle to improve the light they work by – a figure grew out of the light inside it and came up to him; then it happened just as it is recorded in the Apocalypse: the angel gave him a book to eat and said, 'Take it and eat it up; and it shall make thy belly bitter, but it shall be in thy mouth sweet as honey.' The face of the apparition was veiled, only its forehead was visible and glowing on it was a resplendent green cross."

Eva van Druysen remembered her father's words about the ghosts that bear the Mark of Life openly, and for a moment a shiver of fear ran down her spine.

"Since that time Klinkherbogk had the 'inner voice' ", continued Swammerdam, "and it came out of his mouth and told him, and me – at that time I was his only disciple – how we should live that we might eat of the Wood of Life that is in God's paradise. And a promise was made to us: yet a little while and all the sorrows of this vale of tears would slip from us, and like Job we would receive a thousandfold whatever life had taken away."

Doctor Sephardi was tempted to object that it was fooling oneself and dangerous to put one's faith in such prophecies from the subconscious, but he was stopped by the memory of Pfeill's story of the green beetle. Anyway, it was clear that the time for warnings was past.

However, the old man seemed to have guessed the train of his thoughts, more or less, for he continued, "It was fifty years ago that the promise was made to us, but we must exercise patience

and continue to pour our prayers into our hearts without ceasing, until the rebirth is complete." He spoke the words calmly and apparently full of confidence, but there was a tremor in his voice, like the foreboding of dreadful despair to come, which betrayed how much he had to keep himself under control so as not to shake the others' belief.

"You have been doing this for fifty years? That is terrible!" Doctor Sephardi exclaimed before he could stop himself.

"Oh, it is so beautiful, so divine to see how everything is fulfilled", lisped Mademoiselle de Bourignon ecstatically, "and to see all the sublime spirits flock together round Abram – that is the spiritual name of Anselm Klinkherbogk, for he is the Patriarch – and lay the foundation stone for a New Jerusalem here in Amsterdam, in lowly Zeedijk. Mary Faatz (she used to be a prostitute and now she is our pious Sister Magdalena)", she whispered behind her hand to her niece, "has come and ... and Lazarus has been raised from the dead. But of course, I didn't tell you about that miracle in the letter I wrote inviting you to come and join our circle: just imagine, Lazarus was raised from the dead by Abram!" Jan Swammerdam stood up, walked over to the window and stared silently out into the darkness. "Yes, oh yes, raised bodily from the dead! He lay dead on the floor of his shop and Abram came and brought him back to life."

All eyes were fixed on Egyolk, who turned away in embarrassment and whispered into Doctor Sephardi's ear, with much gesticulation and shrugging of shoulders, that there was something in it, "Unconscious I was, certainly, perhaps dead, who knows? Why should I not have been dead? I ask you, an old man like me?"

"And that is why I beseech you, Eva", Mademoiselle de Bourignon urged her niece: "to join our brotherhood, for the Kingdom is at hand and the last shall be first."

The druggist's assistant, who until then had not said a word but sat next to Sister Magdalena holding her hand in his, suddenly rose to his feet, thumped the table with his fist and stuttered, his inflamed eyelids wide apart, "Ye-ye-yes-, th-th-the f-f-first shall b-b-be last and it is easier f-f-for a ca-ca-ca-"

"The spirit has come upon him. It is the Logos speaking

through him", cried the Guardian of the Threshold. "Eva, harbour every word in your heart!"

"-ca-camel to g-g-go through the eye of a n-n-n-"

Jan Swammerdam hurried over to the possessed shop assistant, whose face was gradually taking on an ugly expression, and calmed him down with a few mesmeric passes over his forehead and mouth.

"That is only the 'inversion' as we call it, Mejuffrouw", explained Sister Shulamite to calm down Eva van Druysen, who had rushed in horror to the door. "Brother Ezekiel sometimes suffers from it, and then his lower nature gains control over his higher. But it's over now." Brother Ezekiel had dropped down onto all fours and was barking and growling like a dog whilst the girl from the Salvation Army was kneeling next to him, stroking his hair. "Judge not, lest you yourself be judged; we are all miserable sinners and Brother Ezekiel spends his whole life, day in, day out, down in the dark store-room, so it sometimes happens that when he sees rich people – excuse me speaking so openly, Mejuffrouw – a great bitterness comes over him and clouds his spirit. Believe me, Mejuffrouw, poverty is a great burden; where should a young soul such as his find enough trust in God to bear it?"

For the first time in her life Eva van Druysen found herself looking into the lower depths, and things which until then she had only read of in books suddenly took on a terrible reality. And yet it was only a brief flash of lightning that was scarcely enough to illuminate the darkness of more than a small part of the pit.

'How many much more dreadful things', she thought to herself, 'must there be slumbering in the depths where the eyes of those favoured by destiny seldom reach.'

It was as if a kind of spiritual explosion had blown away all the veneer of social conduct and revealed to her a soul in all its ugly nakedness, reduced to a wild animal in the very same moment as the words of Him who died upon the cross for love came from his lips.

She was filled with horror at the consciousness of her own share in the enormous guilt which came from merely belonging to a privileged class with its quite understandable lack of interest

in the suffering of one's fellow men, a sin of omission whose cause was as minuscule as a grain of sand, its effect as devastating as an avalanche. The shock was like that of someone idly playing with what they think is a rope and suddenly discovering they have a poisonous snake in their hands.

When Shulamite first mentioned Brother Ezekiel's poverty, Eva's immediate impulse was to take out her purse, a reflex action by which the heart hopes to catch reason by surprise; but then she felt that it was the wrong moment to offer assistance, and instead of relieving her sense of guilt by that one action, she resolved that in future she would make better and more thorough amends. It was the oldest stratagem in the armoury of self-deceit: to gain time until the feeling of pity is past.

In the meantime Ezekiel had recovered from his fit and was weeping quietly to himself.

Sephardi, who, like all the aristocratic Dutch Jews, held fast to the custom of his forefathers never to enter someone else's house without bringing some small gift, used it as an opportunity to draw the group's attention away from the poor deranged shop assistant by unwrapping a silver incense-burner and handing it to Swammerdam.

"Gold, frankincense and myrrh, the three Wise Men from the East", whispered the 'Guardian of the Threshold', her voice cracking with emotion and her eyes turned to the ceiling. "Yesterday, Doctor, when we heard you would be accompanying Eva, Abram gave you the spiritual name of Balthasar and lo! you have come bringing incense! And King Melchior – in ordinary life he is called Baron Pfeill, little Kaatje told me that – also appeared to us in spirit today", she turned with a mysterious air to the others who looked up in astonishment, "and sent money. Oh, I can see it with my soul's eye: Caspar, the King from the Land of the Moors, is near at hand," – she gave Mary Faatz an ecstatic stare which Sister Magdalena returned – "yes, the end of time is fast approaching -"

She was interrupted by a knock on the door. Klinkherbogk's little granddaughter Kaatje entered and said, "You are all to come up quickly, grandfather is having his second birth."

Chapter Five

Eva van Druysen held Swammerdam back before they followed the others who were already climbing the stairs to Klinkherbogk's attic. "Excuse me, Mijnheer Swammerdam, I would like to ask you a brief question. All that you said about hysteria and the power that resides in names made me think; but, on the other hand ..."

"Allow me to give you a piece of advice, Mejuffrouw." Swammerdam looked at her earnestly. "I am well aware that everything that you saw and heard just now has only confused you. But it could be of great importance to you if you learn from it the first lesson, and that is to seek spiritual enlightenment not from others but within yourself. Only the teachings that come from our own spirit come at the right moment, at the moment when we are ready for them. You must close your eyes and ears to revelations made to others. The path to eternal life is as narrow as a knife-edge; you cannot help others when you see them stumble, nor should you expect help from them. Anyone who watches others will lose his balance and plunge into the abyss. Here we do not advance together as in the world outside; a guide is essential, but he must come to you from the spirit world. Only in worldly things can a man of this world be your guide and you should judge him by his actions. Everything that does not come from the spirit is lifeless clay, and we refuse to pray to any other God than the one who reveals Himself to us within our own souls."

"But what if God does not reveal Himself within me?"

"Then you must find a moment of calm and quiet and call to Him with the urgency of all your longing."

"And then you think He will come? How easy that would be."

"He will come! But do not be afraid, first He will appear as the chastiser of your former deeds, as the terrible God of the Old Testament who said, 'An eye for an eye and a tooth for a tooth'. He will reveal Himself to you in sudden blows of fate. First of all you must lose everything, even -", Swammerdam said it softly, as if he were afraid of her hearing it, " – even God, if you want to find Him afresh. Only when your vision of Him has been

purified of shape and form, of all division into outer and inner, creator and creature, spirit and matter, will you -"

"See Him?"

"No. Never. But you will see yourself with His eyes. You will be freed from mortal clay, for your life will have merged with His and your consciousness will no longer be dependent on the physical body, which will continue to pursue its path to the grave like a shadow without substance."

"But what is the point of the blows of fate that you spoke of? Are they a test, or a punishment?"

"There are neither tests nor punishments. Physical existence with all its vicissitudes is nothing other than a healing process, more painful for some, less for others, depending on the extent of the sickness our spiritual vision suffers from."

"And you think that if I call on God, as you say, my destiny will change?"

"Immediately! Only it will not just 'change', it will become like a galloping horse that has been going at a slow trot until then."

"Did your destiny gallop along then? Excuse my asking, but from all that I have heard about you ..."

"You assume my life must have ambled along at a slow, monotonous pace, Mejuffrouw", smiled Swammerdam. "Remember what I told you before? Do not concern yourself with what happens to others. For some there is a vast world outside, to others it seems no bigger than a nutshell. If you are serious about wanting your destiny to accelerate to a gallop, then – I warn you about this while I recommend it because it is the only thing a person should do and at the same time the heaviest sacrifice one can make – you must call on the innermost core of your being, the core without which you would be a lifeless corpse (or not even that), and *order* it to lead you by the shortest route to the greatest goal, the only one that is worth striving for, even if you do not realise it at the moment; you must order it to be merciless in leading you without rest through sickness, suffering, death and sleep, through honours, riches and joy, ever onward, through everything, like a runaway horse dragging a carriage over ploughland and stones, past flowers

and blossoming groves. That is what I mean when I say 'Call on God'. It must be like a vow made to a listening ear."

"But, Master, what if destiny should come over me like that and I weaken and ... and want to turn back?"

"Once on the spiritual path the only ones who can turn back – no, not even turn back, stop and look back and turn into a pillar of salt – are those who have not made the vow. A spiritual vow is like an order and, in this at least, God is the servant who is charged with carrying out that order. Do not be shocked, Mejuffrouw, it is not blasphemy. Quite the contrary. Therefore – what I am going to say to you now is foolishness, I know; I say it out of pity and everything that is done out of pity is foolishness – therefore I warn you: do not pledge too much! Otherwise you might end up like the thief whose bones were broken on the cross."

Swammerdam's face had gone white with the intensity of feeling.

Eva grasped his hand. "I thank you, Master. I know now what I must do."

The old man drew her to him and, choking with emotion, planted a kiss on her forehead. "May the Lord of destinies be a merciful doctor, my child."

They went up the stairs.

Just outside the attic Eva stopped, as if struck by a sudden thought. "Tell me one more thing, Master. The millions who bled and suffered: none of them had made the vow. Why all that suffering?"

"Do you know for sure that they had not made the vow? Could it not have happened in a previous existence," answered Swammerdam calmly, "or while they were in a deep sleep, when men's souls are most wide-awake and best know what their need is?"

It was as if a curtain had been rent in two, and Eva was blinded by the light of a new insight. Those few last words had told her more about the goal of human existence than all the religious systems in the world could have. All complaints about the supposed injustice of fate were silenced by the knowledge that we

all follow the road we have chosen.

"If the things that happen in our group mean nothing to you, Meffrouw, do not let that bother you. Often you find a track that goes downhill and it turns out to be the shortest route to the next climb. The fever that accompanies spiritual convalescence often looks very like satanic corruption. I am not 'King Solomon' and Lazarus Egyolk is not 'Simon the Crossbearer'; he is called that because, in Mademoiselle de Bourignon's somewhat too external conception of things, he once lent Klinkherbogk money when he was in great need; but that does not mean that this mingling of Old and New Testament is necessarily nonsense. What we find in the Bible is not only the record of events from past times, but the road from Adam to Christ which we have to follow through the magic of inner growth from 'name' to 'name', that is, with the unfolding of ever greater power", said Swammerdam, giving Eva his arm as they climbed the last few steps, "from the expulsion from the garden of Eden to the resurrection. For some it can become a road of terror and ...", again he murmured to himself the words about the thief whose bones were broken on the cross.

Mademoiselle de Bourignon and the rest had waited outside the attic for them to arrive (apart from Lazarus Egyolk, who had gone down to his own room) and deluged her niece in a cascade of words before they entered, in order to ensure that she was suitably prepared.

"Just think, Eva, an event of indescribable magnitude has taken place. And today of all days, on the precise date of the summer solstice! Oh! it is all so unutterably meaningful and – now what was I going to say? Oh yes, the long-awaited event has come to pass: the spiritual man has been born in Father Abram, and he heard it crying within himself as he was nailing the heel to the sole of a shoe, and that, as is well known, is the 'second birth', for the first is the stomach-ache, it says so in the Scriptures if you know how to read it aright, and soon all the three Kings will be together because Mary Faatz told me recently that she has met – though only briefly – a black savage who lives in Amsterdam, and an hour ago she saw him through the window sitting in the tavern below, and I immediately saw

it was the hand of Divine Providence, since it can be none other than King Caspar from the land of the Moors; oh, that it is I who have been found worthy of discovering the third of the Wise Men! I am so blissfully happy I can hardly wait for the moment when I can send Mary to bring him up."

The door to the attic opened and they all trooped in.

Stiff and motionless, Klinkherbogk was sitting at the end of a long table covered in shoe leather and tools, with his head turned away from them; one side of his profile was illuminated by the bright moonlight shining in through the window, so that the white hair of his sparse Dutch sailor's beard gleamed like threads of metal; the other side was in pitch darkness.

On his bald head he wore a pointed crown cut out of gold paper.

The room was filled with the acrid smell of leather. The cobbler's globe shone like the malevolent eye of some cyclopean monster, whose body was hidden in the darkness of the room, and glinted on a pile of ten-guilder pieces on the table in front of the prophet.

Eva, Sephardi and the members of the spiritual circle stood close to the wall and waited. No one dared move; it was as if a spell had been cast over them all. The poor shop assistant's gaze was fixed on the glittering coins.

The minutes crawled past in absolute silence, as if they wanted to stretch themselves out into hours; a moth fluttered in out of the darkness, circled in a white blur around the candle and went up in a crackle of flame.

Motionless, as if carved out of stone, the prophet stared at the globe, his mouth open, his fingers like claws tensed over the coins, and seemed to be listening to words that came to him from a great distance.

Suddenly a dull thud came from the tavern below and as suddenly died away, as if someone had opened the outside door and then slammed it to; the sound seemed to rush into the room and then choke on the congealed air.

Then the deathly hush reigned once more.

Eva wanted to look over to Swammerdam, but was held back

by a vague fear that she would read in his face the same fore-boding of some approaching catastrophe that was almost choking her. For the length of a heartbeat she thought she remembered hearing a quiet, scarcely audible voice at the table say, "Lord, let this cup pass from me", then the impression faded as scraps of noise from the distant fairground fluttered past the window.

She looked up and saw that the tension in Klinkherbogk's features had relaxed, giving way to a look of confusion.

"There is a great cry in the city", she heard him murmur, "and their sin is very grievous. I will go down now, and see whether they have done altogether according to the cry of it, which is come unto me; and if not, I will know."

"Those were the words of Jehovah in the Book of Genesis", said Sister Shulamite with trembling lips, and crossed herself, "before He rained brimstone and fire out of heaven. Oh let not the Lord be angry, and I will speak but yet this once: Peradventure ten righteous shall be found there!"

Immediately the spark kindled in Klinkherbogk a vision of the end of the world. In a monotonous voice, as if he were reading aloud something he was not listening to himself, he spoke to the wall:

"Behold, I see a stormwind arise, that shall rage over the whole world, and all things that stand erect shall be made level and the clouds shall be as flying arrows. The graves shall be torn open and the stones and the skulls of the dead shall fall from the air as a shower of hail; it shall blow the water from the rivers and ditches, yea it shall spew it as from its mouth, and lay low the poplars by the roads and the tall trees shall be as clumps of grass that wave in the wind. And this He will do for the sake of the righteous who have received the living baptism"; his voice resumed its flat monotone, "but the King, on whom ye wait, will not come until the time is fulfilled. First there must come the one who shall go before Him to prepare the way of the Lord, and the harbinger must be within you and a new man. And yet I say, there will be many with new eyes and new ears, that it might not be said of mankind what was said before, 'They have ears, but they hear not; eyes have they, but they see not'. But", and a

shadow of deepest sadness passed over his face, "Abram I cannot see among them. For with the same measure that ye mete, withal it shall be measured to you again and he, e'er the spiritual birth was ready, cast aside the breastplate of poverty and gathered up gold to make a molten calf as a sacrifice for his soul and an idol for his senses. Yet a little while and he shall be gone from you. The King from the Land of the Moors shall bring the myrrh of the life beyond and cast his body into the dark waters that the fish of the deep might feast upon it, for Melchior's gold has come before the child lay in the manger that could have taken away the curse that lies upon all gold. It has come to wreak its havoc before the darkness shall be past. Balthasar's Frankincense has come too late.

But thou, Gabriel, hear me: do not stretch thy hand out for the harvest before it is ripe for cutting, that the scythe injure not the servant and take away the corn from the harvester."

Mademoiselle de Bourignon who, whilst 'Abram' was speaking, kept on emitting rapturous sighs without making any attempt to follow the dark message his words contained, suppressed a cry of joy when her spiritual name, 'Gabriel', was mentioned, and swiftly whispered to Mary Faatz, who immediately hurried out of the room.

Swammerdam noticed and tried to stop her, but he was too late, the girl was already on her way down the stairs. With a weary gesture he let his hand drop back to his side and when the 'Guardian of the Threshold' gave him a puzzled look, he just shook his head resignedly.

The shoemaker came to for a moment and called out anxiously to his granddaughter, but immediately fell back into his trance.

In the 'Prince of Orange' sat a group of five men who had spent most of the afternoon drinking there. At first they had played cards together but then, as it grew darker and the tavern gradually filled up with the dregs of the Zeedijk until there was scarcely room to bend an elbow, they retired to the adjoining room which the waitress, Antje, inhabited during the day. Known as 'Port-in-a-storm' to the regulars, she was a shapeless

figure with a red silk dress reaching to her knees, heavy make-up, a flaxen pigtail, podgy neck, sagging breasts and scabby nostrils.

The group consisted of mine host, formerly steersman on a Brazilian steamer transporting tropical hardwoods, a stocky, bull-necked man in shirtsleeves, with blue tattoos on his great paws and gold rings dangling from his earlobes, one of which was half bitten off; beside him sat the Zulu, Usibepu, in a dark-blue cotton overall such as stokers on steamships wear, then a hunch-backed artistes' agent with repulsively long fingers like spiders' legs, and Professor Arpád Zitter, who, surprisingly, once more sported a moustache and had adapted his wardrobe to suit the surroundings; the fifth, a sunburnt young man in a white dinner jacket, was a so-called 'Indian', a plantation-owner's son from Batavia or some other tropical colony who, like so many of his kind before him, had come to Europe to see the 'old country', only to throw away his money in a few nights in shady dives.

For a week now the young colonial gentleman had been 'lodging' in the 'Prince of Orange' and in those seven days all he had seen of the light of day had been a glimpse of the dawn behind the green curtains before, unwashed and still in his clothes, he fell into a drunken stupor on the sofa, from which he did not rise until late in the evening. Then it was straight back to the dice and the cards, beer, rough wine and rougher spirits, buying rounds for all the riffraff of the docks, Chilean sailors and Belgian whores, until finally a cheque bounced and he had to turn to his watch-chain, rings and cufflinks.

The innkeeper had felt obliged to invite his friend, Arpád Zitter, to this farewell party and the Professor had duly arrived, bringing with him, as his contribution to the kitty so to speak, the Zulu, who as a leading artiste always had plenty of ready cash on him.

These gentlemen had been playing blackjack for some hours now without one of them being able to get Dame Fortune on his side long enough to clean out the others, for every time the Professor tried to stack the cards the agent grinned, so that Zitter felt compelled to restrain his legerdemain for a while, as it was

not part of his plan to share the pickings from his dusky companion with the hunchback.

Their roles in the case of the 'Indian' were, of course, reversed and thus the two rivals found that they were compelled to play fair for the first time which, to judge by the mournful expressions on their faces, reminded them of their childhood when the stakes were almonds and Brazil nuts.

The innkeeper was also playing fair, but of his own accord, in honour of the occasion. He felt he owed it to his guests, besides which it was clearly understood that they would reimburse him for any losses. The 'Indian' was far too naive for the idea of cheating even to occur to him, and the Zulu still too little au fait with the white man's magic to risk using witchcraft to conjure up a fifth ace.

Towards midnight, however, the tempting tones of the banjo began to sound an ever more insistent invitation to the young benefactor of the thirsty multitude, who finally sent an ambassador in the enticing form of a young lady with the latest pageboy hairstyle to express her concern that her 'admirer' had not yet appeared. At this juncture the opposing generals decided to join forces so that in no time at all the 'Indian' and the Zulu had been picked clean by Professor Zitter and the theatrical gentleman.

The Professor, however, was of a remarkably liberal disposition and therefore insisted on inviting the fair Antje to dine in the room the other players had now vacated with himself and his friend Usibepu, whose taste for rich cuisine and a concoction named Mogador, a cocktail of industrial-grade alcohol and certain extracts containing nitric acid, was well known to him.

The conversation at table was entirely in a mishmash of pidgin English, Cape Dutch and the Basuto dialect, which both gentlemen spoke fluently; this meant that Antje's contribution to the conversation consisted of gestures from the international lingua franca such as sticking out her tongue or casting amorous glances at the two men.

Being a thoroughly companionable type, the Professor had no problem keeping the conversation flowing smoothly, whilst at the same time never for a moment losing sight of his main aim,

namely to wheedle out of the Zulu the secret of how to walk on red-hot coals without burning one's feet, and he thought up innumerable conversational gambits to achieve this.

Even the most seasoned observer would not have been able to tell that he was racking his brains over another quite different problem, which was the result of the confidential information supplied by Antje, namely that the shoemaker Klinkherbogk from the attic had come into the tavern that afternoon and changed a thousand-guilder note into gold coins.

Under the influence of the fiery drink, the spicy food and the brazen behaviour of the young lady the Zulu was becoming more and more frenzied, so that it seemed advisable to remove all sharp or fragile objects from the room and, above all, to keep him from contact with the sailors in the bar who were just spoiling for a fight and, jealous because of Antje's attentions, ready to set on the 'nigger' with their knives.

The Professor finally managed to so infuriate the Zulu with his casual sneering gibe that the act with the hot coals was nothing more than a cheap trick, that he threatened to smash up the whole place unless someone immediately provided him with a basin full of red-hot bricks. This was the moment Zitter had been waiting for; he had ordered a bucket of glowing coals to be kept ready, and now he had it brought in and the contents scattered over the concrete floor of the room. Usibepu squatted down and inhaled the choking smoke through his wide-open nostrils. Gradually his eyes went glassy; he seemed to see something and his lips twitched, as if he were talking to a ghost.

Then he suddenly leapt up and let out a bloodcurdling cry, a cry so piercing and terrible that the raucous crowd in the tavern immediately fell silent and rushed to the door of the room where they stood looking in, a crush of deathly pale faces, to see what was going on.

In a second the negro had torn off his clothes and started to dance around the glowing coals: stark naked, with rippling muscles like a black panther, foaming at the mouth and throwing his head backwards and forwards at a furious rate. The sight was so fearsome that even the rough Chilean sailors were breathless with terror and clung to the wall so as not to fall down

from the benches onto which they had climbed for a better view.

The dance finished abruptly, as if he were responding to some inner command. Usibepu seemed to have regained full consciousness, although his face was an ashen grey, and he walked slowly forward with measured steps onto the burning embers and stood motionless there for several minutes. There was no smell to suggest his skin had been burnt. When he stepped off the pile of coals Zitter found that his soles were completely unharmed and not even hot.

During the last part of the performance a young girl in the navy-blue uniform of the Salvation Army had come in from the alley; she seemed to know the Zulu and nodded a friendly greeting to him.

"Where the hell have you popped up from?" shouted 'Port-in-a-storm' in astonishment as she rushed over to embrace her and give her a tender kiss on both cheeks.

"I saw Mister Usibepu sitting here through the window. I know him from the Café Flora; once I tried to explain the Bible to him, but his Dutch wasn't up to it", explained Mary Faatz. "There's this lady – a real lady – from the Béguine Convent has sent me down here to fetch him. There's another lady and a fine gentleman up there."

"Up where?"

"At Klinkherbogk's, the shoemaker's; where else?"

Zitter's head shot round when he heard the name, but then he made as if the matter were of no interest to him and continued to pump the Zulu, who was much more communicative since his triumphant performance.

"Mister Usibepu, my friend, I must congratulate you. I am proud to see that you have been initiated into the magic of Obeah T'changa."

"Obeah T'changa?" exclaimed the negro; "Obeah T'changa is that!" and he snapped his fingers contemptuously. "Me Usibepu big medicine, me Vidoo T'changa. Me green Vidoo, poison-snake."

Zitter thought he had found a clue. He had heard Indian performers say that the bite of certain snakes could, in people who were capable of assimilating the poison, greatly increase their

74

susceptibility to certain abnormal states with the most remarkable effects, clairvoyance, for example, somnambulism and physical invulnerability. He began to put two and two together. Why should something that was possible in Asia not also occur in Africa?

"I, too, have been bitten by the great witch-snake", he boasted, pointing to the first scar he could find on his hand.

The Zulu spat contemptuously. "Vidoo not real snake. Real snake slimy worm. Vidoo-snake green spirit-snake with man's face. Vidoo-snake souquiant. Name Zombi."

Zitter was out of his depth. What did these words mean? He had never come across them. Souquiant? It sounded French. And what did Zombi mean? He was careless enough to admit to his ignorance and thus lost the Zulu's respect for good.

Usibepu pulled himself up to his full height and, with an arrogant look on his face, explained, "Souquiant man can change skin. Live for ever. Spirit. Invisible. Zombi father of all black men. Zulus Zombi's favourite children. They come from Zombi's left side." He thumped his powerful chest and the note echoed round the room. "All King-Zulu know secret name of Zombi. When they call he come, Zombi come, big Vidoo-snake, green poison-snake with man's face come; on forehead sacred fetish-sign. If Zulu see Zombi first time and Zombi face covered, then Zulu must die. If Zulu see Zombi and fetish-sign covered, green face uncovered, then Zulu live, then Zulu be Vidoo T'changa, big medicine; then Zulu command fire. Me Usibepu, Vidoo T'changa."

The Professor chewed his lip in annoyance. He realised that the secret was useless to him. He was all the more keen, therefore, to offer his services as an interpreter to Mary Faatz, who was trying to persuade the Zulu, who in the meantime had put his clothes back on, to go with her.

"Without me", he insisted, "the ladies and gentlemen will not be able to talk to him", but she ignored him.

Finally Usibepu understood what it was she wanted and went with her up the stairs to Klinkherbogk's attic.

The shoemaker was still sitting at the table, the paper crown

on his head. Little Kaatje had run over to him and he had raised his arms, as if he were going to hug her to his chest, but then he let them drop and went back to staring at the globe as the trance came over him again. The little girl tiptoed back to the wall beside Eva and Sephardi

The silence in the room had become deeper and more tormenting than before; Eva felt that noises could not penetrate it any more, whenever a rustle of clothes or a creak of the floorboards ventured out, it just seemed to contract warily; the silence had become permanent, impervious to the vibrations of sound; it was like a black velvet cloth on which colours are reflected back from the surface without being able to penetrate any deeper.

Tentative steps could be heard coming up the stairs toward the attic. To Eva it sounded as if the Angel of Death had risen from beneath the earth and were feeling its way up towards them. She started in terror when the door behind her opened unexpectedly and the gigantic figure of the negro loomed up out of the shadows. The others started violently too, but no one dared change their position; it was as if Death had appeared on the threshold and its searching glance was going from one to the other.

From his expression Usibepu did not seem at all surprised at the strange gathering and the silence in the room. He stood there, motionless, and, although he did not turn his head, his eyes fixed themselves on Eva and seemed to be burning a hole in her skin. Eventually Mary came to her rescue and placed herself in front of her.

The white of his eyes and his gleaming teeth seemed to hang in the darkness like ghostly points of light. Eva resisted the feeling of terror and forced herself to fix her gaze on the window; outside she could see, glittering in the moonlight, an iron pulley-chain as thick as a man's arm hanging down into the depths. A soft plashing was carried on the air whenever the waters of the two canals that flowed into one another below the house, impelled by the night breeze, slapped against the walls.

A cry from the table made them all start. Klinkherbogk had stood up and held his finger stretched out rigid in front of him,

76

pointing at the spot of light in the globe.

"There it is again", he gasped, "the figure of dread with the green mask over his face who gave me the name of Abram and ordered me to take the book and eat it." As if blinded by the radiance, he closed his eyes and sank heavily back into his chair.

The rest all stood motionless, hardly daring to breathe; only the Zulu had leant forward, staring at a point in the darkness above Klinkherbogk's head, and murmured, "Souquiant behind man."

No one knew what he was talking about. Once more there was deathly silence, a long, seemingly endless time in which no one dared to speak. Eva felt her knees begin to tremble with some inexplicable excitement; it was as if an invisible being were gradually filling the room with its presence, slowly, oh, so terribly slowly. She clutched the hand of little Kaatje, who was standing next to her.

Suddenly there was a startled, fluttering noise in the darkness and a voice called out rapidly. "Abram! Abram!"

Eva's heart missed a beat and she could see that all the others started too.

"Behold, here I am", answered the shoemaker without moving a muscle, as if he were in a deep sleep.

Eva wanted to scream, but mortal terror clutched at her throat.

For another moment deathly silence laid its icy hand over them, then a black bird with white patches on its wings flew wildly round the room, crashed its head against the windowpane and fell in a flutter of feathers to the floor.

"It's Jacob, our magpie", whispered Kaatje to Eva; "he's woken up."

It sounded to Eva as if the words were coming to her through a wall; they brought no comfort, but only increased the petrifying sense of a demonic presence.

Another voice, as unexpected as that of the bird was heard. It came from the lips of the shoemaker and sounded like a strangled cry, "Isaac! Isaac!"

"Behold, here I am", replied Kaatje, just as her grandfather had replied to the cry of the bird, as if from a deep sleep.

Her hand in Eva's felt ice-cold.

From the floor below the window the magpie gave a loud cackle, like the laugh of some fiendish goblin.

With ghostly but greedy lips the silence had swallowed up each word, each syllable, even the fiendish laughter, as it was uttered. They were heard then died away, like the spectral echo of events from Biblical times in the wretched attic of the poor shoemaker.

The boom of the bells of St Nicholas' suddenly reverberated through the room, finally breaking the spell. Eva turned to Sephardi, "I want to go, it's too much for me", she said, going to the door.

She was surprised that the whole time she had not heard the clock from the tower strike; it must have struck midnight while they were in the room.

"Is it safe to leave the old man like that, with no one to help?" She glanced across at the shoemaker as she put her question to Swammerdam, who was silently encouraging the others to leave as quickly as possible. "He seems still to be in a trance, and the little girl is sleeping, too."

"He'll soon wake up when we are gone", Swammerdam assured her, though his voice had an undertone of disquiet, "I'll come back up to see that he's all right later."

They almost had to drag the Zulu away, his eyes were fixed greedily on the pile of gold coins on the table. Eva noticed that Swammerdam did not let him out of his sight for a moment and, once they were all going down the stairs, hurried back and locked the door to Klinkherbogk's attic, slipping the key into his pocket.

Mary Faatz had gone on ahead to bring the visitors' coats and hats from the room on the fourth floor and then to call a cab.

"I just hope the King from the Land of the Moors will come back; we did not even bid him farewell. Oh God! Why was the rite of rebirth so sad?" wailed Mademoiselle de Bourignon to Swammerdam who, silent and with a disturbed expression on his face, was standing next to her in the doorway waiting for the cab that was to take her to the Béguine Convent, Eva to her hotel and Doctor Sephardi to his house in the Herengracht. No one replied; her attempt to strike up a con-

versation trailed off into silence.

The sound of the fair had died away, only from behind the curtained windows of the tavern came the wild twanging of a banjo.

The wall of the house facing the Church of St. Nicholas was in deep shadow; on the other side, where the mansard window of the old shoemaker's attic looked out across the canal to the sea of mist over the port, the wet walls glistened white in the dazzling moonlight. Eva went over to the railing between the street and the canal and looked down at the black, mysterious water. A few yards in front of her the end of the iron chain of the hoist which hung down outside Klinkherbogk's window rested on a narrow ledge scarcely a foot wide. A man was standing in a boat, fiddling with the chain; when he caught sight of the shimmering figure of the woman, he quickly bent down and turned his face away.

Eva heard the cab coming round the corner and hurried, shivering, back to Sephardi. For the length of a heartbeat, she had no idea how or why, the memory of the white eyes of the negro stirred within her.

Klinkherbogk was dreaming he was riding on a donkey through the desert, little Kaatje at his side; before them strode their guide, the man with the veiled face who had given him the name of Abram. Day and night he rode on until he saw a mirage in the sky, and a land, more rich and abundant than he had ever seen, descended to the earth, and the man told him it was called Moriah.

And Klinkherbogk went up the mountain and built an altar of wood and laid Kaatje upon it. And he stretched forth his hand and took the knife to slay the child. His heart was cold and without pity, and he knew according to the Scripture that he was to slay a ram as a burnt offering in the stead of the child. And when he had sacrificed her, the man took the veil from his face and the glowing sign on his forehead vanished, and he said, "I have shown you my countenance, Abram, that from this time forth thou mightst have eternal life. But I have removed the Sign of Life from my brow, that the sight of it shall never more burn

79

itself into thy brain. For my brow is thy brow, and my countenance thy countenance. And by this shouldst thou know that this is the 'second birth': that thou art one with me and I, who am thy guide who have led thee to the tree of life, am none other than thine own self.

There are many who have seen my face, but they do not know that it signifies the second birth, thus it is that they cannot partake of eternal life now.

Once more Death shall come to thee before thou goest through the strait gate; and before shall come the baptism of fire in a cauldron of pain and despair.

Even so hast thou desired it.

Then shall thy soul enter into the kingdom that I have prepared for thee, just as a bird flies out of its cage into the eternal glow of dawn."

And Klinkherbogk saw that the face of the man was of green gold and filled the whole sky, and he remembered the days of his youth when, to help smooth the way of those who might come after him, he had prayed and made a vow that he would not take one step forward on the spiritual path unless the Lord of Destiny should lay the burden of a whole world upon him.

The man disappeared.

Klinkherbogk was standing in deepest darkness and heard a thunderous rumbling that slowly paled into the distant clatter of a cart on bumpy cobblestones. Gradually consciousness returned, the dream vision faded from his mind and he saw that he was in his attic and holding in his hand a bloody awl.

The wick in the lamp had burnt down and was struggling to stay alight. Its flickering rays played over the pale face of little Kaatje lying on the threadbare sofa, stabbed to the heart.

Klinkherbogk was seized with a frenzy of despair; he tried to thrust the awl into his own breast – his hand would not obey; he tried to roar like an animal – his jaw was locked in a cramp and he could not open his mouth; he tried to smash his skull against the wall – his feet stumbled as if his ankles were broken.

The God to whom he had prayed all his life awoke in his heart, transformed into a grinning demon.

He staggered to the door to fetch help and rattled it until he

fell to the ground: it was locked. He dragged himself over to the window, thrust it open and was about to call to Swammerdam when he saw, suspended between heaven and earth, a black face staring at him. The Zulu, who had clambered up the chain, jumped into the room. For a moment there was a narrow strip of red below the clouds in the east; the memory of his dream vision flashed back into Klinkherbogk's mind and he turned, arms widespread, towards Usibepu as if he were his saviour.

The negro started back in horror when he saw the radiant smile transfiguring Klinkherbogk's face, then he leapt on him, grabbed him and broke his neck.

One minute later he had filled his pockets with the gold coins and flung the body of the shoemaker out of the window. As it splashed into the murky, stinking water the magpie flew out over the murderer's head and into the dawn with an exultant cry of "Abraham! Abraham!"

In spite of the fact that he had slept until noon, Hauberrisser felt weary and heavy-limbed when he opened his eyes. All night he had tossed and turned, disturbed by a subconscious curiosity about what was in the roll of paper that had dropped onto his head and where it had come from.

He stood up and investigated the walls of the little alcove where the bed was. Almost the first thing he saw was the open flap and the hole in the panelling where it must have been hidden. Apart from a pair of broken spectacles and a couple of quills, it was empty; to judge by the ink-stains, the previous tenant must have used it as a miniature escritoire.

Hauberrisser smoothed out the sheets of paper and tried to see if he could decipher them. The writing was faded, illegible in some places and because of the damp a number of the pages had stuck together into a kind of mildewed cardboard. There seemed to be little hope of ever being able to reconstruct the contents.

The beginning and the end were missing and to judge by the frequent crossings-out the document seemed to be the rough copy of some kind of literary work, or perhaps a diary. There was nothing to suggest who the author was, nor was there a date to suggest how old the manuscript might be.

Tired and irritable from lack of sleep, Hauberrisser flicked through the sheets that were not stuck together for one last time before going back to bed. Suddenly his eye caught sight of a name which so surprised him that he at first thought he must have misread it. The page where he thought he had seen it had already passed and his impatient efforts to find it again did not improve the state of the paper. And yet he could have sworn that the name that had leapt out at him from the document was 'Chidher Green'. If he closed his eyes and imagined the page, he could see it clearly.

The warm sun was streaming in through the wide, uncurtained window; the room, with its walls covered in yellow silk, was filled with a golden glow. And yet, in spite of its midday brightness, Hauberrisser felt a shudder of horror. It was a feeling of a kind he had not known before, a sudden feeling of dread that

came without any good reason, as if a twilight creature from the dark side of the soul had suddenly appeared and, dazzled by the light of the sun, immediately crawled back into its lair.

He was sure it was not something that was connected with the manuscript, nor with the reappearance of the name Chidher Green; it was an abrupt and profound feeling of mistrust towards himself that, in spite of the bright daylight around, seemed to open up a chasm beneath his feet.

He washed and dressed quickly and rang for the old house-keeper, who looked after his bachelor establishment. "Tell me, Mevrouw Ohms", he asked as she set his breakfast down on the table, "do you happen to know who lived here before me?"

The old woman thought for a while. "A long time ago, as far as I can remember, it belonged to an old gentleman who, if I remember rightly, was very rich and was said to be an eccentric. After that it stood empty for a long time before it was taken over by the Royal Orphans' Society, sir."

"And have you any idea what the old gentleman was called, or whether he's still alive?"

"I'm afraid not, sir."

"Oh well, thank you anyway."

Hauberrisser set about trying to decipher the manuscript again. He soon managed to work out that in the first part, written in short, disjointed sentences, the author was looking back on the life of a man who, pursued by misfortune, had tried everything imaginable to give himself a decent life. Every time, his efforts foundered at the last moment. Later on he appeared to have become rich overnight, but how he did so was unclear, as several sheets were missing.

Then came several pages that were so yellowed that there was nothing legible left on them; the following section must have been written some years later, since the ink was a little fresher and the writing unsteady, suggesting it was that of an old man. One passage that seemed to reflect a mood similar to his own Hauberrisser reread to see what the context was:

"Whoever believes he is living for the sake of his children and his children's children is deceiving himself. It is not true; mankind has not advanced one inch; it only seems to have. There are

merely occasional individuals who are more advanced than the rest. To go round in a circle means not making progress. We must break out of the circle or we will achieve nothing. All they who think that life begins with birth and ends with death cannot even see the circle, how should they break out of it!"

Hauberrisser turned the page.

The very first words he read, right at the top of the page, were like a whip-lash across his face: "Chidher Green"!

He had been right, after all.

Tense and breathless, he sent his eye racing over the next lines. They told him nothing. "Chidher Green" was the end of a sentence, but the rest was missing, the previous page did not seem to belong with the one with the name. There was nothing in the material that suggested with any certainty what the author associated with the name, or even that he might have been personally acquainted with a certain "Chidher Green".

Hauberrisser shook his head in disbelief. Whatever it was that had come into his life, it looked as if an invisible hand were toying with him. Although the manuscript seemed to be interesting, he could not summon up the patience to continue poring through it. The letters were beginning to swim before his eyes. And he refused to be made to look foolish by some silly coincidence.

'I'll sort this thing out once and for all!' He shouted for his housekeeper and ordered her to call him a cab. 'I will go straight round to the Hall of Riddles and confront this Chidher Green', he decided. He immediately realised it would be a waste of time and breath – 'What fault of the old Jew's is it if his name keeps on pursuing me like a demon?' – but Mevrouw Ohms had already gone to fetch the cab.

He paced up and down the room in his agitation.

'I'm behaving like a madman', he reasoned; 'what has it all to do with me, anyway? Instead of enjoying a quiet life -' *like a nice, respectable family man,* added a sarcastic voice from within, with the result that he immediately abandoned the train of thought. 'Has life itself not taught me often enough that to live as the majority of mankind do is so stupid, it's a disgrace. Even if what I was going to do were the most hare-brained thing

imaginable, it would still be more sensible than to slip back into the old groove, which only leads to a pointless death.'

World-weariness crept over him again, and he felt he had no other choice, if he were to avoid the inevitable suicide from ennui, than to drift along in the wake of events, for a time at least, until fate should cast him an anchor or call out in ringing tones, 'there is nothing new under the sun; the goal of life is death.'

He took the roll of papers into his study and locked it in his desk. But by now he was so wary of mysterious influences that he took out the sheet with the name Chidher Green at the top, folded it and put it into his wallet. He did this not because he thought it might vanish by magic, but so as to have the paper to hand and not be forced to rely on his memory alone. It was an instinctive reaction, a kind of defence mechanism to protect himself from the confusion to which the human mind is subject, by having the evidence of his senses to rely on should further bewildering coincidences threaten to disrupt normality once more.

"The cab is waiting below", said his housekeeper, "and this telegram has just been delivered."

> "Please be sure to come to tea today. Quite a large gathering, including your friend Cienchonski and, unfortunately, Madame Rukstinat.
>
> My curse be upon you if you abandon me.
>
> Pfeill."

Hauberrisser read it and muttered irritably to himself. He had no doubt that the brazen 'Polish Count' had made free with his name in order to become acquainted with Pfeill. Then he told the cabbie to take him to the Jodenbreetstraat. When the latter asked him, with a worried look on his face, whether he should take the most direst route through the 'Jordan', by which he meant the ghetto, he smiled and said, "That's right, straight through the Jewish quarter."

Soon they were in the middle of what was the strangest district of any European city. The inhabitants seemed to do everything out on the street. There was cooking, washing and ironing

going on; a line across the street with dirty stockings hung on it to dry was so low that the cabbie had to bend down so as not to become entangled in it. Clockmakers sitting at tiny tables stared up at the cab, looking like startled deep-sea fish with their lenses still wedged in their eyes; children were being suckled or held over the drains to relieve themselves.

One crippled old man had been carried out in his bed – and the chamber pot placed underneath it – so that he could get some 'fresh air', and on the street corner next to him a Jew with a bloated face and dolls climbing all over him like the Lilliputians on Gulliver was selling toys; without appearing to breathe and in a voice which sounded as if he had a silver breathing-tube in his throat, he kept up a constant cry of "dollidollidollidollidol-lidolli".

"Olecloes, olecloes, o-l-ecloes", roared a kind of Isaiah in a caftan and with snow-white sidelocks whose chosen career was buying and selling old clothes; he waved a pair of trousers with one leg above his head like a victory banner and loudly suggested that Hauberrisser should honour his establishment with a visit, "Come on sir, don't be shy, see what I give you for that lovely coat."

From the next side-street came a polyphonic chorus with the most remarkable modulations, "Herrings, lovely fresh he-e-errings"; "Strawberries, sweet strawberries, the best in the town"; "Gherkins, crisp and cheap, ghe-e-erkins", such appetising music that the cabbie listened with a reverent look on his face, even though he was a captive audience: he could not drive on until the street in front had been cleared of a mountain of stinking rags. Hordes of Jewish rag-and-bone men were piling them up and were still bringing along more bundles; they scorned the usual sacks, rolling the filthy scraps of material into large balls, which they pushed up under their half-opened caftans, clutching them to their bare skins under their armpits. It was a bizarre sight to see them all arrive as roly-poly dumplings and then scamper off, skinny as sewer-rats.

Eventually the street broadened out and Hauberrisser saw the glass veranda of the Hall of Riddles gleaming in the sun.

It was quite some time before the window in the partition was

lowered – much less noisily than yesterday, without the same entrepreneurial clatter – to reveal the upper half of the salesgirl.

"Yes?" asked the young lady in strikingly cool tones and with her mind clearly on other things, "What can I do for you, Mijnheer?"

"I would very much like to speak to your boss."

"I'm afraid Professor Zitter left yesterday on business. He didn't say when he would be back." The girl pressed her lips together in a saucy pout and shot Hauberrisser a challenging look.

"You needn't worry, I didn't mean the Professor. I would just like to have a word with the old gentleman I saw at the desk in there yesterday."

"Oh, *him*", relief appeared on the girl's face. "That is Herr Pedersen from Hamburg. The one who was looking at the peep-show, you mean?"

"No, I mean the old ... Israelite in the office. I thought the business belonged to him."

"Our business? Our business never belonged to no old Jew, sir. We're a Christian business, completely Christian."

"Well that's your business. But I would still like to speak with the old Jew who was standing at the desk yesterday. You could arrange that for me, couldn't you?"

"By the Holy Mother of God", the girl assured him, falling quickly into her most sincere dialect as a sign that she was speaking the truth, "there's never a Jew allowed in our office, nor was there ever a one in there, as sure as I'm standing here. And specially not yesterday."

This merely exasperated Hauberrisser, who did not believe one word of it. He searched around for some way to allay her suspicion of him.

"Very well, Miss. But perhaps you could at least tell me who this Chidher Green is on the sign outside?"

"Which sign would that be?"

"But for goodness sake! Your own shop sign outside!"

The salesgirl looked at him, wide-eyed with astonishment. "But our sign says Arpád Zitter", she said in bewilderment.

In fury Hauberrisser grabbed his hat and rushed outside to

make sure. Mirrored in the glass of the door he could see the astonished salesgirl tapping the side of her head. In the street he turned round and looked up at the sign; it said – his heart missed a beat as he read it – Arpád Zitter's Hall of Riddles.

No mention of Chidher Green at all.

He was so confused and felt so embarrassed that he abandoned his walking stick in the shop and hurried off down the first alleyway he came to, just to get away from the area as quickly as possible.

He must have wandered round in a daze for a good hour. He drifted through alleys silent as the grave and narrow courtyards where churches dreaming in the hot sunshine suddenly rose up before him; he passed through dark entrances, cool as a cellar, where his footsteps echoed as in a deserted cloister. The houses seemed empty of life, as if no one had lived there for hundreds of years. The only sign of life was an occasional Angora cat on a baroque window-ledge amid pots of gaudy flowers blinking lazily in the golden midday sun; there was not a sound to be heard. Tall elms, their leaves and branches motionless, towered up from tiny green gardens, surrounded by an admiring crowd of ancient gabled buildings which, with their black façades and bright latticed windows all in their Sunday best, looked like a huddle of kindly old women.

He sauntered beneath flying buttresses where the cobbles had been worn smooth by the passing years, and into winding, twilit passageways, blind alleys hemmed in on either side by high walls with polished heavy oaken doors which were locked and had probably never been opened as long as they had been there. Moss was growing in the cracks between the cobbles, and slabs of reddish marble with weathered inscriptions set in niches in the wall told of a graveyard that might once have occupied the ground.

Then he was following a narrow pavement past plain, whitewashed houses with a stream shooting out from underneath them. From inside came an eerie pounding, booming sound, like the thump of huge stone hearts. The air smelt damp and a clear rivulet flowed quickly along a zigzag course of wooden gutters to fall into a labyrinth of rotting, splintered planks.

Immediately after that the daylight was obliterated by a crooked row of tall, spindly houses; they stooped forward, apparently about to collapse, each supporting the other as if the ground were shaking. Passing a number of bakeries and cheese shops, he came upon the peaty surface of a broad, still canal beneath the bright blue sky. The rows of houses on either bank confronted one another like strangers; on the one side they were low and modest, like humble craftsmen, on the other towering, massive warehouses, aloof and self-confident. There was no bridge between them, only a tree which, growing out of a wooden fence festooned with fishing-lines with floats of red and green feathers hanging down to catch eels, leant its inquisitive trunk across the water and stretched out its branches towards the windows of the rich.

Hauberrisser strolled back in the direction from which he had come and soon found himself back in the middle ages, as if time had stood still for hundreds of years in that part of the city: sundials on the walls above richly-wrought, elaborate coats of arms, gleaming windowpanes, red tiled roofs, tiny chapels sunk in shadow, brass door-knobs reflecting the white, cherubic clouds.

A wrought-iron gate leading into a convent courtyard stood open and he went in. Beneath the drooping branches of a willow he saw a bench. The whole area had been taken over by tall grass. There was no sign of a human being anywhere, no faces at the windows. It seemed completely deserted. He sat down on the bench to collect his thoughts. His unrest had vanished, and the worry that reading the wrong name over the shop might be the sign of incipient illness had also long since disappeared. He had come to feel that much stranger than the – admittedly odd – external events was the alien mode of thought into which he had recently fallen.

'How has it come about', he asked himself, 'that I, who am still relatively young, look on life like an old man? People of my age don't think as I do.' He went through his memory to try and establish the point at which the change had taken place within him. Like every young person, he assumed, he had been a slave to his passions until he was well over thirty; the only bounds to

his search for pleasure had been the limits of his wealth, and his physical and mental endurance. He could not remember having been particularly withdrawn as a child, so where were the roots from which this alien stem had sprung, this flowerless stalk that he called his present self?

'There is a secret, inner growth ...', he suddenly remembered he had read those words only a few hours ago. He took the sheet from the roll of paper out of his pocket and looked for the place.

"... for years it seems impeded and then, unexpectedly, often set off by something trivial, the veil falls away and there is a branch full of ripe fruit; we had not noticed it flowering, but now we see that without knowing it we had tended a mysterious tree. Oh that I had never allowed myself to be persuaded that any power outside myself could bring forth that tree, how much misery would I have been spared! I was sole lord of my destiny and knew it not! I thought that because I could not alter it by deeds, I was powerless before it. How often did it not occur to me that to be master of one's own thoughts must also mean to be the all-powerful controller of one's own destiny. But I always rejected the idea, because my half-hearted attempts never showed immediate results. I underestimated the magical power of thought and fell back into the old error that has plagued mankind since Adam: to take the deed for a giant and the thought for a mere figment. Only when you can command light can you also command the shadow and – destiny; anyone who tries to achieve it by his deeds is only a shadow fighting a vain battle with shadows. But it seems that we must allow life to torture us almost to death before we finally grasp the key. How often have I tried to help others by explaining this to them; they listen and they nod and they believe, but it all goes in at the right ear and comes out at the left. Perhaps the truth is too simple for people to understand it straight away. Or must the 'tree' reach up into the sky before understanding can come? I sometimes fear that the difference between one person and another is greater than that between a person and a stone. The whole purpose of our life is to develop a fine sense for what makes the tree flourish and keeps it from withering. Everything else is merely shovelling dung without knowing the reason why. But how many are there

alive today who understand what I mean? They would imagine I was talking in images if I were to tell them. It is the ambiguity of language that separates us. If I were to publish something about 'inner growth', people would interpret it as meaning becoming cleverer or better, just as they take philosophy for a theory and not the practice. Obeying the Commandments alone, even with complete sincerity, is not sufficient to promote inner growth, for it is merely outward form. Breaking the Commandments is often a better hot-bed, but we keep the Commandments when we should break them and break them when we should keep them. Because saints only perform good deeds, people imagine that by performing good deeds they can become saints. They follow that path and believe they will be counted among the just; but they are following a false belief in God and it will lead them to the abyss. They are blinded by mistaken humility, so that they start back in horror, like children at their own image in the mirror, and fear that they are going mad when the time comes *when they shall see His face.*"

Suddenly Hauberrisser felt himself refreshed by a glimmer of hope that had slept so long within him that it seemed completely new; joy and hope sprang up within him, although he did not know why he should rejoice or what he should hope for – nor, for the moment, did he desire to know. Everything that had happened to him since he had first seen the name Chidher Green no longer seemed the workings of a malevolent fate; he suddenly felt that fortune was smiling on him once again,

Something within him exulted, 'I should rejoice that such a noble beast from the uncharted forests of the spirit has broken through the fence surrounding the familiar world and come to graze in my garden, rejoice, and not be concerned that a few rotten fence-posts have collapsed.'

He was now convinced that the last lines of the page very probably referred to the face of Chidher Green, and he was burning with impatience to learn more, especially as the last few words suggested that the next page would describe in detail what was meant by 'magical power over one's thoughts'. He would have preferred to dash straight home and spend all night poring over the roll of papers, but it was almost four o'clock, and

Pfeill was expecting him.

A humming noise reached his ear and caused him to turn round. He stood up in astonishment at the sight of a man, quite close to the bench, wearing a fencing mask and holding a long pole in his hand. A few feet above him hung a sack-like object that swayed back and forth, then caught one corner on a branch of the tree and hung there, bouncing up and down.

Suddenly the man went after it with the stick and caught it by the point, or rather, by a small net that was attached to it, shouldered the pole with the strange sack attached and climbed, with a satisfied grunt, up the fire-escape of the house, disappearing along the flat part of the roof.

"It's the convent beekeeper", said an old woman, appearing from behind a water-pump and noticing Hauberrisser's bewildered expression. "They swarmed and he has just caught the queen."

Hauberrisser went out and after following a few twisting alleyways came to a square where he found a taxi-cab to take him to Pfeill's country-house near Hilversum.

There were thousands of cyclists along the broad, straight road. The car sailed along through a sea of heads and shining pedals, but Hauberrisser ignored them for the whole of the hour the journey took. The landscape flew past unnoticed; his eyes were fixed on the image he had just seen: the man with the mask and the swarm of bees, huddled round their queen as if they could not live without her.

Nature, which had said her silent farewell to him on his last journey out into the country, had now turned a new face towards him, and he felt he could read the words she was forming with her lips.

The man catching the queen, and with her the whole swarm, seemed like a symbolic image to Hauberrisser.

'What else is my body than a teeming army of living cells', he said to himself, 'revolving round a hidden centre according to a habit that has been handed down over the millennia?'

He suspected there was some mysterious connection between what he had just seen and the laws of physical and spiritual nature, and he realised how the world would glow anew

with a magical radiance if he should ever manage to see all the things that habit and routine had robbed of speech in a fresh light.

Chapter Seven

At Hilversum the car turned off the main road and glided up the avenue of limes through the park surrounding Pfeill's villa, Sans Souci, which was glowing white in the afternoon sun.

Pfeill was standing at the top of the outside staircase and came down with a cry of pleasure when he saw Hauberrisser arrive.

"It's marvellous that you could come, you old stork. I was beginning to fear that my telegram hadn't reached you in your lair. Has something happened? You look so pensive. By the way, may God reward you for sending that superb Count Ciechonski; he's a real tonic in these depressing times." Hauberrisser wanted to protest and explain that he was nothing more than a confidence trickster but Pfeill was in full swing and would not let him get a word in. "He came to visit this morning and I naturally invited him for lunch. I think three pairs of silver spoons have disappeared already. He introduced himself as –"

"– a godson of Napoleon the Fourth?"

"Yes. Of course. But he also dropped your name."

"He had the effrontery!" said the furious Hauberrisser. "He needs a good box round the ears; that would teach him to stick his brass neck out!"

"But why? All he wants is entry to a gentleman's gambling club. Why not let him have his way? Liberty consists in doing what one desires. If he's determined to ruin himself, why not let him?"

"He won't. He's a professional card-sharp", Hauberrisser interjected.

Pfeill looked at him pityingly. "You think he would get away with that in these modern poker-clubs? They all cheat. He'd lose his shirt. By the way, have you seen his watch?"

Hauberrisser laughed.

"If you love me", Pfeill said, "buy it from him and give it me for Christmas." He crept up quietly to one of the windows opening onto the veranda, signalled to his friend and pointed inside – "Look, isn't that marvellous?"

'Professor' Zitter, in spite of the hour wearing tails with a hyacinth in the buttonhole, shoes as yellow as an egg-yolk and

a black tie, was sitting in a cosy tête-à tête with a middle-aged lady who was so excited at finally having captured a man again that she had red blotches on her cheeks and was making a rosebud mouth.

"Do you recognise her?" whispered Pfeill. "It's Madame Rukstinat; God rest her soul – as soon as possible. Look! He's showing her the watch. I would like to bet that he'll try to charm her by showing her the mechanical couple behind the dial. He's a real ladykiller, there's no doubt about that."

"It was a christening present from Eugène-Louis-Jean-Joseph", they heard the 'Count' say, his voice trembling with emotion.

"Oh Vladdymeersh!" lisped the lady.

"By Jove, she's already calling him by his first name!" Pfeill whistled through his teeth and drew his friend away with him. "Quick, off we go; we are *de trop* here. Pity the sun's shining, otherwise I would switch off the light – out of pity for Ciechonski. No, not in there!" He pulled Hauberrisser back as he was about to go through a door the servant was holding open. "There's politics a-brewing in there." He had a brief view of a large gathering assembled round a bald-headed speaker with a full beard who was standing in an eloquent pose with his fingers spread out on the table in an imperious gesture. "Let's go to the Jellyfish Room."

As he sank into the soft beige chamois-leather of the club chair Hauberrisser looked round in astonishment: the walls and ceiling were covered with sheets of smooth cork that had been so skilfully hung that the joins were invisible; the windows were made of curved glass and the furniture, the corners where the walls joined, even the door standards were all gently rounded; there was not a straight edge anywhere, the carpet was so fluffy it was like walking ankle-deep in sand, and everywhere was the same soft, matt, light-brown colour.

"I eventually realised", explained Baron Pfeill, "that anyone who is condemned to live in Europe needs a padded cell more than anything else. Even just an hour in a room like this is enough to transform the most neurotic fidget into a gentle mollusc for quite some time. I assure you, at times when I have so

many demands made on me they're coming out of my ears, the mere thought of this soft room is enough to send all my good intentions floating away, like fleas from a fox when it's bathed in milk. Thanks to this sensible arrangement I can, whenever I like, avoid even the most pressing duties completely without regret."

"Anyone who heard you speak like that", said Hauberrisser with a laugh, "would be sure to assume you were the most cynical hedonist imaginable."

"Wrong!" said Pfeill, pushing the cigar-box with its curved and bulging sides towards him. "Wrong and wrong again! I am punctiliousness itself – towards myself. I know that your opinion is that life is meaningless. It is a delusion that I myself shared for a long time, but it gradually dawned on me that all one needs to do is to quit the rat-race and start living a natural life once more."

"And all this", Hauberrisser gestured at the cork-lined walls, "you call natural?"

"Of course! If I were poor I would have to live in some bug-infested attic, but if I were to do that now, of my own free will, it would be as unnatural as you could get. Destiny must have had something in mind when it sent me into the world rich. Was it to reward me for some deed I did in my former existence and – touch wood! – have forgotten? That tastes a bit too much like theosophical humbug to me. No, I think it most likely that fate has allotted me the noble task of gorging on the sweet things of this world until I am replete and desire a crust of stale bread for a change. Well, I'm ready to do my bit. I could be mistaken, but that wouldn't be a disaster. Should I give my money to the poor? At once, if you like; but first I would want to know the reason. Just because it's been written in so many fat tomes? No. And I refuse to be taken in by the socialist slogan of 'Get away from the trough and let me get my snout in'. If someone is in need of sharp medicine should I give them a syrupy draught? Water the wine of destiny? That's the last thing I want to do."

Hauberrisser gave a wink.

"I know why you're grinning like that, you old rogue", Pfeill went on in an irritated tone. "You're alluding to those couple of

guilders I sent to the shoemaker – by mistake, of course. The spirit is willing but the flesh is weak. A gentleman doesn't remind a friend of his moments of weakness! I've spent all night berating myself for letting myself go like that. What if it should be too much for the old fellow and drive him out of his mind? I'd be to blame."

"As you brought the matter up", said Hauberrisser, "I must say that I don't think you should have given him so much at once; instead you should have –"

"– let him starve bit by bit", Pfeill broke in sarcastically. "That's all balderdash. I admit that if you follow your feelings, much will be forgiven you because you have much loved, but I think that before condemning me people should at least have the decency to ascertain whether I am deliberately looking for forgiveness. I intend to pay my debts, moral as well as financial, right down to the last cent. I have this idea that long before I was born my admirable soul was cunning enough to ask for great wealth, as an insurance policy; so as not to be able to enter the Kingdom of God through the eye of a needle. You see, my soul just doesn't like raucous hallelujahs and hates tedious music. If only heaven were nothing but an empty threat! But I am firmly convinced that there is such an institution waiting for us after death. That makes it an extremely difficult balancing act on the one hand to remain a decent person, and on the other to avoid ending up in a future paradise. The blessed Buddha himself used to rack his brains over that problem."

"And you too, as I can see."

"Certainly. Just to be alive is not enough, is it? You seem to have no idea at all of the demands that are made on me. I don't mean social engagements and such, I have a lady who looks after the house and sees to all that as well; no, I mean the demands of spiritual labour that come from my intention to – to – found – a – new – state and a new religion. There, it's out."

"Good God, you'll be locked up next!"

"Don't worry, I'm no revolutionary."

"And are there many in your sect, yet?" asked Hauberrisser with a smile, suspecting it was all a joke.

Pfeill gave him a sharp look, paused for a moment and then

said, "I'm afraid you seem to misunderstand me, as usual. Can't you sense that there's something in the air, something more palpable than ever before, perhaps since the world began? Prophesying the end of the world is a thankless task, it's been predicted too often down the centuries for it to be credible any more. In spite of that, I think that those who feel such an event is approaching will be proved right this time. It doesn't have to mean the destruction of the earth, the destruction of a way of life is also the end of a world."

"And you think such a drastic change in attitude could take place overnight?" Hauberrisser shook his head doubtfully. "I am more inclined to believe that some devastating natural catastrophe is imminent. People don't change from one day to another."

"Did I say that natural catastrophes would not occur?" cried Pfeill. "On the contrary, I can sense their approach with every nerve within me. But as far as an abrupt change in human attitudes is concerned, I hope you only appear to be right. What do you base your assumption on? How far back in history can you look? Only a miserable couple of thousand years! And even over that short period haven't there been enough sudden outbreaks of spiritual contagion to make one wonder? There have been children's crusades – though I grant you that it is unlikely whether mankind will ever rise to a bureaucrats' crusade. But all things are possible, and the longer they are in coming, the more probable they are. Until now men have torn each other apart for the sake of certain dubious invisible beings that are careful not to call themselves spirits but 'ideals'. I think the hour has finally come for the war against these invisible enemies, and I would like to play a part in it. For years I have been aware that I was being trained in spiritual warfare, but until now I have never had this clear feeling that a great battle against these damn'd ghosts is at hand. I tell you, once you start clearing out all those false ideals, there's no end to it. You've no idea what piles of humbug brazenly posing as truth you have inherited. That's what I call founding a new state, you see, this clearing the mind of intellectual lumber. However, out of consideration for the existing order and out of courtesy towards my fellow human

beings – God forbid I should try to impose my views about inner truthfulness and unconscious hypocrisy on them – I decided from the outset that my state – I call it the Germ Free State because it has been thoroughly disinfected of the spiritual virus of *false* idealism – should only have one subject, namely myself. I am also the only millionaire of my belief. I have no need of converts."

"I see you're not much of an organiser, then", said Hauberrisser in relief.

"Nowadays everyone thinks they can organise; that shows how wrong it must be. What is right is always the opposite of what the herd does." Pfeill stood up and started walking up and down. "Even Jesus did not attempt to organise people, he just set an example. Madame Rukstinat and company naturally assume the right to organise all and sundry. Only nature and the world spirit have that right. My state will last for ever; it doesn't need an organisation. If it did, it would have failed."

"But, my dear Baron, if your state is to have any point at all, it must eventually consist of more than one person. Where are you going to find your citizens?"

"Listen. If *one* man has an idea, that just means that many others will have the same idea at the same time. Anyone who doesn't see that doesn't know what an idea is. Thoughts are contagious, even if they are not expressed; perhaps most contagious when they are not expressed. I am firmly convinced that at this very moment a large number have already joined my state and eventually it will flood the world. We have made great progress in physical hygiene, people even disinfect door-knobs so as not to catch some disease, but I tell you, there are certain slogans that transmit much worse diseases, racial and ethnic hatred, for example, demagoguery and such. They need a much stronger disinfectant than we use on door-knobs."

"You want to eradicate nationalism, then?"

"I am not going to weedkill things in other people's gardens that won't die of their own accord, but in my own I can do as I like. Nationalism seems necessary for most people, I admit, but it is high time there was a 'state' whose citizens were held together not by borders and a common language, but by their

outlook; that will still allow them to live as they like.

In a certain sense people are right to laugh at someone who says he intends to transform mankind. But they overlook the fact that all that is needed is for one person to transform himself root and branch. His achievement will never fade, whether the world recognises it or no. Anyone who does that tears a hole in the established order that will never heal, whether the rest notice it immediately or in a million years. All things that come into being remain, they only seem to disappear. That is what I want to do, to tear a hole in the net in which mankind has caught itself; and not by preaching, but by escaping from the meshes myself."

"Do you think there is any causal connection between the catastrophes you believe are imminent and the change of attitude you assume is about to come over mankind?" asked Hauberrisser.

"Of course, it will always seem as if it is some physical calamity, a huge earthquake, for example, that makes men search their conscience, but that is an illusion. The question of cause and effect, or so it seems to me, is quite different. We can never perceive causes; all that we can see is the effect. What appears as the cause is only the first symptom. If I let this pencil go it will fall to the floor. Every schoolboy would assume that letting go of the pencil was the cause, but I don't. Letting go is simply the first, unmistakable sign that it is going to fall. Every event that precedes another is its symptom. The cause is something completely different. It is true that we imagine we are capable of bringing forth an effect, but that is just a terrible delusion, that is just the world making us see things in the wrong light. In reality there is one mysterious cause, and one cause alone, which makes the pencil fall to the ground and which, before that, made me let go of it. A sudden change in men's attitudes and an earthquake may well have the same cause; but that the one should be the cause of the other is completely out of the question, however plausible it might appear to common sense. Each is an effect as much as the other. One effect cannot produce another; at most, as I said, it can be a first sign in a chain of events, but nothing more. The world we live in is a world of effects; the realm of true causes is hidden. If we should ever

discover it we would be able to perform magic."

"But to be master of one's own thoughts, that is, to discover their hidden roots, would that not be the same as performing magic?"

Pfeill came to a sudden halt. "Of course! What else? It would take us to a distant peak from which we would not only be able to view everything, but also to make everything we want come about. At the moment the only magic we men perform is with machines, but I believe the hour is at hand when a few at least will be able to perform it through will-power alone. All those marvellous inventions, all those admired machines are nothing more than blackberries that we gathered along the path that leads to the summit. What is of value is not the invention itself, but man's inventiveness, not the picture – it's value is measured in monetary terms at the most – but the ability to paint. Any one picture can fall to pieces, but the ability to paint will not be lost, even if the painter should die. What remains is the power that has come from heaven; even if it should sleep for centuries, it always awakens when the genius who can reveal its majesty is born. It is a great comfort to me that what our worthy merchants manage to cheat our artists out of is merely the mess of pottage and not the true blessing."

"You're not letting me get a word in edgeways", Hauberrisser broke in. "I've had something on the tip of my tongue for ages."

"Why don't you say it? Out with it, then."

"But first of all another question: have you any reasons or – or signs for saying we are approaching a turning point?"

"Hm. – Well. – I suppose it's more a matter of feeling. I'm really pretty much groping in the dark myself. There is one thread I'm following, but it's as thin as a spider web. I think I have found certain boundary markers which tell us when we are entering a new area. It was a chance meeting with a Juffrouw van Druysen – you will meet her today – and something she told me about her father that gave me the idea. My conclusion – perhaps a completely unjustified conclusion – was that such a 'boundary marker' in human consciousness is a similar inner experience for all those who are ripe for it. And this experience – please

don't laugh – is the vision of a green face."

Hauberrisser grasped his friend's arms excitedly, suppressing an exclamation of astonishment.

"For goodness' sake, what's the matter with you?" exclaimed Pfeill.

The words tumbling out of his mouth, Hauberrisser told Pfeill what he had experienced.

They were so engrossed in their conversation on these strange events that they scarcely noticed when a servant came in to announce the arrival of Juffrouw van Druysen and Doctor Ishmael Sephardi, handing Baron Pfeill a tray with two visiting cards and the evening edition of the Amsterdam News.

Soon they were all immersed in a discussion on the green face.

Hauberrisser left it to Pfeill to recount his experiences in the Hall of Riddles and Eva, too, only put in a word here and there as Doctor Sephardi told them of their visit to Swammerdam. Hauberrisser and Eva were not embarrassed, but they were both in the grip of a mood in which they found it difficult to speak. They had to force themselves not to avoid looking at each other, yet each could sense the effort the other had to make to keep their remarks to banalities. Hauberrisser found Eva's complete lack of feminine coquetry almost confusing. He could see how careful she was to avoid anything that might suggest a desire to please or that she took more than a passing interest in him; and yet at the same time he felt ashamed, as if he were being tactless in his inability to conceal the fact that he was well aware of how far her apparent inner calm was the result of iron self-control. He guessed that his thoughts were equally apparent to her; he saw it in the pretence of boredom with which she played with a bouquet of roses, in the way she smoked her cigarette and in a thousand other tiny details. But he could find no way of helping her.

A single pompous remark on his part would have been enough to give her the confidence she was feigning, but it would also have been enough either to wound her deeply or to have

made him appear a prig, both of which he naturally wanted to avoid.

When she entered he had for a moment been struck speechless in amazement at her beauty and she had accepted it as a kind of admiration to which she was accustomed; but then, when she realised that his confusion had not solely been caused by her but was also the result of the interruption of his interesting conversation with Baron Pfeill, she became convinced that the impression she had made on him was one of a crude self-confidence in her female charms, and this filled her with an embarrassment which she found impossible to rid herself of.

Hers was a beauty that any woman would have borne with pride, but Hauberrisser instinctively sensed that for the moment Eva's virginal sensitivity felt it as an embarrassment. What he wanted most of all was to tell her openly how much he admired her, but was afraid he would not be able to strike the right, natural tone.

He had loved too many beautiful women in his life to lose his head at the first sight of even such loveliness as Eva's. In spite of that he was already more in thrall to her than he realised. Initially he assumed she was engaged to Sephardi, and when he saw that that was not the case he felt a thrill of delight. He immediately rejected it. The vague fear of losing his freedom again and being carried away by the old torrent of emotions made him wary. Very soon, however, he felt growing inside him such an intimate sense of belonging together, that any comparison with what he had until then called love paled into insignificance.

The silent communication between the two set the air tingling, and Pfeill was too sharp-sensed for it to remain hidden from him for long. What particularly moved him was the expression of deep sorrow which, however much Sephardi tried to conceal it, clouded his eyes and vibrated in every word of the normally reserved scholar's hasty, forced conversation. Pfeill could feel this lonely man relinquishing a silent but perhaps all the more ardent hope.

"But where do you think it will lead", he asked, when Sephardi had finished his account, "this bizarre path that

Swammerdam's – or Klinkherbogk's – 'spiritual circle' imagine they are following? I fear it is leading them to a boundless ocean of visions and –"

"– and expectations that will never be fulfilled." Sephardi gave a melancholy shrug of the shoulders, "It is the old story of the pilgrims who entrust themselves to the desert without a guide on their journey to the Promised Land, only to march towards a mirage or a painful death from thirst. It always ends with a cry of 'My God, my God, why hast thou forsaken me?' "

Now Eva's serious voice joined in the discussion. "You may well be right about all the others who believe Klinkherbogk is a prophet, but not about Swammerdam. I am certain of that. Remember what Baron Pfeill told us about him. He did find the green beetle. I am convinced it will be granted him to find the greater goal he seeks."

Sephardi gave a gloomy smile. "I wish him every success, but the greatest insight he will achieve, if he does not destroy himself in the attempt, is 'Lord, into thy hands I commend my spirit.' Believe me, Eva, I have spent more time pondering the hereafter than you probably give me credit for. I have spent a lifetime racking my brains – and my heart – over whether there is any escape from this earthly prison: there is none! The purpose of life is to wait for death."

"But then", objected Hauberrisser, "the most sensible people would be those who live for pleasure."

"Certainly. If you can. But some are incapable of that."

"What should they do?"

"Love one another and keep the Commandments, as it says in the Bible."

"And you say that?!" cried Pfeill in astonishment. "You who have studied all systems of philosophy from Lao Tse to Nietzsche! Who was it who invented these 'Commandments'? Some mythical prophet, some supposed miracle-worker. How do you know he wasn't just a madman? Don't you think that in five thousand years our good shoemaker Klinkherbogk will be surrounded by the same legendary nimbus, providing his name has not been long forgotten by then?"

"Certainly, providing his name has not been long forgotten

by then", was Sephardi's simple reply.

"So you assume there is a God enthroned in majesty above mankind and guiding our destinies? Can you demonstrate that with any kind of logic?"

"No, I can't. Nor do I want to. Don't forget, I'm a Jew; I mean not just a Jew by religion, but also a Jew by race, and as such I keep on returning to the old God of my fathers. It is in the blood and the blood is stronger than any logic. My reason, it is true, tells me that my belief is leading me astray, but then my belief tells me that my reason is leading me astray."

"And what would you do if, as has happened to Klinkherbogk, a being should appear and dictate to you what you were to do?" Eva wanted to know.

"Try to cast doubt on his message. If I managed to do that, then I would not follow his counsel."

"And if you did not succeed?"

"There would be only one logical conclusion: to obey."

"I would not do that, even then", said Pfeill.

"A cast of mind such as yours would merely have the effect of ensuring that a being from the world beyond such as Klinkherbogk's – let us call it his 'angel' – would never appear to you; but he would give silent commands that you would nevertheless obey, in the firm conviction, however, that you were acting completely on your own initiative."

"It might be the opposite", Pfeill objected. "You might imagine God was speaking to you through the mouth of a phantom with a green face while in fact it was you yourself."

"Where is the real difference?" replied Sephardi. "What is a message, after all, but a thought dressed in *spoken* words? And what is a thought? A word unexpressed. At bottom no different from a message. Are you quite certain that an idea that you have was indeed born within you and is not a message from somewhere else? I for my part consider it just as likely that mankind does not father ideas; we are merely more or less sensitive receivers for all the ideas that, for argument's sake, let us say the earth generates. The fact that one and the same idea so frequently occurs to different people at the same time speaks volumes for my theory. If that should happen to you, of course,

you would just say you had the idea first of all and the others had just 'caught' it from you. But *I* would say that you were merely the first to receive this thought, that was in the air like a wireless message, because you possess a more sensitive mind; the others received it in just the same way, only later. The more vigorous and self-assured a person is, the more they will tend to think they themselves created any great idea they have; the weaker and more pliable, the more likely they are to believe it was the result of outside inspiration. Basically both are right. Please, don't ask me how that can be; I do not want to have to start on a complex explanation of a central psyche, common to all mankind. As far as Klinkherbogk's vision of the green face is concerned – whether it is a message or an idea is, as I have explained, the same thing – I would refer you to the scientifically-proven fact that there are two kinds of person: those who think in words and those who think in images. Let us assume Klinkherbogk has spent his whole life thinking in words and suddenly a completely new idea, for which there is as yet no word, wants to force its way into his mind, to 'occur' to him, so to speak; how else could this idea reveal itself than through the vision of a speaking image that is trying to find a bridge to him; in Klinkherbogk's case, as in yours and that of Mijnheer Hauberrisser, as a man or a portrait with a green face?"

"Would you allow me to interrupt for a moment?" asked Hauberrisser. "As you mentioned just after you came in while you were telling us about your visit to Klinkherbogk, Juffrouw van Druysen's father called the man with the green bronze face the 'ancient wanderer who will not taste death'; the vision I had in the Hall of Riddles said something similar and Pfeill believed he had seen the portrait of the Wandering Jew, that is, of a similar being whose origin lies deep in the past. How do you explain this remarkable agreement, Doctor Sephardi? Is it a 'new' idea which we cannot formulate in words but only understand through an image that appears to our inner eye? My belief, however childish it may sound to you, is that it is one and the same ghostly creature that has entered our lives."

"That is what I believe as well", said Eva quietly.

Sephardi thought for a moment. "The agreement which I am

supposed to 'explain' seems to me to prove that it is the same 'new' idea which tried to force itself on all three of you, to explain itself to you or, perhaps, is still trying. The fact that the phantom appeared in the mask of an ancient wanderer through the years means, I think, nothing less than that some knowledge, some insight, perhaps even some exceptional spiritual gift, which existed in a long-departed age of the human race, was known and then forgotten, wishes to renew itself and is revealing its arrival in the world in a vision granted to a few chosen ones. Do not misunderstand me, I am not saying that the phantom could not be some independently-existing being; on the contrary, I maintain that every idea is such a being. And Eva's father also said, 'He – our forebear – is the *only person who cannot be a ghost*'."

"Perhaps by that my father meant that the forebear was a being that had already achieved immortality. Don't you think so?"

Sephardi rocked his head from side to side. "When people become immortal, my dear, they remain as an everlasting thought, and it is immaterial whether they enter our minds as an image or a word. If those who are alive on the earth at the time are incapable of grasping – or 'thinking' – them, that doesn't mean they die; they just move far away from us. And to return to my argument with Baron Pfeill: I repeat, as a Jew I cannot get away from the God of my fathers. At bottom the religion of the Jews is a religion of deliberately-chosen weakness; it puts its hope in God and the coming of the Messiah. I know there is also a path of strength. Baron Pfeill indicated it. The goal remains the same and in both cases it cannot be recognised until the end is reached. Neither the one nor the other path is wrong in itself; it only becomes disastrous when a weak person or one who, like myself, is full of longing, chooses the path of strength, or a strong person the path of weakness. In the past, at the time of Moses, when there were only ten Commandments, it was relatively simple to become a Tsadik Tomin, a just and perfect man; today it is impossible, as every Jew knows who attempts to keep all the ritual laws. Today we need God's help, or we Jews cannot follow the path. Those who bemoan the fact are foolish; the path

of weakness has simply become easier and more complete, and that means that the path of strength is clearer, for no one who knows himself, will stray onto the way where he does not belong. The strong do not need a religion any more, they can walk upright, without the support of a stick; those who only think of food and drink similarly have no need of religion – not yet. They do not need the stick for support because they are not walking, they are fixed to the spot."

"Have you never heard of the possibility of controlling thought, Doctor Sephardi?" asked Hauberrisser. "I do not mean it in the everyday sense of so-called self-control, that would be better described as the repression of an upsurge of feeling and so on. I have in mind the papers that I found and that Pfeill talked about a while ago."

Sephardi gave a start, even though he seemed to have expected, or even feared, the question; he glanced quickly at Eva. He pulled himself together, but it was noticeable that he was having to force himself to speak.

"Mastery over thought is an ancient heathen path to truly transcending humanity. Not to become the *Übermensch* the German Philosopher Nietzsche spoke of; I know little about that and what little I do know horrifies me. Over the last few decades a certain amount of information about the 'Bridge to Life' – that is the real name for this dangerous path – has reached Europe from the East, but fortunately it is still so little that no one who does not possess the basic keys could make anything of it. But that little has been enough to send many thousands, especially in England and America, wild with curiosity to learn this magic path, for that is what it is. An extensive literature has grown up, or been exhumed, there are dozens of swindlers of all races going round pretending to be initiates, but fortunately there's not one of them who really knows what he's talking about. People have set off in droves for India and Tibet without realising that the secret has long since been lost there. Even today people refuse to accept it. They find something there that has a similar name, but it is something else that ends up by taking them back to the path of weakness, that I mentioned before, or to Klinkherbogk's delusions. The few original manuscripts on

it that are still extant sound very straightforward but in fact they lack the key, which is the surest kind of fence to protect the mystery. There was at one time a 'Bridge to Life' among the Jews as well, the fragments concerning it that I know of date from the eleventh century. One of my ancestors, a certain Solomon Gebirol Sephardi, whose life is missing from our family chronicle, recorded them in veiled comments in the margin of his book, Mekor Hayim, and was murdered because of them by an Arab. The complete secret is said to be preserved by a small sect in the East whose members wear blue coats and, surprisingly, derive their origin from Europeans who emigrated there, disciples of the old fraternities of the golden and the rosy crosses. They call themselves Parada, that is, 'One who has swum over to the other side'."

Sephardi paused for a moment; he seemed to have reached a point in his account where he had to call on all his reserves of strength to proceed any farther.

He dug his fingernails into the flesh of his palms and stared silently at the floor.

Finally he pulled himself out of his reverie, gave Hauberrisser and then Eva a steady look and said in a toneless voice,

"If, however, a man should succeed in crossing the 'Bridge of Life', then it would be a great good fortune for the world. It is almost more than if a saviour were sent. Only there is one thing that is essential: he cannot reach the goal alone, he needs a female companion. It is only possible, if at all, by a combination of male and female forces. Therein lies the secret meaning of marriage which has been lost to mankind for thousands of years." His voice gave way, and he stood up and went to the window, to conceal his face from the others. When he continued, his voice appeared calm again. *"If I can help the pair of you at all with my meagre knowledge of these matters, you have only to ask."*

His words struck Eva like a bolt of lightning. Suddenly she understood what had been going on inside him. Tears welled up in her eyes.

It was obvious that Sephardi, with the keen eye of one who spent his whole life shut away from the outside world, had

become aware of what was happening between Hauberrisser and Eva even before they had. But what could have impelled him so brutally to expose the tender shoots of their mutual love to the cold air, forcing its natural development by his almost brusque insistence on an immediate declaration?

Had his honesty not been above all doubt, she would inevitably have interpreted it as the cunning attempt of a jealous rival deliberately to tear the delicate web between them, even as it was being spun.

Or was it perhaps the heroic decision of a man who knew he was not strong enough to bear the gradual separation from the woman he secretly loved, preferring to bring matters to a head himself rather than fighting against it?

But gradually the feeling forced its way into her mind that there was some other cause for his precipitate action, something connected with his knowledge of the 'Bridge of Life', about which he had given such a deliberately pithy reply. Swammerdam's words about destiny suddenly breaking into a gallop came into her mind, she could almost hear him saying them. The previous evening, as she had stared down from the railing into the dark waters of the canal, she had suddenly felt the courage to follow the old man's advice and call on God. And was all this that was happening now the result? So soon? She felt terrified by the fear that it was so. The scene with the dark bulk of the Church of St. Nicholas, the sunken house with the iron chain and the man in the boat trying to conceal himself from her flitted timidly through her mind like the memory of a bad dream.

Hauberrisser was standing silently at the table, leafing excitedly through a book. Eva felt it was up to her to break the awkward silence. She went to him, looking him steadily in the eyes, and said,

"What Doctor Sephardi has just said should not cause embarrassment between us, Mijnheer Hauberrisser, they are the words of a friend. Neither of us can know what fate has in store for us. At the moment we are still free, at least I am, and if life is to bring us together then we cannot change that, nor would we want to. I see nothing unnatural, nothing to be ashamed of, in openly considering the possibility. Tomorrow I shall return to

Antwerp; I could postpone the journey, but I think it better if we do not meet for some time. I would not like to be prey to the feeling that you or I had acted on impulse in tying a knot which it would be very painful to have to untie later on. From what Baron Pfeill has said I gather that you are lonely. So am I. May I take with me the feeling that that is no longer so and that there is one whom I can call my friend and with whom I share the hope of finding a path that will lead us beyond the everyday world? And our friendship", she turned with a smile to Sephardi, "will continue as ever, I hope?"

Hauberrisser took the hand she held out to him and kissed it. "Eva – do not be angry if I use your first name – I will not even ask you not to go, to stay in Amsterdam. It shall be the first sacrifice I make for you, that I lose you on the very same day when you ..."

"If you would give me the first proof of your *friendship*", Eva interrupted, "then please stop talking about me. I know that what you are about to say will not be an empty formula, said out of mere politeness, but still, please do not finish the sentence. I would prefer to leave it to time to tell us whether we can be more than friends to each other."

Baron Pfeill had stood up when Hauberrisser began to speak and was about to make an unobtrusive exit, so as not to be in the way. He realised, however, that Sephardi could not follow without having to push past the couple, so he went to the small round table by the door and picked up the newspaper. The very first lines he read made him exclaim in horror, "There was a murder in the Zeedijk last night!" Concentrating on the essentials, he hurriedly read out the article to the others,

"MURDERER ALREADY FOUND

Since our report in the afternoon edition, the following facts have emerged:

It was before first light when Jan Swammerdam, a well-known local entomologist, went to unlock the door to the attic where Klinkherbogk lived. For reasons that have not yet been established, he had locked it from outside the previous evening, but when he arrived he found the door wide open and on the floor

the blood-soaked corpse of Kaatje, Klinkherbogk's little grand-daughter. The shoemaker, Klinkherbogk, had disappeared, likewise a large sum of money which, according to Swammer-dam's statement, he had had with him the previous evening.

Suspicion immediately fell on a shop assistant who worked in the same building. A witness came forward who claimed to have seen him on the darkened landing with a key at the door of the attic. He was arrested at once, but was released when the real murderer gave himself up to the police.

The police are working on the assumption that the murderer first of all killed Klinkherbogk and then his granddaughter, who must have been woken up by the noise. The body must have been thrown out of the window into the canal which has been dragged, but so far without result. At that point it is over ten feet deep and the bottom is soft mud.

The murderer has made a statement, but it is very confused, and the police are not ruling out the possibility that the crime was committed while he was mentally deranged. He admits to having stolen the money, which was presumably the motive for the crime. It is thought that the money, a sum of several thousand guilders, was given to the shoemaker by a well-known spend-thrift – let this serve as a warning against the dangers of rash and excessive charitable gestures."

Pfeill let the newspaper sink as he nodded sadly to himself.

"And the murderer? Who was it?" Eva quickly asked. "That terrible negro, I'm sure."

"The murderer?" Pfeill turned the page. "The murderer is ... here it is, 'The man who confessed to the murder was an old Russian Jew by the name of Egyolk who runs a liquor store in the same building. It is high time that the area around the Zeedijk was etc., etc.' ..."

"Simon the Crossbearer?" exclaimed Eva in shocked sur-prise. "I could never believe he would wilfully commit such a horrendous crime."

"Not even in a state of mental derangement", murmured Doctor Sephardi.

"So you think it was the shop assistant, the one they call Ezekiel?"

"No more likely than Egyolk. At most he had a skeleton key and intended to enter the attic in order to steal the money but was prevented at the last moment. The negro was the murderer, it's as plain as a pikestaff."

"But then what in heaven's name can have impelled old Lazarus Egyolk to confess to the crime?"

Doctor Sephardi shrugged his shoulders. "Perhaps it was an attack of hysteria brought on by the initial shock; when the police came, he thought Swammerdam had murdered Klink-herbogk and wanted to sacrifice himself for him. One glance was enough to tell me that he's not normal. Do you remember, Eva, what old Swammerdam said about the power that resides in names. Egyolk only needs to have borne his spiritual name of Simon for a sufficient length of time and it is not impossible that he was just waiting for the opportunity to sacrifice himself for another. I am even of the opinion that Klinkherbogk, before he was murdered himself, killed the little girl in a fit of religious mania. It is well known that he practised the name of Abram for years; if, instead, he had repeated the word Abraham to himself, the disastrous playing-out of the sacrifice of Isaac would never have occurred."

"What you are saying there is a complete mystery to me", Hauberrisser broke in. "How can repeating a word constantly to oneself determine or change a person's fate?"

"Why ever not? The threads that guide a man's actions are exceedingly delicate. What is said in the Book of Genesis about the change of name from Abram to Abraham and from Sarai to Sarah is connected with the Cabbala, or rather, with other, much deeper mysteries. I have come across a certain amount of evidence which suggests that it is wrong to speak secret names aloud, as they did in Klinkherbogk's group. As you perhaps know, every letter in the Hebrew alphabet also stands for a number. For example, $S = 300$, $M = 40$, $N = 50$ etc. It is possible, therefore, to turn names into numbers and to construct geometrical figures in our imagination from the relationships between the numbers, a cube, a pyramid and so on. And these geometrical shapes can become the axis round which our inner life, which until then has been completely formless, rotates, so to speak, if

we imagine it in the right way and with the necessary force. When we do this we turn our soul – I have no other word for it – into a crystalline structure from which it derives its eternal laws. The Egyptians imagined a soul that had reached perfection in the form of a sphere."

"But what", mused Baron Pfeill, "in your opinion, assuming the poor shoemaker really did kill his granddaughter, was wrong with his 'practice'? Is the name Abram so very different from Abra-ham?"

"It was Klinkherbogk who gave *himself* the name of Abram. It rose from his subconscious and that is what led to the disaster. What it lacked was what we Jews call the 'Neshamah', the spiritual breath of the deity descending from above, in this particular case the syllable 'ha'. In the Bible it was Abra-ham who was spared from having to sacrifice Isaac; Abram would have become a murderer, just as Klinkherbogk has. In his thirst for eternal life, Klinkherbogk called down his own death. I said before, whoever is weak should not take the path of strength. The path of weakness, of waiting, was Klinkherbogk's path and he departed from it."

"But something must be done for poor Egyolk!" exclaimed Eva. "Are we to stand around idly whilst he is tried and sentenced?"

"It takes longer than that to sentence a man", said Sephardi soothingly. "Tomorrow morning I will go and speak to the police psychiatrist, de Brouwer, I know him from the University."

"And you'll look after the poor old butterfly-man as well, won't you and write and tell me how he is getting on?" asked Eva, standing up and shaking hands with Pfeill and Sephardi as she made to leave. "Goodbye; I trust we shall meet again in the not-too-distant future."

Hauberrisser realised straight away that she wanted him to accompany her, and helped her on with her coat, which the servant had brought in.

As they walked through the park the cool of the evening lay damp upon the redolent lime trees. Greek statues shimmered palely in the darkness of tree-lined arcades, dreaming in the

splash of the fountains which glistened silver in stray light from the lamps outside the castle.

"Might I not visit you occasionally in Antwerp, Eva?" asked Hauberrisser in a choking, almost shy voice. "You ask me to wait until time should bring us together. Do you really think it would be better to do it by writing rather than by seeing each other? We both have a different view of life from the masses, why put a screen between us that can only separate us?"

Eva looked away. "Are you so sure that we are meant for one another? Two people living together may well be a source of joy, but why then does it happen so often, almost always indeed, that after a short while it ends in hatred and bitterness? I have often told myself there must be something unnatural in a man chaining himself to one woman. I feel as if it clipped his wings. – Please, let me finish; I can imagine what you are about to say ..."

"No, Eva", Hauberrisser broke in quickly, "you are wrong. I know what you are afraid I might say. You don't want to hear me tell you what my feelings for you are, and I am not going to mention them. In spite of the fact that what Doctor Sephardi said was said in all honesty, and in spite of the fact that I hope with all my heart that it will come to pass, yet it has still raised an almost insurmountable barrier between us, of which I am painfully aware. If we do not put all our effort into tearing it down it will stand between us for ever. And yet I am filled with an inner sense of joy that it has happened in this way. I think neither of us need fear a calculated marriage. The danger that was threatening us – please excuse me, Eva, when I use the words 'we' and 'us' in this way – was that it would be love and desire alone that brought us together. Doctor Sephardi was right when he said the meaning of marriage had been lost to mankind."

"But that is what torments me", said Eva. "Life seems to me a dreadful, devouring monster and I feel at a complete loss as to how to deal with it. Everything is stale or threadbare. Every word we use has become dry as dust. I feel like a child who is looking forward to being transported into a fairytale world and then goes to the theatre and sees actors dripping with grease-paint. Marriage has become an ugly institution which robs love

of its bloom and reduces men and women to mere functions. It is like slowly sinking into the desert sand. Why can't we be like mayflies?" She stood still and cast longing glances at a floodlit fountain enveloped in a golden haze of fluttering moths. "They spend years as grubs, crawling over the earth, preparing for their wedding as for something sacred, to celebrate one short day of love before they die." She stopped with a shudder of horror.

Her eyes had darkened, and Hauberrisser could see she was in the grip of some deep emotion. He raised her hand to his lips. For a while they stood there motionless then slowly, as if half asleep, she put her arms around his neck and kissed him.

"When will you become my wife? Life is so short, Eva."

She gave no answer, and without a word they walked together towards the open wrought-iron gate where Baron Pfeill's car was waiting to take Eva home. Hauberrisser wanted to repeat his question before she said goodbye, but she was the first to speak, snuggling up against him.

"I long for you as I long for death", she said softly. "I will be your lover, of that I am sure; but we will be spared what people call marriage."

He scarcely grasped the meaning of her words, he was numb with the joy of holding her in his arms. Then he responded to the shudder of horror still within her and felt his hair stand on end as an icy breath enveloped both of them, as if the angel of death were taking them under his wings and carrying them far away from the earth to a realm of eternal bliss.

As he awoke from the trance, the strange, rapturous ecstasy of dying that had seemed to consume all his senses, slowly left him and was replaced, as he watched the car take Eva away from him, by the gnawing torment of the fear that somehow he was destined never to see her again.

Eva had intended to visit her aunt early the next day, to give her what comfort she could, and then take the morning express to Antwerp, but she changed her mind when she arrived at the hotel to find a hastily-scribbled note, smudged with tears.

The terrible events on the Zeedijk appeared to have put the old lady in a state of shock, for she wrote that she had resolved not to set foot outside the Convent until she felt sufficiently recovered from the distress they had caused her to concern herself once more with what she insisted on calling the hurly-burly of the modern world. Her final sentence, however, culminating in the lament that a horrid migraine made it impossible for her to receive visits from anyone at all, suggested that serious concern about the old lady's mental health was unnecessary.

Eva did not hesitate, but sent her luggage to the station straight away. The porter recommended she take the midnight train to Belgium, as there were usually many free seats on it.

It took her some time to overcome the feeling of disgust the letter had left in her. Was that what the female heart had come to? Eva had been afraid that 'Gabriela' would never recover from the blow and what did she find – a headache! 'We women have lost our sense of greatness', she complained to herself bitterly. 'Our grandmothers took it all and embroidered it into their wretched samplers.' It was a young girl's fear that made her press her head between her hands. 'And am I to become like that, too? It is humiliating to be a woman.'

The loving thoughts, which had accompanied her all the way from Hilversum back into the city, tried to reassert their power. The whole room seemed to fill with the scent of the flowering limes, but Eva tore herself away and went out to sit on the balcony, gazing up at the star-bright sky. As a child she had often found comfort in the idea that up there was a Creator who looked down on her insignificance; now she felt humiliated by her insignificance. She had a profound distaste for all the attempts by women to rival men in public life, but to have nothing to give the man she loved but her beauty seemed a poor, miserable

offering, seemed to be making much ado about a matter of course.

Sephardi's words, that there was a hidden, royal way along which a woman could be more to her husband than a mere provider of earthly pleasure, brought her a faint ray of hope. But where did that path begin?

Tentatively, timidly, she made a start, trying through the exercise of reason to work out what she would need to do to find such a path. But she soon sensed that it was nothing more than a vain, feeble begging for light from the powers above the stars, instead of the vigorous struggle for illumination which she knew a man would have been capable of. She felt miserable, her heart consumed by the most delicate and yet deepest sorrow a young woman can know: to appear before her beloved empty-handed and yet to be overflowing with longing to give him a whole world of joy.

No sacrifice would have been too great; she would have made it gladly for his sake. With the instinct of her sex, she knew that the most a woman could do was to sacrifice herself, but whatever course of action she thought of, it seemed fleeting, paltry, childish, compared with the intensity of her love.

To subordinate herself to him in all things, to relieve him of care, to anticipate his every wish: how easy that must be, but would it make him happy? It was nothing more than what millions of women did, but she longed to be able to give him something beyond what was humanly possible.

She had long sensed within her the deep bitterness of being as rich as a king in her desire to give, yet as poor as a beggar in the gifts she could offer; it now manifested itself with a crystal clarity that made her shudder, as the saints before her had shuddered as they had trodden the path of martyrdom through the scorn and derision of the mob.

Overwhelmed by the torment, she rested her forehead on the balcony rail and, her lips pressed tight together, screamed a silent, inward prayer that the very least among the host of those who had crossed the river of death for the sake of love might appear and reveal to her how to find the mysterious crown of life, that she might take it, and give it away.

118

She looked up, as if she had felt the touch of a hand on her head, and saw that the sky had suddenly changed. Across it ran an oblique slash of pale light and the stars were pouring into it like a swarm of glittering mayflies blown by a stormwind. Then it opened up to reveal a hall with ancient greybeards in flowing robes sitting at a long table; their eyes were fixed on her as if they were ready to hear her declaration. The features of the chief among them were foreign, between his brows he bore a shining mark, and from his temples rose two blinding rays, like the horns of Moses.

Eva knew that she should swear an oath, but she could not find the words. She wanted to beseech them to hear her prayer, but she could not lift up her voice, the words stuck in her throat then piled up in her mouth.

Slowly the tear in the sky began to close up again and, as the hall and the table gradually faded, the Milky Way spread over it like a glowing scar. Only the man with the blazing mark on his forehead was still visible. In despair Eva stretched her arms out to him, mutely pleading with him to stay and hear her out, but the face made to turn away. Then she saw a man on a white horse dash in a wild gallop up through the air from the earth; and she saw that it was Swammerdam.

He dismounted, walked up to the man, screamed at him and then grabbed him angrily by the breast.

With a commanding gesture he pointed down at Eva.

She knew what he was saying. In her heart the words from the Bible rang out, that the Kingdom of Heaven shall be taken by force. Her supplicant tone evaporated like a summer mist and, confident in her eternal right to self-determination, she commanded, as Swammerdam had taught her, those who guide destiny to drive her onward towards the highest goal a woman can achieve; to drive her ever onwards, faster than time itself, without pity, deaf to her pleading should she weaken, bypassing pleasure and happiness, without pause for breath, even if she should die a thousand times in the attempt.

She realised that she would have to die, for the radiant sign on the man's forehead was uncovered and when she commanded him it shone with such a blinding light that it burnt into her

mind, her thoughts; but her heart rejoiced, she would live, since she had seen his countenance at the same time. She trembled under the immense pressure from the power that was released within her and burst open the prison gate of slavery; she felt the ground tremble beneath her feet, she felt a swoon coming over her, but still her lips murmured the same command, over and over again, even when the face in the sky had long since disappeared.

Slowly, very slowly, awareness of who she was and where she was returned.

She knew that she intended to go to the station, remembered that she had sent her luggage on ahead, saw the letter to her aunt lying on the table, picked it up and tore it to shreds. Everything that she did, she did as naturally as she had done before, and yet everything seemed new and unaccustomed, as if her hands, her eyes, her whole body were now mere implements that were no longer directly connected to her inner being. She felt as if at the same time, in some distant corner of the cosmos, she were living a second life as a child that had only just been born and had not yet awoken to full consciousness. The objects around her in the room no longer seemed essentially different from her own organs, both were utensils for her will and nothing more.

The evening in the park in Hilversum was like a fond memory from her childhood, from which she was now separated by long years; she thought of it with tenderness and joy, but she was also aware of its insignificance compared with the ineffable bliss a time still to come would bring. She felt like a blind girl who had known nothing but pitch-blackness and for whom all the joys she had so far experienced paled in the light of the certainty that the hour would come, perhaps only after long and painful sufferings, when she would be able to see.

She tried to settle in her own mind whether it was merely the great difference between what she had just experienced and earthly things that made the physical world suddenly seem so insignificant; she found that everything she perceived through her senses floated past her almost like a dream which, pleasant or unpleasant, is only a phantasm without deeper significance for the awakened soul.

When she looked into the mirror as she was putting on her coat she found there was a mild strangeness in her own features; it was as if her memory at first only tentatively recognised the image as herself. In all that she did there was an almost deathly calm. The future appeared to her as impenetrable darkness and yet she confronted it with serenity, like someone who knows that the ship bearing them on life's voyage is firmly anchored and can look forward with composure to the following day, whatever storms the night may bring.

It occurred to her that it must be time to go to the station, but a presentiment that she would never see Antwerp again stopped her from leaving. She took out paper and ink to write a letter to her beloved, but stopped after the first line. All initiative was paralysed by the inner certainty that anything she might now do of her own will was in vain and that it would be easier to stop a bullet in its flight than to try to steer the mysterious power, into whose hands she had put her destiny.

The murmur of a voice from the next room that had been audible through the wall without Eva having paid any attention to it, stopped all at once, leaving behind a silence which gave her the sensation of suddenly having become deaf to physical sounds. Instead she thought after a while that she could hear, deep within her ear, as if it came from another land, an insistent whispering that gradually swelled into the muffled guttural sounds of an alien, barbaric language. She could not understand the words. It was just the irresistible compulsion to stand up and go to the door that told her that they expressed an order which she could not resist.

At the top of the stairs she remembered that she had forgotten her gloves, but, scarcely had the thought occurred to her than her attempt to turn round was brushed aside by a power which seemed alien and malevolent and yet, in its deepest roots, her own.

With swift and yet unhurried steps she went through the town, not knowing whether at the next corner she should go straight on or not, and yet certain that when the moment to choose came there would be no doubt as to the direction she should take.

Her every limb was trembling. She knew that it was from fear

of death, but her heart was unaffected by it. She was impervious to the fear her body felt, stood apart from it, as if her nerves were those of another.

When she reached an open square, with the dark, massive block of the Stock Exchange in the background, she thought for a moment that it had all been an illusion and that she was on her way to the station after all, but suddenly she was dragged off to the right through narrow twisting alleyways.

The few figures she passed stopped and she could feel them looking back at her.

With a new power of inner vision, that she had never before realised she possessed, she found she could guess whatever it was that most worried each individual she met. Some seemed to exude concern, like a mental current of deep pity that was directed at her; and yet she knew that these people had not the least idea of what was going on inside themselves, that they were completely unaware of why they turned to look at her, and had they been asked, they would have said they did it out of curiosity or some such similar motive.

She was astonished to learn that there was a secret, invisible bond uniting all men and that, without any physical awareness of the fact, their souls recognised and spoke to one another in imperceptible vibrations and in feelings that were too faint to be registered by the physical senses. Resentful, greedy, murderous, they were like predators struggling for existence; and yet it would perhaps have only taken a tiny rent in the curtain that veiled their eyes to turn the bitterest of enemies into the most faithful of friends.

The alleys she passed through were becoming emptier and eerier; she no longer felt any doubt that the next hours would bring something terrible – she assumed it would be death at the hand of a murderer – if she did not succeed in breaking the spell that drew her ever onwards; and yet she did not even try to fight it. Unresisting, she bore the alien will that compelled her to follow the path into the darkness, calm in her confidence that whatever should happen to her, it would be one more step towards her goal.

For a brief moment, as she was crossing an iron footbridge

over a canal, she saw the silhouette of St. Nicholas' through a gap between two gables, its two towers standing out from the horizon like a dark hand raised in warning. She gave an involuntary sigh of relief at the thought that it might only be Swammerdam calling to her with his heart in his sorrow for his friend Klinkherbogk.

The animosity that she sensed all around her told her that she was mistaken. The very earth gave off a dark malevolence which was directed against her: the icy, pitiless fury of nature towards any man who tries to cast off the bonds of his servitude.

For the first time since she had left her room, she felt afraid; she almost collapsed under the awareness of how completely defenceless she was. She tried to stop, but her feet carried her on, as if she had lost all power over them.

In her desperation she looked up to the sky and was deeply moved by the immense feeling of solace she drew from the sight of the host of stars, like a thousand eyes glittering threateningly down at the earth, the eyes of all-powerful helpers who would not suffer a hair of her head to be harmed. She remembered the greybeards in the hall into whose hands she had put her destiny and they seemed to her a gathering of immortals, who only needed to bat an eyelid for the world to crumble to dust.

And again she heard in her ear the strange, compelling guttural sounds; hoarsely, urgently, as if from very close, they urged her to hasten. Then suddenly in the darkness she recognised the crooked house in which Klinkherbogk had been murdered.

A man was sitting on the railing above the confluence of the canals. He sat motionless, leaning tensely forward as if he were listening for her approaching steps. Eva felt that it was from him that the demonic power emanated that had compelled her to make her way to the Zeedijk.

Even before she could make out his face, she knew from the mortal fear that paralysed her every limb and froze her blood, that it was the terrible Zulu that she had seen in the shoemaker's attic.

In her terror she wanted to scream for help, but the link be-

tween desire and action seemed to have been cut within her; her body was under another power. As if she had died and were outside her body, she saw herself stumble towards the man and stop right in front of him.

He raised his head and seemed to look at her, but his eyeballs were turned upwards, like someone sleeping with open eyes.

Eva realised that he was as stiff as a corpse and that she only needed to give him a push in the chest to send him tumbling backwards into the water. In spite of that, she was completely under his spell and incapable of doing it. She knew she would be defenceless before him when he awoke, and she could count the minutes that separated her from her fate: from time to time his face twitched with the first signs of the gradual return of consciousness.

She had often heard and read of women, particularly blondes, who were supposed to have succumbed to negroes in spite of the violent repugnance they felt; they said the untamed African blood exerted a spell over them which it was impossible to resist. Eva had never believed these explanations, and had regarded such women as low creatures who gave way to their animal instincts; but now, with an icy shudder, she recognised from what was happening within her that a dark force of that nature did indeed exist. Disgust and sensual pleasure were only apparent opposites, in reality the partition dividing them was thin and transparent and when it gave way a woman had no defence against the bestial instincts let loose within her.

What was it that gave this half animal, half human savage such inexplicable power, as he called to her from afar, that it drew her like a sleepwalker to him through strange alleyways? There must be chords within her that responded to his lust, although she, in her pride, had imagined she was free from them.

Did every woman feel the satanic power emanating from this negro, she asked herself, trembling with fear, or was she herself so much lower than all the others, who had not even heard his magic call, much less followed it?

She saw no hope of salvation. The bliss she had craved for her beloved and herself would be destroyed along with her body. Anything she could take with her over the threshold of death was

formless and incapable of giving her that which she desired. She had wanted to turn her back on the earth, but the earth spirit kept an iron grip on his own: the giant figure of the negro before her was the embodiment of its omnipotence.

She saw him shake off his trance and leap down from the railing. He grabbed her by the arms and pulled her to him. She screamed, and her cry for help echoed from the walls of the houses around, but he pressed his hand over her mouth so hard that she was almost suffocated.

Like a butcher's cur, he had round his neck a dark-red leather leash; she grasped it and held on tight so as not to be thrust to the ground. For a moment she managed to free her head. She gathered her last reserves of strength and screamed for help again.

It must have been heard, for she heard the crash of a glass door followed by a babble of voices; a broad glare of light illuminated the alleyway.

Then she felt the negro set off with wild leaps and bounds towards the shadow of St. Nicholas', pulling her along with him. Two Chilean sailors with orange sashes round their waists were already close on his heels, she could see the bare knives gleaming in their hands as their bold bronze faces drew nearer. Instinctively she held on tight to the negro's neckthong and dragged her feet behind so as to encumber him as much as possible, but he seemed scarcely to notice her weight; he jerked her up from the ground and rushed with her along the churchyard wall. Close before her she could see the fleshy lips around his bared teeth, like the jaws of some beast of prey, and the savage intensity of expression in his white eyes burned her senses, so that she froze as if hypnotised, incapable of any resistance at all.

One of the sailors had overtaken the negro and now threw himself, curled up like a cat, at his feet to trip him up, at the same time stabbing upwards at him with his knife; in a flash, the Zulu leapt up and his knee caught the sailor on the head, knocking him to the ground where he lay, his skull smashed.

Then Eva felt herself thrown over the wrought-iron bars of the churchyard gate and expected to crash to the ground, breaking every bone in her body; but her dress caught on the iron

spikes and through the bars she watched as the Zulu fought with his second assailant. It lasted only a few seconds; the sailor was thrown like a ball against a window in the wall of the house opposite which shattered in an explosion of glass and wood.

Quivering in fear of her life, Eva had freed herself from the spikes of the gate and tried to flee, but there was nowhere to go in the narrow garden behind the church. Like a hunted animal she crawled under a bench, but she knew that she was lost all the same: her light-coloured dress shone in the darkness and would surely give her away any moment.

With trembling fingers and scarcely able to think, she felt for the pin at her neck; she wanted to plunge it into her heart, for already the negro had vaulted over the wall, and she did not intend that he should take her alive. The last thing she could recall was her mute, desperate cry to God that she might find something with which she could kill herself before her tormentor found her. Then, for a sudden moment, she thought she must have gone mad, for there, in the middle of the garden, with a calm smile on her face, stood her own double.

The negro must have seen it as well; he halted in astonishment and then went over to it. She thought she could hear him talking to the apparition; she could not understand what was said, but his voice suddenly changed to that of a man paralysed by horror and hardly able to stammer a few words.

It must be an illusion! Perhaps the savage had already had his way with her and it had driven her mad! Nevertheless, she could not tear her eyes away from the scene. For a moment she became convinced she herself was the double and in some mysterious way the Zulu was in her power, and in the next she was desperately searching for the pin once more.

She made a supreme effort. She was determined to establish whether she had gone mad or not. She stared fixedly at the phantom and saw it disappear, as if her concentration had sucked it back into her body; it was like a magic part of herself that returned to her every time she strained her eyes to see it in the darkness. It was like a spectral breath that she could inhale and exhale at will, but each time it left, an icy tingling made her hair stand on end, as if Death were at her side.

The negro did not respond at all to the appearance and dis-
appearance of her double. Whether it was there or not, all the
time he muttered to himself, as if he were talking in his sleep.
Eva gradually realised that he had once more fallen into the
strange, trancelike state as when she had seen him sitting on the
canal railings.

Still trembling with fear, she finally plucked up the courage
to leave her hiding place. She could hear shouts and voices
approaching along the alley; the windows of the houses oppos-
ite reflected the bobbing gleam of the lanterns and the shadows
of the trees on the church wall were transformed into a line of
dancing ghosts.

She counted her heartbeats; now, now the crowd looking for
the negro must be close by! Her knees almost giving way, she
ran past him to the gate and gave a piercing cry for help. As she
fainted she was aware of the comforting figure of a woman in
a red dress kneeling beside her bathing her forehead; she was
saved.

A motley army of half-naked figures clambered over the
wall, blazing torches in their hands, gleaming knives between
their teeth; they seemed like fantastic, capering demons, sprung
from the ground to come to her aid. Flames flared up, bringing
the saints on the stained-glass windows of the church to life;
there was a hubbub of shrill Spanish oaths, "There's the nigger!
Slash his guts!"

She saw the sailors, yelling with fury, hurl themselves on the
Zulu, and she saw them fall to the ground, felled by the massive
blows of his fists, heard the spine-chilling shout of triumph that
rent the air as, like an unleashed tiger, he cut his way through
the pack of assailants, swung up onto a tree and then leapt with
enormous bounds from niche to niche, over the gables and onto
the roof of the church.

For a few brief seconds, as she was waking from a deep
swoon, she dreamt an old man with cloth round his forehead had
bent over her and called her name. She thought it was Lazarus
Egyolk, but then, through his features as if through a glass mask,
the face of the negro appeared, with the white eyes and fleshy
lips around his bared teeth, just as it had carved itself on her

memory while he carried her in his arms, until lashed by a witches' sabbath of feverish images, she lost consciousness once more.

Chapter Nine

After they had finished their dinner together, Hauberrisser stayed with Doctor Sephardi and Baron Pfeill for an hour, but he was poor company, monosyllabic and absentminded. His thoughts were constantly with Eva, and he started in surprise whenever one of the others addressed him. The solitude he had enjoyed in Amsterdam, and which he had found so refreshing, now seemed unbearable when he thought of the coming days and weeks.

Apart from Pfeill – and Sephardi, to whom he had felt attracted from the moment he had met him – he had no friends or acquaintances and he had long since broken off all connections with the land of his birth. Would he be able to endure the hermit's life that he had lived so far, now that he had found Eva?

He thought about moving to Antwerp, so that even if she did not want them to live together, at least they would be breathing the same air; perhaps that would also give him the opportunity of seeing her.

He still felt a stab of pain when he remembered how coolly she had expressed her decision to leave it to time and chance whether any kind of permanent union should develop between them. Then he would spend minutes in joyful intoxication at the thought of her kisses and that they were already united for ever. It would be his fault, and his alone, he told himself, if the separation lasted for more than a few days. What was there to stop him visiting her during the coming week, to suggest that they should continue to see each other? As far as he knew, she was completely independent and did not need to consult anyone about her decision.

But however clear and smooth the way to Eva appeared to him, when he took everything into account, he found that his hopes kept on coming up against a feeling of fear, an indefinable fear for Eva, that he had felt for the first time when they had said farewell. He kept trying to paint a rosy picture of the future, but never got beyond the first strokes; his forlorn attempts to ignore the 'No' that rang out in his breast in answer to his question to fate whenever he forced himself to imagine a happy end brought

him to the brink of despair.

He knew from long experience that, once they had been roused, there was no point in trying to drown out those inner voices threatening disaster with a certainty that was no whit diminished by its apparent lack of foundation in reality. Instead, he tried to lull them by telling himself that his concern was merely the natural consequence of his love. Nevertheless he could scarcely wait for the moment when he would hear that Eva had arrived safely in Antwerp.

He got out of the train together with Sephardi at Muiderpoort Station, which was nearer to the city centre than Central Station, accompanied him part of the way to the Herengracht, and then hurried to the Amstel Hotel to leave the bunch of roses, which Pfeill had given him with a smile, as if he had guessed his thoughts, at the porter's desk for Eva. There he was told that Juffrouw van Druysen had just left, but that if he took a taxi he might well reach the train before it went.

The taxi took him quickly to Central Station.

He waited. The minutes passed, but Eva did not come.

He telephoned the hotel; she had not returned there; perhaps he should enquire at the luggage counter.

Her cases had not been collected. The ground seemed to tremble beneath him.

Only now, in his all-consuming fear for Eva, did he realise the intensity of his love for her, and that he could not live without her. The last barrier between them, that slight feeling of not-yet-belonging-together that had come from the unusual way they had been thrown together, collapsed under the immensity of his anxiety for her, and he knew that if she were to appear before him now, he would take her in his arms and cover her with kisses and never let her go again.

Although there was scarcely any prospect of her arriving at the last minute, he waited at the station until the train set off. It was obvious that some accident must have happened to her. He had to force himself to remain calm. What route could she have taken? Not a minute was to be lost! If the worst had not already happened, then what was needed was a cool, clear appraisal of the situation, such as had almost always saved the day in his

former profession of engineer and inventor.

Straining his imagination to its limits, he made a desperate attempt to visualise any mysterious chain of events in which Eva might have been involved before she left the hotel. He tried to create within himself the mood of expectancy she had probably been in before she left. The fact that she had sent her luggage on ahead, instead of using the Hotel carriage suggested that she meant to visit someone on the way.

But whom? And at such a late hour?

He suddenly remembered that he had urged Sephardi to see how Swammerdam was. And Swammerdam lived in the Zeedijk district, a shady part of town if ever there was, as was obvious from the newspaper report of the murder! That was where she must have gone!

An icy shudder went down Hauberrisser's spine at the thought of the possible horrors she was exposing herself to amongst the unsavoury denizens of dockland. He had heard of taverns where strangers to the area were robbed, murdered and dumped through trapdoors into the canal; his hair stood on end at the thought that that might be happening to Eva.

Before he could follow this thought any farther, his taxi was racing across the Openhaven Bridge and screeching to a halt outside St. Nicholas'. The driver explained that he could not take him any farther in the narrow streets of the Zeedijk and suggested Hauberrisser went to the 'Prince of Orange' – he pointed to where then tavern lights shone across the street – and asked the landlord for the house he was looking for.

The tavern door was wide open and Hauberrisser rushed straight in; the place was empty, apart from one man standing behind the bar who gave him a shifty look. From the distance came the sound of raucous shouts, as if a street brawl were going on.

A tip elicited from the landlord the information that Swammerdam lived on the fourth floor; with ill grace he lit the way up the precipitous stairs.

"No, Juffrouw van Druysen has not been back here", said the aged lepidopterist with a shake of his head after Hauberrisser had given him a breathless account of his worries.

Swammerdam had not been in bed, he was fully dressed even. The single tallow candle on the empty table that was almost completely burnt down as well as his grief-stricken face told Hauberrisser that he had been sitting for hours in his room, pondering over the terrible death of his friend Klinkherbogk.

Hauberrisser took his hand. "Forgive me, Mijnheer Swammerdam, for descending on you in the middle of the night like this at a time – at a time when you would want to be alone with your sorrow. Yes", he added when he saw the old man's surprised look, "I know what a loss you have just suffered, I even know the details; Doctor Sephardi told me about it earlier today. If you would like, we can talk about that later, but at the moment I am going out of my mind with anxiety about Eva. What if she really did intend to visit you and was attacked on the way and – and – my God! It doesn't bear thinking about!"

Unable to keep still any longer, he leapt up from his chair and paced up and down the room.

Swammerdam thought hard for a while and then said with certainty, "Please don't think these are empty words, just said to comfort you, Mijnheer: Juffrouw van Druysen is not dead."

Hauberrisser swung round, "How do you know?" He could not have said why, but the old man's calm, firm voice had taken a great weight off his mind.

Swammerdam hesitated for a moment before answering.

"Because I would see her", he finally said softly.

Hauberrisser grabbed him by the arm. "I beg of you, help me if you can! I know that your whole life you have followed the path of belief; perhaps you can see more deeply than I. An uninvolved outsider can often see -"

"I am not as uninvolved as you imagine, Mijnheer", interrupted Swammerdam. "I have, it is true, only met Juffrouw van Druysen once in my life, but when I say I love her as dearly as if she were my daughter, I am not exaggerating in the least." He waved away Hauberrisser's protestations of gratitude. "Do not thank me, there is no reason. I will naturally do everything that is within my power, weak as it is, to help her and you, even if it means shedding my own, worthless blood. But please, now, be calm and listen carefully: You are certainly correct in your

feeling that some accident must have befallen Juffrouw Eva. She has not been to see her aunt, I would have heard from my sister who has just come back from the Béguine Convent. I cannot say whether we can do anything to help her – that is, to find her – tonight, but at least we will leave no stone unturned. But even if we do not find her, you should not worry: as sure as we are both standing here, I know that there is Another, compared to Whom we are as nothing, keeping watch over her. I prefer not to talk in riddles; perhaps the time will come when I can tell you what it is that makes me so certain that Juffrouw Eva followed the advice I gave her. What happened today is probably the first result of it.

Many years ago my friend Klinkherbogk also set off on the same course as she is on now. For a long time I have been inwardly aware of what the end would be, although I clung to the hope that it could be turned aside by fervent prayer. Last night has proved to me what I always knew, only was too weak to act upon: that prayers are only a means of forcing awake powers that sleep within us. To believe that prayers can make a god change his will, is foolishness. People who have submitted their destiny to the spirit within them stand under spiritual law. They have come of age. They are free from the tutelage of earth, over which one day they shall be lords. Whatever shall still befall them in their physical being, shall drive them onward; everything that happens to them is always the best that could happen.

You must believe, Mijnheer, that that is the case with Juffrouw Eva as well.

The hardest part is calling up the Spirit that is to guide our destiny. Only a person who has reached spiritual maturity can make his voice heard, and his cry must come from love and must be made for the sake of someone else, otherwise we only arouse the forces of darkness within us. In the Cabbala the Jews put it like this, 'There are beings from the lightless realm of Ov which catch prayers that have no wings'; by that they do not mean demons outside us, for our body is a bastion against them, but magic poisons within us which, when roused, can split the self."

"But then might not Eva", Hauberrisser interrupted feve-

rishly, "just as well be heading for disaster, like your friend Klinkherbogk?"

"No! Please let me finish. I would never have dared to give her such dangerous advice if at that moment I had not sensed the presence of the One of whom I said before, compared to Him both of us are as nothing. In the course of a long, long life, and through untold suffering, I have learnt to talk to Him and to distinguish His voice from the cajolings of human desires. The only danger was that Juffrouw Eva would call on Him at the *wrong* moment, but this moment of danger, the only one, is past, thank God. Her cry was heard", Swammerdam smiled happily, "just a few hours ago. Perhaps – I am not boasting, since I do such things in a state of complete trance – perhaps I have been fortunate enough to be of assistance to her already", he went to the door and opened it for his visitor, "but now we must follow the course common sense suggests. Only when we for our part have done everything within our earthly power, have we the right to expect help from spiritual influences. Let's go down to the tavern; you can give the sailors money to look for her and promise a reward for the one who finds her and brings her back safe; you'll see, they'll risk their lives for her, if need be. They are much better men than is generally believed; they are just lost in the spiritual jungle and are like wild animals. In each of them is a heroism many a respectable citizen lacks, only in them it appears as wildness, because they do not realise what the force is that drives them on. They are not afraid of death and no brave person can be really bad. The truest sign that a man bears immortality within him is that he is contemptuous of death."

They entered the tavern.

The taproom was jam-packed with people, and on the floor in the middle of them lay the corpse of the Chilean sailor with the shattered skull, whom the Zulu had knocked on the forehead with his knee as he fled.

"Only a brawl", was the landlord's evasive reply to Swammerdam's enquiry; they happened almost every day around the harbour.

"That bloody nigger yesterday –", broke in Antje, the waitress, but she did not finish the sentence; the landlord gave her

such a dig in the ribs that she swallowed the rest of her words. He screamed at her, "Shut your gob, you trollop! It was a *black stoker* off a Brazilian tramp steamer; get that straight!"

Hauberrisser took one of the ruffians to one side, slipped a coin into his hand and started to question him. Soon he was surrounded by a pack of rough figures, all gesticulating wildly as each tried to outdo the rest in descriptions of how they had thrashed the negro; there was only one point on which each and every one of them was agreed: it had been a *foreign stoker*. The landlord's warning looks and the way he cleared his throat made it clear to them that under no circumstances were they to give anything away that might lead the others to the Zulu. They knew that the landlord would not have lifted a finger if they had decided to knife a customer, even if it had been one of his free-spending regulars, but they also knew that it was the sacred law of the harbour tavern that all held together, even enemies, when the threat came from outside.

Impatiently Hauberrisser listened to their boasting until something was let slip that made his heart race; Antje mentioned that the negro had attacked a young lady – "very respectable she was."

He had to hold on to Swammerdam for a second, to stop himself collapsing on the spot, then he emptied the contents of his purse into the waitress' hand and, incapable of uttering a word, gestured to her to tell him what had happened.

They had heard a woman's voice screaming, they had run out – everyone started talking at once. "I 'eld 'er in my lap, she was out for the count", yelled Antje over the commotion.

"But where is she? Where is she?" exclaimed Hauberrisser.

The sailors fell silent and looked at each other in bewilderment, as if they had just become aware of what had happened: no one knew where Eva had disappeared to.

"She was on my lap", Antje kept on insisting, but it was clear from her face that she had no idea what might have happened to Eva.

Then they all rushed outside, Hauberrisser and Swammerdam among them, hunted through the alleys screaming "Eva! Eva!" and shone their torches in every corner of the churchyard.

"That's where the nigger went, up there", explained the waitress pointing to the green, glistening roof, "and I laid 'er down on the cobbles when I tried to follow 'im, then we took the corpse back inside and I clean forgot about 'er."

They knocked on the doors of the adjoining houses to see if Eva had perhaps taken refuge in one of them. Windows were pushed up, voices shouted down to see what it was all about – but of Eva there was no trace.

Weary and distraught, Hauberrisser promised everyone within earshot they could name their reward if they brought him any news at all of her. Swammerdam tried to calm him down, but in vain: the idea that in her despair at what she had been through – or possibly driven out of her mind and not knowing what she was doing – Eva might have committed suicide by throwing herself into the canal was more than he could bear.

The sailors ranged over the whole area, beyond the Prince Henrik Quay and all along the New Cut, and returned empty-handed. Soon the whole harbour area was on its feet; fishermen, still only half-dressed, rowed around with boats' lanterns, checking the wharfs and piers; they promised to drag all the canal outlets when it was light.

All the while Hauberrisser was afraid that Antje, who kept on recounting her story in a thousand variations, would tell him that the negro had raped Eva. The question burnt within him, but he could not bring himself to put it; finally he overcame his reluctance and, haltingly, indicated what was on his mind. The rabble around him, who had never stopped trying to comfort him with their descriptions, accompanied by the vilest oaths, of how they would chop up the nigger alive as soon as he was caught, were immediately silent, avoided his eye or spat vigorously on the pavement.

Antje was sobbing quietly to herself. In spite of a life spent amongst the most horrible filth, she was still woman enough to know how his heart was being torn to shreds.

Swammerdam alone remained calm and untroubled. The expression of unshakeable confidence on his face, and his gentle smile as he kept patiently shaking his head whenever anyone suggested Eva might have been drowned, gradually restored

Hauberrisser's hope, so that eventually he followed the old man's advice and let him take him home.

"You must lie down", Swammerdam told him when they reached his door, "and do not take your troubles to sleep with you. Our souls can do more than we imagine, when they are not disturbed by the worries of the flesh. Leave it to me to take any practical steps that are still necessary; I will report your fiancée's disappearance to the police, so that they can set up a search for her. I don't think anything will come of it, but we should do everything that common sense dictates."

On the way back home he had gently tried to divert Hauberrisser's thoughts, and the young man had told him of the roll of papers and the plans he had made to start studying it which would presumably be interrupted now for some time, if not for good. Swammerdam returned to the papers when he saw the old despair begin to reappear in Hauberrisser's face. He grasped his hand and held it for a long time. "I wish I could make you feel the same certainty that I have regarding Juffrouw Eva. Even if you had only a small portion of it, you would know what destiny requires of you. As things are, however, I can only give you some advice; will you follow it?"

"You can rely on that", promised Hauberrisser, suddenly moved at the memory of Eva's words in Hilversum, that Swammerdam with his living faith was capable of heights beyond any man. "You can rely on that. You radiate such strength that I sometimes feel as if a thousand-year-old tree were giving me shelter from the storm. Every word you utter helps me."

"I will tell you of a little incident", Swammerdam went on, "that once served as a signpost in my life, although it was apparently insignificant. I was still fairly young at the time and had just suffered such a bitter disappointment that the world seemed dark, seemed like hell. It was in this mood of bitterness at the way fate seemed to torment me pitilessly without, as I thought, any point or purpose, that one day I witnessed a horse being trained.

They had it on a long rein and were driving it round and round in a circle, without giving it a moment's rest. Every time it came

to a hurdle, which it was supposed to jump, it refused or swerved. For hours the lashes rained down on its hide, but still it would not jump. And yet the man who was tormenting it so was not a vicious person, indeed he was himself visibly distressed by the task he had to perform. He had an open, genial face, and when I protested, he said, 'I would willingly spend a day's pay on sugar-lumps for the nag, if it would only understand what I want it to do. But I've tried that method before, and it doesn't work. It's as if these animals had a demon in their brain that stops it working. And what I want the beast to do is so simple!' Every time the horse came to the hurdle I could see the glint of fear appear in its wild eyes and I knew what was going through its mind, 'The whip, the whip.' I racked my brains to see if I could not find some other way of making the animal understand. I tried to tell it, first by telepathy, later by shouting out loud, that it only had to jump and it would all be over. But my efforts were futile; to my sorrow, I had to acknowledge that it was only the terrible pain that would finally teach it its lesson. And as I came to that realisation, I saw in a flash that my situation was just like that of the horse: fate was lashing me with its whip, and all I was aware of was my suffering. I hated the invisible power that was tormenting me, but I had not understood that it was all being done so that I should learn to perform some task, take some spiritual hurdle, so to speak.

That little incident was a milestone on my road. I learnt to love the invisible forces that were whipping me onward, for I sensed that they would have given me 'sugar-lumps', if it were possible by that to lift me from the lower stage of mortality into a new state.

The analogy has, of course, a flaw", Swammerdam went on with a smile. "It is by no means certain that for the horse to learn to jump could really be called progress; it might have been better to leave it in its wild state. But I don't need to tell you that. The important thing for me was that until then I had lived under the delusion that my suffering was a punishment and had racked my brains trying to work out how I had earned it; now the blows of fate had meaning for me and, even though I could often not work out what the 'hurdle' was that I was supposed to 'jump', I was

a willing horse from that time on.

In that experience I suddenly understood the hidden meaning behind the verse in the Bible about the forgiveness of sins: when the idea of punishment disappeared, so did that of sin and the distorted *image* of God as a vengeful God was transformed into the *concept* of a beneficent power that wanted to teach me, as the man did the horse.

How often have I told others of this apparently insignificant incident, but how seldom has the seed fallen on good ground. Whenever they followed my advice, people always thought they could easily guess what the invisible 'trainer' expected of them, and if the blows of fate did not stop immediately, they slipped back into their old ways and bore their cross, either grumbling or, for those who took refuge in the self-deception of so-called humility, submissively. I tell you, anyone who has reached the stage when he can *occasionally* work out what those above – the name I prefer for them is 'The Great Inwardness' – want from him, is more than half-way to completing the task. The *willingness* itself means a complete revolution in our attitude to life; the *ability* to work out what is required is the fruit of that seed. But how hard it is to learn to work out what we should do.

At the beginning, when we make our first, hesitant attempts, it is like a mindless groping in the dark, and sometimes we do things that resemble the actions of a madman and for a long time seem to lack all consistency. It is only gradually that the chaos forms into a countenance, in whose varying expressions we can read the will of destiny. At first they are grimaces, but that is the way it is with all great matters. Every new invention, every new idea to appear in the world puts on a grotesque face as it develops. For a long time the first models for a flying machine were dragon-like gargoyles, before they became real faces."

"You were about to tell me what you thought I should do", said Hauberrisser, almost shyly. He surmised that the old man had only embarked on such a long digression because he was afraid that if he put his advice, which he obviously saw as of extreme importance, forward too soon, it might not be fully appreciated and be wasted.

"I was indeed, Mijnheer, and I shall. But I needed to lay a firm foundation first of all, so that you would find it less offputting when I advised you to do something which looks more like a breaking-off than a continuation of your present concerns. I know that at the moment you are filled with one desire alone: to search for Eva; that is very natural and understandable, and yet what you *must* do is to search for the magic power that will make it impossible for any misfortune ever to strike your bride again. Otherwise you might well find her, only to lose her for ever, just as people come together on earth, only to be torn apart by death.

When you find her, it must not be like finding something you have lost, but in a new way, and in a double sense. You told me yourself on our way here that your life has gradually become like a stream that is petering out in the sand. Everyone comes to this point at some time or other, although not always in each single existence. I know what it is like. It is like a death of the soul that spares the physical body. But precisely this moment is one of the most precious and can lead to victory over death. The earth spirit knows well that it is at such moments that it is in danger of being overcome by men and so that is when it sets its most cunning traps. Just ask yourself: what would happen if you were to find Eva at this very moment? If you have the strength to look the truth in the face, you must reply that the river of your life and of your bride would run in the same bed for a while, only to dry up for good in the sands of everyday routine. Did you not tell me that Eva was afraid of marriage? And it is because destiny wants to keep you from that that it brought you together and tore you apart within such a short time. In any other age than the present, when almost the whole of humanity faces an immense void, what has happened to you could have been merely one of life's grimaces, but *today* that seems out of the question.

I do not know what is in the roll of papers that came to you in such a strange manner, yet I advise you – I urge you – to let all practical matters take their course and seek what you need in the teachings that the unknown author wrote down. Everything else will come of its own accord. Even if, contrary to expectation, its teachings should turn out to be false and you

should only find the twisted features of the Deceiver grinning out at you, yet I believe you would still find in them what was right for you.

He who seeks aright cannot be deceived. There is no lie that does not contain an element of truth, only the seeker must be standing at the right point." Swammerdam quickly shook Hauberrisser's hand in farewell. "And it is today that you are at the right point. You are safe to reach out for those terrible powers which otherwise bring certain madness: today you are doing it for the sake of love."

Chapter Ten

The first thing Sephardi did on the morning after his visit to Hilversum was to go and see the police psychiatrist, Dr. de Brouwer, to find out what he could about the case of Lazarus Egyolk.

He was so firmly convinced that the old Jew could not be the murderer, that he felt it his duty to put a word in for his co-religionist, especially as Dr. de Brouwer had the reputation of being a poor observer who tended to jump to conclusions to a degree unusual even for a psychiatrist.

Although he had only met him once in his life, Sephardi felt a keen concern for Egyolk. The very fact that as a Russian Jew he belonged to a spiritual group of decidedly Christian mystics suggested that he must be a cabbalistic Hasid with more to him than met the eye, and Sephardi was extremely interested in anything to do with that strange sect.

He had not been wrong in his assumption that de Brouwer would come to the wrong conclusion. Hardly had he expressed his own conviction that Egyolk was innocent and that his confession was a result of hysteria than the psychiatrist – whose very appearance, with his flowing blond beard and 'kindly but penetrating gaze', betrayed the empty-headed scientific poseur – interrupted in his sonorous voice, "No abnormality has been diagnosed at all. Although I have only had the case under observation since yesterday, I have established that there are no signs at all of mental illness."

"So you think the old man is a thief and a murderer who knew what he was doing, and you are completely satisfied with his confession?" asked Sephardi in a neutral voice.

The expression in the doctor's eyes changed to one of exceptional shrewdness. He carefully positioned himself against the light, so that its reflection in the small, oval lenses of his spectacles would heighten his imposing, scholarly presence, and said in a low, conspiratorial tone, as if he had suddenly remembered that 'walls have ears', "It is out of the question that Egyolk is the murderer, but there is a plot and he is involved in it."

"Aha. And what makes you say that?"

Dr. de Brouwer leant towards him and whispered, "Certain features of his confession correspond to the actual facts, *ergo* he must be aware of them. He only confessed to being the murderer in order to avert suspicion of receiving stolen goods, at the same time giving his accomplices time to make good their escape."

"Do they already know how the crime was carried out?"

"Certainly. One of our most able detectives has reconstructed it from his confession: In a fit of ... of *dementia praecox*" (Sephardi suppressed a smile as he noted the expression) "Klinkherbogk stabbed his granddaughter to death with a shoemaker's awl, and immediately after, as he was about to leave the room, he himself was killed by an intruder and his body thrown out of the window into the canal. A crown of gold paper that he had been wearing was found floating on the water."

"And Egyolk described it in all that detail?"

"That's the whole point!" de Brouwer laughed out loud. "When they heard of the murder some people went to Egyolk's room to wake him and found him completely unconscious. He was shamming, of course. If he really had had nothing to do with the murder he could not have known that the little girl had been killed with a shoemaker's awl; and yet that is what he expressly said in his confession. That he also claimed that he himself was the murderer, well, that was just a rather obvious ploy to put the police off the scent."

"And how does he claim to have killed Klinkherbogk?"

"He claims he climbed up a chain that hangs down from the gable into the water. Klinkherbogk flung out his arms in joy and went to welcome him. He said he killed him by breaking his neck, but that's all nonsense, of course."

"You say he could not have known about the awl? Is there really no possibility that he heard about it from someone or other before he gave himself up to the police?"

"None whatsoever."

The more Sephardi thought about it, the less sure he became. His initial theory, that Egyolk had confessed to the murder in order to fulfil some imaginary mission as 'Simon the Cross-bearer', was no longer tenable. Assuming that the psychiatrist was telling the truth, how could Egyolk have known about the

awl? A suspicion formed in his mind that it must have something to do with unconscious clairvoyance, but it was difficult to see how that worked. He opened his mouth to suggest that the Zulu might be the murderer, but before the words passed his lips he felt such a violent jolt from inside himself, that he remained silent. Although it was almost like physical contact, he did not dwell on it, but asked whether he would be permitted to speak to Egyolk.

"I shouldn't allow it, really", said Dr. de Brouwer, "especially since you were with him at Swammerdam's shortly before the events, as the police well know. But if it means so much to you – and in view of the high reputation you enjoy as a scholar throughout Amsterdam", he added with a hint of envy, "I am quite happy to overstep my authority."

He rang for a warder to take Sephardi to the cell.

As could be seen through the spyhole in the wall, the old Jew was sitting by the barred window looking up at the sun-drenched sky.

When he heard the door open, he stood up. Sephardi went quickly over to him and shook his hand. "I have come to see you, Mijnheer Egyolk, firstly because I felt it was my duty as a fellow Jew -"

"Fellow Jew", murmured Egyolk respectfully, and made a bow.

"– and secondly, because I am convinced that you are innocent."

"Are innocent", echoed the old man.

"Perhaps you do not trust me", Sephardi went on after a pause, since the old man remained silent. "Do not worry, I come as a friend."

"As a friend", repeated Egyolk mechanically.

"Or do you not believe me? That would be a pity."

The old Jew slowly rubbed his forehead, as if he were only now waking up. Then he placed his hand on his heart and said haltingly, taking care to pronounce each word separately and as clearly as possible, "I – have – no – enemy. – Why should I? – You tell me you come as my friend; would I have the chutzpah to doubt your word?"

"Good. I'm glad. That means I can talk quite openly to you, Mijnheer Egyolk." Sephardi took the chair he was offered and sat down where he could observe the old man's expression as clearly as possible. "I want to ask you various questions, but not out of idle curiosity. You are in a dreadful situation, and you need help."

"Need help", muttered Egyolk to himself.

Sephardi paused deliberately for a while and carefully observed the old man's face, which was turned fixedly towards him and showed not the slightest trace of emotion. One glance at its deep furrows told him that here was a man who must have suffered terribly in the course of his life; and yet, in a strange contrast, his wide-open, jet-black eyes had a childlike glow, such as he had never seen in a Russian Jew. He had not noticed all that in the sparse light of Swammerdam's room. Then he had merely seen in the old man a zealot who tormented himself out of an excessive sense of piety. The man before him seemed someone completely different.

His features were not broad, nor had his face the rather repulsive expression of cunning that is often characteristic of the Russian Jews. Every line in his face suggested a powerful mind, though at the moment it had a frighteningly vacant look.

It was a mystery to Sephardi how this mixture of childlike innocence and decaying senility managed to run a liquor shop in such a shady district.

He began his interrogation in a friendly tone. "Can you tell me what gave you the idea of pretending to be the murderer of Klinkherbogk and his granddaughter? Was it to help someone?"

Egyolk shook his head. "Who would it have helped? I did kill them."

Sephardi pretended to accept this. "And why did you kill them?"

"Why? For the thousand guilders."

"And where is the money now?"

"The *gaon* with the beard asked me that before." Egyolk jerked his thumb towards the door, "I don't know."

"Are you not sorry for what you've done?"

"Sorry?" The old man thought. "Why should I be sorry? I couldn't help it."

Sephardi was puzzled. That was not the answer of a madman. He said, as lightly as possible, "Of course you couldn't help it, because you didn't do it at all. You were asleep in bed and just imagined it all. You didn't climb up the chain, that was someone else; at your age you couldn't do something like that, anyway."

Egyolk hesitated. "You mean to say, sir, that I'm not the murderer at all?"

"Of course you're not! It's perfectly obvious."

Again the old man thought for a minute, then he muttered calmly, "Well then, that's all right then." There was not the slightest trace of joy or relief in his face, not even surprise.

Sephardi found the matter more and more puzzling. Had some shift of consciousness taken place, it would have been visible in the expression in Egyolk's eyes, which still gazed out with the same childlike innocence, or on his face. The idea of deliberate deception was out of the question; the old man had registered the fact that he was not a murderer as if it were hardly worth mentioning.

"And do you know what they would have done to you, if you had really murdered him?" asked Sephardi insistently. "Executed you, that's what they would have done!"

"Hm. Executed me."

"Yes. Doesn't the idea frighten you?"

Obviously the question made no impact whatsoever on the old man; if anything, his expression became a shade less thoughtful, as if brightened up by some memory. Then he shrugged his shoulders and said, "Much more terrible things have happened to me, Doctor Sephardi."

Sephardi waited for him to go on, but Egyolk had sunk back into his corpse-like repose once more.

"Have you always run a liquor store?"

A shake of the head.

"How is your business going? Well?"

"I don't know."

"But listen, if you show such little interest in your business, you might one day suddenly find that you have lost everything."

"Of course; if I don't watch out", was the simple-minded answer.

"Who watches out? You? Or have you got a wife? Or children? Do they watch out?"

"My wife died, long ago. And – and the children too."

Sephardi thought he had found the door to the old man's heart. "Don't you think of your dear family sometimes? I don't know how long it is since you lost them, of course, but you must feel lonely and that can't make you happy. You see, I have no one to care for me, either, so I can very easily understand how you feel. Really, I'm not just asking out of curiosity, or to find out what it is that makes you tick" – he was gradually forgetting why he had come – "I am asking purely out of sympathy –"

"– and because you can't help it, because that's how you feel, nebbich", Egyolk added, to Sephardi's great astonishment. For a moment he was transformed; a flash of pity and deep understanding lit up the face that until now had been completely expressionless. A second later it was once more the empty sheet it had been all along, and Sephardi heard him mutter absent-mindedly to himself, "Rabbi John said: to bring together a true couple from among mankind is more difficult than Moses' miracle in parting the Red Sea." At once he realised that, if only for a brief second, the old man had shared his pain at the loss of Eva, of which at that moment he had not been conscious himself.

He remembered there was a legend among the Hasidim that there were people in their community who gave the impression of being mad, but yet were not. Divested for a time of their own personalities, their hearts could feel the joys and sorrows of their fellow men as if they were their own. Sephardi had assumed it was a myth, but could this confused old man really be the living proof? If that were indeed the case, then his behaviour, his delusion that he had killed Klinkherbogk, his actions, in short, everything appeared in a new light.

His interest aroused, he asked, "Can you remember, Mijnheer Egyolk, whether it has ever happened before that you imagined you had done something, and it turned out later that another had done it?"

"I've never bothered about that."

"But perhaps you are aware that you think and feel in a different way from your fellow men, from me, or from your friend Swammerdam, for example? The other evening, when we first met, you were not taciturn like this, you were quite lively. Is it Klinkherbogk's murder that has had this effect on you?" Sephardi grasped the old man's hand in commiseration. "If there is anything worrying you or if you need a rest, you can confide in me, I will do all I can to help you. And I don't think that liquor store is the right thing for you. Perhaps we will be able to find a different occupation that is more worthy of you. Why reject a friendship when it is offered?"

It was clear to see that his friendly words did the old Jew good. He gave a delighted smile, like a child who has been praised, but he seemed to have no comprehension of what was being offered him. A few times he opened his mouth, as if to thank Sephardi, but apparently could not find the words.

"Was – was I different then?" he finally brought out haltingly.

"Certainly. You spoke at length to us all. You were more human, so to speak; you even had an argument with Mijnheer Swammerdam about the Cabbala. It showed me that you had thought much about questions of religion and God -" Sephardi broke off when he saw a change appear on the old man's face.

"Cabbala – Cabbala", murmured Egyolk. "Yes, of course I've studied the Cabbala. For a long time. And Babli, too. And – and Jeruschalmi." His thoughts started to wander back into the distant past; he spoke like someone pointing to pictures and explaining them to another, now slowly, now quickly, according to the speed with which they passed through his memory. "But what they say in the Cabbala – about God – it's wrong. The living truth is quite different. All those years ago ... in Odessa ... I didn't know then. In the Vatican ... in Rome ... I had to translate from the Talmud ..."

"You have been to the Vatican", Sephardi exclaimed in astonishment.

The old man ignored him.

"... and then my hand withered." He raised his right arm: gout had turned the fingers into gnarled roots. "In Odessa the Greek Orthodox thought I was a spy and in league with the Roman

goyim, and suddenly there was a fire in our house, but Elijah, his name be praised, preserved us; we were not killed, we just lost the roof over our heads, my wife Berurje and me and the little ones. Later Elijah came and sat at my table, after the Feast of the Tabernacles. And I knew it was Elijah, though my wife said it was Chidher Green."

Sephardi started. The name had been mentioned in Hilversum the previous day, when Baron Pfeill had recounted Hauberrisser's story!

"People always laughed at me, and when my name cropped up, they would say, 'Egyolk? He's just a nebbich; he's weak in the head.' They didn't know that Elijah was teaching me the double law that Moses handed down by word of mouth to Joshua" – his face was transfigured by a rapturous glow – "or that he changed round the two obscuring lamps of the Makifim within me. Then there was a pogrom in Odessa. I tried to take the blows, but they struck Berurje, so that her blood flowed over the ground while she was trying to protect the children as they were cut down one after the other."

Sephardi leapt up, holding his hands over his ears and staring in horror at Egyolk, whose smiling face showed not the least trace of emotion.

"My eldest daughter, Ribke, screamed to me for help when they attacked her, but they held me down. Then they poured kerosene over my child and set her alight."

Egyolk stopped and examined his caftan reflectively, pulling threads from the fraying seams. He seemed to be in his right mind and yet not to feel any pain, for after a while he went on in a steady voice. "Later on, when I tried to study the Cabbala again, I couldn't any more because the lamps of the Makifim had been changed round inside me."

"What do you mean by that?" asked Sephardi, his voice trembling. "Did your terrible grief unhinge your mind?"

"Not the grief. And my mind is not unhinged. It is just as they say about the Egyptians, that they have a potion which makes you forget. How else could I have survived it. For a long time I didn't know who I was, and when that came back to me I had lost whatever it is that makes men cry and some other things as

well, that we need for thinking. The Makifim have been changed round. Since then I have – how shall I put it? – I have my heart in my head and my brain in my breast. Some times more than others."

"Could you tell me more about that?" Sephardi asked in a gentle voice. "But, please: only if you want to. I don't want you to think I'm asking out of idle curiosity."

Egyolk took hold of his coat-sleeve. "See, sir, if I pinch the cloth, you don't feel any pain, do you? Whether it hurts the sleeve, who can tell? That's how it is with me. I know that something has happened that should hurt me, I know that quite well, but I feel nothing. Because my feeling is in my head. And now, whenever anyone tells me anything, I can't question it any more, as I could when I was younger in Odessa; I must believe it because my thought is in my heart now. I can't work things out any more, either. Either something occurs to me, or nothing does; if something occurs to me, then it really is so, and it is all so clear that I cannot say whether I was there or not. So I don't even try to think about it."

Sephardi began to understand how it had come to his confession to the police. "And your work? How do you manage to do that?"

Egyolk pointed to his coat-sleeve again. "Your clothes protect you from the wet when it rains and from the heat when the sun shines. Whether you think about it or not, the clothes do it automatically. It's my body that looks after the store, only I don't know anything about it any more. Didn't Rabbi Simon ben Eleassar say, 'Have you ever seen a bird that had learnt a trade? And yet they feed themselves without toil; and why should I not be able to feed myself without toil?' Of course, if the Makifim within me had not been changed round, I would not be able to leave my body to fend for itself, I would be fixed to it."

This clear, logical speech made Sephardi sit up and subject the old man to a searching look, and he saw that he appeared no different from a normal Russian Jew: he gesticulated with his hands as he spoke and his voice had taken on a penetrating whine. He seemed to slip without transition from one very different mental state into another.

"Of course, men can't do that kind of thing on their own", Egyolk went on pensively. "All your studying, and praying, and the Mikvot – the ritual baths – is no use at all. We can't do it, not unless one from the other side has changed round the lamps within us."

"So you think it was one from 'the other side' who did it?"

"Of course; Elijah the Prophet, as I said before. One day he came into our room, and before I saw him I could tell from his footsteps that it was he. When I used to think that one day he might come to visit us – you know that we Hasidim live in constant hope of him – I thought I would tremble all over at the sight of him. But it was all quite natural, just as if it were any Jew coming through the door. My heart didn't even beat faster. However hard I tried to make myself think I might be wrong, I found it impossible. I couldn't take my eyes off him, and his face became more and more familiar, until I suddenly realised *that not a single night in my life had gone without my seeing him in my dreams*. I gradually went back through my memory (I wanted to find out when I had seen him for the first time), and my whole childhood seemed to unroll before my inner eye: I saw myself as a tiny baby, and then before that, as a grown-up in a previous existence that I had never suspected, and then as a child and so on and so on; but every time he was with me, and every time he was the same age and looked the same as the visitor at my table. So of course I kept a sharp eye on his every movement; if I had not known it was Elijah, I would not have noticed anything particular, but because I did, I sensed that every one of his actions had a deep meaning. Then, whilst he was talking, he swapped over the two candlesticks on the table, and I could feel him moving the lights inside me, and from that time on I have been a different man, a *meshuggenah*, as we Jews say. Why he changed round the lights inside me, I only learnt later, when my family was slaughtered. You wanted to know why Berurje thought his name was Chidher Green? She said he told her."

"Did you never meet him afterwards?" asked Sephardi. "I thought you mentioned that he instructed you in the Merkabah; by that I mean the secret second law of Moses?"

"Meet him?" repeated Egyolk, and rubbed his forehead, as if

he needed time to work out what was being asked of him. "Meet him? Once he was with me, why should he ever leave me? He is always with me."

"And you see him constantly?"

"I don't see him at all."

"But you said he was always with you. What do you mean by that, then?"

Egyolk shrugged his shoulders. "You cannot understand it by reason, Doctor Sephardi."

"But could you not give me an example? Does Elijah talk to you when he instructs you, or what does he do?"

Egyolk smiled. "When you're happy, is happiness there with you? Yes, of course it is. But you can't see or hear your happiness. *That* is what it's like."

Sephardi was silent. He realised there was a gulf in understanding between himself and the old man that could not be bridged. When he thought about it, much of what he had just heard from Egyolk corresponded to his own theory about the spiritual evolution of the human race; he himself had always tended towards the view – and argued it, most recently the previous day in Hilversum – that the way forward lay in religions and in belief in them. But now, confronted with a living example in the person of the old man, he felt surprised and at the same time disappointed by the reality. He had to admit that Egyolk, through the fact that he was no longer subject to fear, was infinitely richer than his fellow creatures; he envied him his state, and yet he would not have wanted to change places with him.

He was struck with doubt as to whether, after all, what he had said the previous day in Hilversum about the path of weakness and of waiting for salvation was right. Surrounded by a luxury of which he did not avail himself, he had spent his life in solitude, pursuing various studies, cut off from his fellows; now it seemed to him that there was much that he had overlooked, and that he had missed the most important part.

Had he truly longed for the coming of Elijah, like this poor Russian Jew? No, he had only imagined he longed for it, and it was through *reading* that he had learnt that longing was essential for an inner awakening. Now here was a man before him

who had *experienced* the fulfilment of his longing, and he, Sephardi, the master of book-learning, had to admit that he would not like to change places with him.

Humbled, he resolved that he would take the first opportunity to tell Hauberrisser, Eva and Baron Pfeill that in reality he knew as good as nothing, that he now subscribed to what a half-demented Jewish liquor merchant had said about spiritual experiences: "You cannot understand them by reason."

"It is like crossing over into the realm of abundance", Egyolk went on after a pause, which he had spent smiling blissfully to himself. "It is not a coming home, which is what I had always believed, but then everything a person believes is wrong, as long as the lights inside him have not been changed round, so completely wrong that we cannot comprehend it. We hope that Elijah will come and then, when he does come, when he's there, we see that he has not come at all, but that we have gone to him. We think we are taking, whereas instead we are giving. We think we are standing still and waiting, whereas instead we are searching. Man travels, God stands still. Elijah came into our house; did Berurje recognise him? She did not go to him, so he did not come to her; she thought he was another Jew who was called Chidher Green."

Deeply moved, Sephardi looked into the old man's radiant, childlike eyes. "Now I can understand very well, what you mean, even if I cannot feel it as you do, and I thank you. I wish I could do something for you. I can certainly promise to have you set free, it should not be difficult to convince Dr. de Brouwer that your confession has nothing to do with the murder. However", he went on, more to himself, "I'm not quite sure yet how I'm going to explain it to him."

"Could I ask you a favour, Doctor Sephardi?" interrupted Egyolk.

"Certainly. Of course."

"Don't tell the man out there anything. Let him believe I did it, just as I believed it myself. I would not like to be responsible for the murderer being found. I know now who it was. This is just for your ears, mind: it was a black man."

"A negro? What makes you suddenly say that?" said

Sephardi in astonishment and momentarily filled with suspicion.

"It is like this", explained Egyolk calmly: "Whenever I have been completely united with Elijah in dreamless sleep and then come partly back into life in my liquor store, and something has happened in the meantime, I often think I was there and did it myself. If, for example, someone has beaten a child, I think I beat it and have to go and comfort it; if someone has forgotten to feed the dog, I think it was I who forgot and I have to take it its food. Later on, if by chance I learn somehow that I was wrong, I only need to be fully united with Elijah again for a moment and then come straight back again, and I know straightaway what really happened. I don't do that very often, because there's no point, and because even partial separation from Elijah makes me feel as if I were blind; but just now, while you were thinking, I did it, and I saw that it was a black man who killed my friend Klinkherbogk."

"How ... how could you *see* that it was a negro?"

"Well, in my mind I just climbed up the chain again, only this time I watched myself and I saw it from outside: I was a black man with a red leather thong around my neck, no shoes and a blue linen suit. And looking at myself in my mind's eye, I knew that I was a savage."

"But Dr. de Brouwer really ought to be told", exclaimed Sephardi, standing up.

Egyolk grabbed him by the sleeve, "You promised not to say a word, Dr. Sephardi. For Elijah's sake, blood must not be spilt. Revenge is mine. And then -", the old man's friendly face suddenly took on a threatening, fanatical look, as of an Old Testament prophet, "– and then, the murderer is one of our people! Not a Jew, as you might be thinking", he explained when he saw the bewildered look on Sephardi's face, "but still one of our people. I realised it when I saw him just now in my mind's eye. He's a murderer? Who is to judge? You and I? Revenge is mine. He is a savage and has his own faith. God forbid that many men should have such a cruel faith as he has, but it is a true, a living faith. That's what I mean by our people, those who have a faith which does not melt in God's furnace, Swammerdam, Klink-

herbogk and the savage too. Jew, Christian, heathen – what is the difference, they are all names for people who have a religion instead of a faith. And that is why I forbid you to tell them what you know about the black man. If I am to suffer death for his sake, who are you to take such a gift away from me?"

It was a much affected Sephardi who made his way home from the prison. He could not get over how strange it was that, within his own lights, Dr. de Brouwer had not been so far wrong with his silly remark that Egyolk was involved in a plot and had confessed in order to gain time for the real murderer. Each individual assertion was correct and represented the *naked* truth, and yet de Brouwer could not have been more wrong in his assumption.

It was only now that Sephardi fully understood Egyolk's words, "As long as the lights within him have not been changed round, everything a man believes is wrong, however correct it might be, so completely wrong that it is beyond comprehension. You think you are giving, and instead you are taking; you think you are standing still and waiting, whereas instead you are travelling, searching."

Weeks passed, but nothing was heard of Eva. Pfeill and Sephardi heard the terrible news from Hauberrisser and did everything humanly possible to find her; soon every available wall was covered with descriptions of the missing woman and appeals for information, so that the case quickly became common gossip among both locals and tourists.

In Hauberrisser's flat there was a constant coming and going, people crowded outside the house and for each one that left, two more entered; everyone claimed to have found something which could well have belonged to the missing woman, for there was a large reward offered for the least bit of news of her.

Rumours that she had been seen here or there spread like wildfire, anonymous letters, written by malicious or deranged citizens, accused innocent people of having abducted Eva, of holding her captive; mediums offered their services by the dozen; clairvoyants that no one had ever heard of popped up claiming powers they did not possess: the soul of the teeming city which, until then, had seemed harmless enough, revealed itself in all its baseness, with its lust for gossip and gold, its self-importance and petty vengeance.

Some of the reports had a ring of truth, and Hauberrisser, tossed between hope and despair, spent hours chasing round with the police, checking houses where someone had said Eva was being kept. Soon there was no street, alley or square in which, misled by false information, he had not turned one or more houses upside down in his search for Eva. It was as if the city were taking its revenge on him for his earlier indifference.

In his dreams at night he saw the faces of the hundreds of people he had spoken to during the day, all screaming at him that they had news of Eva, until they dissolved into an amoeba-like grimace, as if a mass of transparent photographs were piled on top of each other.

His only comfort during these dreary weeks and months was the fact that Swammerdam came to see him early each morning. Even though he brought nothing new, even though he shook his head every time Hauberrisser asked him whether he had heard

anything about Eva, the old man's unshakeable confidence gave him the strength to face the trials of each new day. No mention was made of the roll of papers, and yet Hauberrisser felt that that was the main reason why Swammerdam came to visit him. One morning, however, the old man could restrain himself no longer. He did not look at Hauberrisser as he spoke,

"Do you still not realise that a horde of hostile, alien thoughts is attacking you, is trying to make it impossible for you to reflect calmly on matters. If it were a swarm of angry wasps defending their nest against you, you would know what it was straight away and take action; why do you not defend yourself against the cloud of hornets destiny has sent buzzing round your soul?"

He stopped abruptly and went out.

Ashamed of his inaction, Hauberrisser pulled himself together. He wrote a note for the housekeeper to fix to the door, saying that he had gone away and that any communications concerning the case of Eva van Druysen should from now on be sent to the police. That was not enough, however, to restore his inner calm; every five minutes he had to repress the desire to go and tear the note down.

He took out the roll and tried to compel himself to read, but after every line his thoughts wandered off to Eva and when he tried to force them to concentrate on the paper, they whispered to him that it was foolish to waste his time poring over musty parchments full of abstruse theories when every minute was screaming for action.

He was about to put the document back in his desk when he was so overcome with a sudden and strong feeling that he was being duped by some invisible power, that he stopped a moment for reflection. Actually, it was more listening than reflection:

'What is this strange, enigmatic power', he wondered, 'that seems so innocent and conceals its separate existence from me by behaving as if it were my own inner self, and makes my will choose the opposite of what I decided to do a moment earlier? I want to read and yet am not allowed to?' He leafed through the pages, and every time he came across a difficulty in making sense of their contents, the insistent thought returned, 'Leave it alone; you don't know where to start; it's a waste of time', but

he set a sentinel outside his will and barred the entry to the thought. His old habit of observing himself slowly started to reassert itself.

'If I only knew where to start!' Self-deception reared its head once more, giving a hypocritical sigh as he mechanically turned the pages, but this time the sheaf of papers itself provided the right answer. He started reading a sentence at random and gave a gasp of surprise at the coincidence that he should light on precisely these words:

"The beginning is what men lack. It is not that it is so difficult to find it; the great obstacle is the delusion that we must *seek* it. Life is merciful; every moment it grants us a beginning. Every second brings the question, 'Who am I?', but we do not ask it, and that is the reason why we cannot find the beginning.

But when we once ask it in earnest, then the day will dawn which by evening will see the death of those thoughts that have broken into the command centre and suck the blood of our souls.

Like a colony of industrious polyps, they have, over the millennia, built up a reef where they live and move and have their being: we call it 'our body'; first of all we must make a breach in this reef of flesh and bone and then dissolve it back into the spiritual essence it was at the very beginning, if we want to escape out into the open sea. Later I will teach you how to make a new shell from the remains of the reef."

Hauberrisser put the page down for a moment to reflect. He was not in the least interested in whether this page was the copy or draft of a letter that the author had sent to someone; he was gripped by it as if it were directed at him alone and that was the spirit in which he intended to read it.

One thing in particular struck him: what was written down here sounded almost like a speech, sometimes from the lips of Pfeill or Sephardi, sometimes from Swammerdam's. He realised now that all three of them breathed the same spirit as this roll of papers exuded, and that, in order to make a true man of the tiny, helpless, worldweary Hauberrisser, the stream of time was making them almost into double figures.

"But now hear what I have to say to you:
Arm yourself for the time that is to come!

Soon the world's clock will strike twelve; the number on its dial is red, is dipped in blood, and by that you will recognise it.

And a stormwind shall precede the new first hour.

Be watchful, that you are not sleeping when it comes, for those that cross over into the new dawn with their eyes closed will for ever be the animals they were before; never more can they be wakened.

There is a spiritual equinox and the new dawn of which I speak is the turning point when the Light shall be equal to the Darkness.

For a thousand years and more men have learnt to understand the laws of nature and put it to their service. Happy are they that have understood the *meaning* of this labour, namely that the spiritual laws are the same as the physical laws, only an octave higher, for they shall enjoy the fruits of their labour whilst the others continue to toil, their faces turned towards the earth.

The key to power over spiritual nature has been rusting since the flood. It is: wakefulness.

Wakefulness is all.

Man thinks himself secure in his belief that he is watchful and yet, in truth, he is caught in a net he has woven himself from sleep and dreams. The more closely meshed the net, the stronger the power of sleep; those that are caught in it are they that sleep, that go through life like the lamb to the slaughterhouse, un-knowing, uncaring, unthinking.

The dreamers among them see the world split into segments by the meshes of the net; all they see are misleading scraps and they act upon them, not knowing that these images are merely meaningless parts of a mighty whole. These 'dreamers' are not, as perhaps you think, the poets and visionaries, but the active ones of the earth, never idle, never resting, eaten up with the worm of industry; they are like busy, ugly beetles climbing up a smooth pipe: when they reach the top, they fall into it.

They think they are awake, but in reality their life is all a dream, a dream that is predetermined down to the last iota, and that they cannot influence at all.

There were – and there still are – a few among men who *knew* very well that they were dreaming, pioneers who reached the

ramparts, behind which the eternally wakeful spirit is hidden: visionaries such as Goethe, Schopenhauer and Kant. But they did not possess the weapons necessary to storm the stronghold, and their war-cry did not wake the sleepers.

Wakefulness is all.

The first step towards it is so simple that any child can take it; only the over-educated have forgotten how to walk and are lame in both feet because they refuse to let go of the crutches they inherited from their forefathers.

Wakefulness is all.

Be watchful in all that you do. Think not you are already so. No, you are asleep and dreaming.

Stand firm, gather up your thoughts and force yourself for one single moment to send the sensation coursing through every fibre of your body, 'now I am awake.'

If you manage to feel that, then you will recognise that before you were drugged with sleep.

That is the first, faltering step on the long road from slavery to omnipotence.

It is the road I take and each new awakening takes me farther forward.

It gives you power over all thoughts that torment you; they are left behind and cannot reach you; you tower above them, as the crown of the tree soars above the dry brushwood round the bole.

When you reach the stage where the wakefulness takes hold of your body as well, pain will drop away from you like withered leaves.

The ice-cold baths of the Jews and Brahmins, the night-long vigils of the disciples of Buddha and the Christian ascetics, the tortures the Indian fakirs underwent to stop themselves falling asleep, they are all externalised rites; like fragments of columns, they tell the searcher: here in the dim and distant past stood a mysterious temple to wakefulness.

Read the sacred books of the peoples of the earth: like a thread running through them all is the hidden teaching of wakefulness. It is the ladder of Jacob, who wrestled for the whole 'night' with the Angel of the Lord until the 'day' came

and he prevailed over him.

Sleep, dream and stupor are the armoury of Death; if you would overcome Death, you must ascend rung by rung into ever brighter states of wakefulness.

The very lowest rung of this ladder, that reaches up to heaven, is called 'genius'; what names shall we find for the higher ones! They are unknown to the common mass of people, they are assumed to be legends. But the story of Troy was for centuries thought to be a legend, until finally someone found the courage to dig.

The first enemy you meet on the road to wakening will be your own body. It will fight you until the first cockcrow; but if you should see the dawn of eternal wakefulness, which will remove you from the company of the eternal somnambulists, who believe they are men and know not that they are sleeping gods, then for you the sleep of the body will be gone and the universe will be subject to you.

Then you will be able to perform miracles, if you want; no longer will you be like a snivelling slave, awaiting the pleasure of a cruel idol, to reward you or to chop off your head.

There is, though, one comfort that will be denied you: the comfort of the faithful, tail-wagging hound, who knows he has a master whom it is his privilege to serve; but ask yourself, would you, as the man you are now, change places with your dog?

Do not let yourself be put off by the fear of failing to reach your goal in *this* life. Anyone who has once started out on our road will keep coming back to earth on an inner journey which will permit him to continue his work: he will be reborn as a 'genius'.

The path that I show you is strewn with miraculous experiences: dead friends you knew during your life will rise again before you and talk with you. They are but images! Beings of light, wreathed in a blissful radiance, will appear to you and bless you. They are but images, formed of the exhalations of your body as, under the influence of your transformed will, it dies a magic death and turns from matter into spirit, just as the hard ice, under the influence of heat, dissolves into ever-

changing cloud-shapes.

Only when you have purged your body of all trace of the corpse can you say, 'Now sleep has left me for all time'.

Then will the miracle be complete that men cannot believe, because they are deceived by their senses and cannot understand that matter and force are the same; the miracle is that, even if you are buried, there will be no corpse in the coffin.

Only then, and not before, will you be able to distinguish what is of the essence from mere appearances; anyone you meet *then* can only be one who has taken the path before you. All others will be shadows.

Until then at every step it will be uncertain whether you are to become the happiest or the unhappiest of beings. But fear not, none who have trodden the path of wakefulness have ever been abandoned by the guides, even if they have gone astray.

There is a sign I will give you by which you shall know whether a vision you have is of the essence or a delusion: if it should appear to you and your mind is clouded, and the things of the physical world seem unclear or invisible, then trust it not. Be on your guard. It is part of you. If you cannot understand the metaphor concealed within it, then it is only a ghost and without substance, a spectre, a thief that sucks out your life from you. The thieves that steal the strength from your soul are worse than earthly thieves. Like will-o'-the-wisps, they tempt you into the marshes of false hope, to leave you behind in the darkness and disappear for ever.

Do not let yourself be blinded, not by any miracle that they appear to perform for you, nor by any sacred name they adopt, nor by any prophecy they pronounce, not even if it should be fulfilled: they are your mortal enemies, spewed out from the hell of your body, and you are wrestling with them for mastery. Know, now, that the miraculous powers they possess are your own, which they have wrested from you in order to keep you enslaved. They can only live by preying on *your* life, but if you can conquer them, they will be reduced once more to mute, obedient tools, which you can use at your will.

Countless are the victims which they have claimed among mankind; look at the history of visionaries and sects, and you

will see that the path of self-control that you are following is strewn with skulls.

Unaware of what it was doing, mankind built a wall to keep these visions out: materialism. This wall is an impregnable defence; it is built in the image of the body, but it is also a prison wall that blocks the view outside.

Today, as this wall is slowly crumbling, allowing our inner life to rise on new wings like a phoenix from the ashes, in which for centuries it lay as if dead, the vultures of another world are also stretching their wings. So beware. Only the balance in which you weigh your mind can tell you whether the visions you see are ones you can trust; the more awake it is, the more the scales are being tipped in your favour.

If a guide, a helper or a brother from a spiritual world wishes to appear to you, then he must be able to do so without battening upon your mind, as do the others. Like Doubting Thomas, you can thrust your hand into his side.

It would be easy to avoid the visions and their dangers, all you need to do is to be like an ordinary man. But what is the advantage of that? You will remain captive in the prison of your body until Death, the executioner, drags you to the block.

The longing of mortal men to see the celestial beings in visible form is a cry that also wakes the spectres of the underworld, because such longing is not pure, it is greed, not longing, because in some way or other it wants to 'take', instead of crying out to learn to 'give'. Everyone who feels the earth is a prison, every great soul that longs for deliverance: unconsciously, they all call up the world of ghosts.

Do you likewise. But consciously!

I do not know whether there is some invisible hand to aid all those that call up the ghosts unconsciously by forming islands for them in the marshes they blunder into. I do not dispute it, but I doubt it.

When, on the path of *awakening*, you pass through the realm of ghosts, you will gradually come to see that they are nothing but thoughts, which have suddenly become visible to your sight. That is the reason why you see them as beings, and also why they seem strange, for the language of forms is different from the

language of the brain.

That is the time when the strangest metamorphosis that can happen to you will take place: the people around you will turn into ghosts. All that you have loved will become phantoms, your own body as well. It is the most fearful solitude imaginable: a pilgrimage through the desert, and anyone who does not find the spring of life will die of thirst.

Everything I have told you here, can be read in the writings of the holy men of all peoples: the coming of a new kingdom, the awakening, the overcoming of the body, the solitude; and yet there is an unbridgeable gap separating us from those holy men: they believe the day is approaching when the good will enter paradise and the evil be cast down into the pit. *We* know that a time is coming when many will awake, and they will be separated from the sleepers like the lords from the slaves, because the sleepers cannot understand those that are awake; we know that there is no good and no evil, only 'right' and 'wrong'; they *believe* that staying 'awake' is keeping their eyes and their senses open and their body alert during the night, so that they can say their prayers; we *know* that 'waking' is the awakening of the immortal self and that the sleeplessness of the body is its natural consequence; they *believe* that the body must be despised and neglected, because it is sinful; we *know* that there is no sin; the body is our starting-point, we came down to earth to transform it into spirit; they *believe* they should take their body into solitude to purify the spirit; we *know* that our spirit must first go into solitude to transfigure the body.

It is up to you to choose your path, ours or the other. It should come of your own free will.

I cannot advise you; it is better to pick a bitter fruit of your own choice, than to take another's advice and find a sweet one, that is too high on the tree.

Do not be like the multitude that know that it is written, 'All test, then take the best', but yet go and do not test and take the first that comes to hand."

The text seemed to break off at the end of that page, but after some searching, Hauberrisser thought he had found the continuation. The unknown person, to whom the papers were ad-

dressed, seemed to have decided to take the 'heathen path of mastery over thought', for the author went on with his instruction on a new sheet with the title,

The Phoenix

"This day you have been accepted into our community; from now on you are a new link in the chain that stretches from eternity to eternity. With that my task is finished, it will be taken over by another, whom you cannot see as long as your eyes still belong to this earth.

He is infinitely far away from you and yet close by; he is not separated from you by space, and yet is farther away than the farthest corners of the universe; you are surrounded by him, just as someone swimming in the ocean is surrounded by water, and yet you are not aware of him, just as the swimmer will not taste the salt if the nerves on his tongue are dead.

Our symbol is the phoenix, the symbol of renewal, the mythical Egyptian eagle with red and gold feathers which makes a pyre of its nest of myrrh and rises anew from its ashes.

I told you that the body is our starting point; once you know that, you are ready to begin your journey. Now I will teach you the first steps.

You must detach yourself from your body, but not as if you wanted to abandon it; you must release yourself from it as if you were separating light from warmth.

Here the first enemy is already lying in wait for you.

If you *tear* yourself away from your body, in order to fly through space, you are following the path of the witch, who merely draws a ghostly body out of the coarse, earthly one and rides on it as on a broomstick to the witches' sabbath.

With a sound instinct, mankind has erected a bulwark against this danger in the smile with which it greets any suggestion that such black arts should be taken seriously. You no longer need the protection of doubt, you already possess a better sword in what I have given you. The witches believe they are attending the devil's sabbath, when in reality their bodies are lying on their beds, rigid and unconscious. They merely exchange earthly for

spiritual perception, they lose the better part to win the worse; it is impoverishment instead of an enrichment.

That alone should tell you that it is not the path of awakening. Men commonly believe they *are* their bodies, and to come to understand that this is not the case, you must learn what weapons the body uses to maintain its mastery over you. At the moment, of course, you are so deep in its power that you are plunged into darkness whenever it closes its eyes, and your life would be snuffed out if its heart should stop beating. You believe you make it move, but that is an illusion: it moves itself, using your will as a lever. You believe you create ideas; no, it sends them to you, so that you think they come from yourself and do everything it wants.

Sit upright and resolve not to move at all, to remain as motionless as a statue, and you will see how at once it will attack you furiously to try and force you to submit to it. It will shower you with missiles until you allow it to move again. And its fury and the haste, with which it shoots dart after dart at you, will tell you, if you pause to think, how fearful for its mastery it must be and how great your power must be if it is so afraid of you.

But there is another ruse in all this: it wants you to believe that it is here, in physical control, that the decisive battle for the sceptre is fought. But that is only a skirmish, which it will let you win, if necessary, only to have you even more firmly under its yoke. Those who win such minor affrays become the most wretched slaves; they imagine they are victorious and on their brows they bear the stigma: 'a man of character'.

Taming your body is not the goal you are seeking. If you forbid it to move, then you only do that in order to acquaint yourself with the forces it has at its command. There are hosts of them, they are so numerous as to be almost unconquerable. If you insist on continuing with the apparently simple test of sitting still, it will send them out against you, one after the other: first of all the brute force of the muscles, which want to twitch and tremble; then the seething of the blood which covers your face in sweat; the thumping of the heart; the shivering of the skin until your hair stands on end; the unexpected jerk of the body, as if gravity had suddenly changed its axis – all of this you can

overcome, apparently through your will; but it is not your will alone, there is already a higher wakefulness that stands invisible behind it.

This victory, too, is of no value. Even if you could control your breathing and your heart-beat, that would only make you a fakir, and what does that mean in our language but 'a poor man'.

'A poor man', that says it all.

The next warriors your body will send out against you will be thoughts, whirring round you like a swarm of flies. Against them, the sword of will-power is of no use. The more you strike out at them, the more furiously will they buzz around your head; even if you do manage to drive them off for a second, you will just fall asleep and will have been defeated just the same.

It is impossible to command them to be still; there is but one way of escaping from them: by fleeing to a higher wakefulness. What you must do to achieve that, you must find out for yourself. All I can tell you is that you must be firm and decisive and at the same time feel your way tentatively with your heart.

Any advice anyone else might give you for this agonising struggle is as poison. You are faced with a precipice and no-one can help you overcome it but yourself.

The important thing is not to rid yourself of these thoughts *for good*, the purpose of your battle with them is to enter the state of higher wakefulness. Once you have achieved that, the realm of ghosts, of which I have already spoken to you, will be near. You will see apparitions, both terrible and radiant, that will try to make you believe they are beings from another world. They are merely thoughts in visible form, over which you do not yet have power.

The more sublime they appear, the more lethal they are, remember that!

Many a mistaken belief is founded on such apparitions, and has dragged mankind down into darkness. In spite of that, each one of these spectres conceals a deeper meaning. They are not mere pictures; irrespective of whether you can understand their symbolic language or not, they are signs of each stage of your spiritual development.

The transformation of your fellow human beings into ghosts which, as I told you, will follow this stage, contains, like everything else in the spiritual realm, both a poison and healing power. If you do not get beyond the point where you see people *solely* as ghosts, then you will drink only the poison and will become like those, of whom it is said, 'though they speak with the tongues of men and of angels and have not love, they are become as sounding brass'. If, however, you find the 'deeper meaning' concealed within each of these spectral people, then you will be able to see with your spiritual eye not only their living core, but also your own. Then will everything that was taken from you be returned, as to Job, a thousandfold; then you will be – back where you started, as the foolish say in their mockery; they do not know that it is one thing to stay at home, and quite another to return home after one has been abroad for a great length of time.

No one can say whether, after such a long spiritual journey, you will be granted miraculous powers, such as the prophets of antiquity possessed, or whether you will be allowed to enter into eternal peace.

Such powers are the free gift of those who guard the keys to these mysteries. If they become yours to use, then it is only for the sake of humanity, which stands in need of such signs.

Our path leads finally to the journey; if you reach that stage, then you are worthy to receive that gift. Will it be granted you? I do not know.

But however that might be, you will have become a phoenix; it is in your power to *enforce* that.

Before I take my leave of you, there is one more thing you should learn: the signs by which you shall know, when the time of the 'great equinox' is come, whether you have been called to receive the gift of miraculous powers, or not.

One of those who guard the keys to the mysteries of magic has remained on earth, to seek and gather together the elect. He cannot die, just as the legend surrounding him cannot die.

Some say he is the 'Wandering Jew'; others call him Elijah; the gnostics maintain he is John the Evangelist; but each one who claims to have seen him, gives a different description of his

appearance. Do not let yourself be disconcerted if, in the burgeoning days of the future, you should meet some who talk of him in this manner. It is only natural that each person should see him differently. A being such as he, who has transformed his body into spirit, cannot be bound to a single fixed form.

One example will suffice to show you that his form and his face can only be images, ghostly reflections of his true essence, so to speak.

Let us assume he appears to you as being of a green colour. Although you can see it, green is not a real colour, it arises from a mixture of blue and yellow; if you thoroughly combine blue and yellow, you will get green.

Every painter knows that; but few people realise that the world we live in stands likewise under the sign of green and thus does not reveal its true nature, namely blue and yellow.

From this example you can see that if he should appear to you as a man with a green face, his true countenance has still not been made manifest.

But if you should see him in his true form, as a geometrical sign, as a seal in the sky which only you and no other can see, then know: you have been called to work miracles.

I met him in physical form, as a man, and it was allowed me to thrust my hand into his side.

His name was ..."

Hauberrisser guessed the name. It was on the slip of paper he always carried with him. It was the name that constantly leapt out at him:

Chidher Green.

Chapter Twelve

A breath of decay in the air; the stifling heat of dying days, the chill of misty nights; spider webs like patches of mould on the rotting grass in the early morning light; the purplish-brown clods of earth around dull, cold puddles that keep out of the way of the sun; straw-coloured flowers that lack the strength to raise their faces towards the glassy sky; tumbling butterflies with ragged wings that have lost their bloom; the harsh rustle of brittle-stemmed leaves in the avenues of the city ...

Like a fading beauty trying to hide her age beneath a welter of bright cosmetics, nature was flaunting her autumn colours.

Amsterdam had long forgotten the name Eva van Druysen. Baron Pfeill assumed she was dead; Sephardi mourned for her. Hauberrisser alone kept her image alive; but he did not talk of her when his friends or Swammerdam occasionally came to visit him. He did not breathe a word of the cocoon of hope he was wrapping himself up in; he still believed he would find her, and the belief grew stronger with every day, but he felt that to mention it might tear a delicate web. To Swammerdam alone he hinted at this feeling, though not with words.

Since he had finished reading the roll of papers a transformation had taken place within him which he hardly comprehended himself. First of all he had practised sitting still, whenever it had occurred to him, for an hour, sometimes more, sometimes less; he had approached this exercise partly out of curiosity, and partly with the scepticism of one whose heart bore the legend, 'Nothing will come of it', a motto which almost guarantees failure.

After a week the exercise had been reduced to fifteen minutes each morning; but now he was putting all his effort into it, performing it for its own sake and not with the exhausting and ever-disappointed feeling that a miracle might after all happen.

Soon it had become indispensable to him, like a refreshing bath that he looked forward to every evening when he went to bed. By day he was for a long time often driven to deepest despair by the sudden thought that he had lost Eva, at the same time recoiling in horror from the idea that he should combat such

painful reflections by means of magic, that he should run away, as it were, from the anguish of the memory of Eva; such an escape from the pain seemed selfish, a denial of love, a lie, but one day, when his sorrow became too much for him and he thought he was about to commit suicide, he did try it.

Following the instructions, he had sat upright, trying to force himself into a state of higher wakefulness, in order to escape from his bitter thoughts at least for a few moments; strangely enough, and quite contrary to his expectations, he succeeded at the very first try. Before the attempt, he had assumed that if he did manage to reach the state of higher wakefulness he would leave it with regret, and return to life with his pain redoubled. Nothing of the kind happened. On the contrary, he was filled with an incomprehensible feeling of certainty that Eva was alive and threatened by no danger whatsoever; however much he deliberately encouraged his doubts, they could not penetrate his new-found confidence.

Before, the thought of Eva had come to him a hundred times a day, and each time it had been like the lash of a red-hot whip; now it seemed like a joyful message that, far away, Eva was thinking of him and sending a greeting. What had previously been a cause of anguish had been suddenly transformed into a source of joy.

Thus the exercise had created a refuge within him, to which he could withdraw at any time, to find new assurance and that mysterious growth, which will ever be an empty word to those who do not know it from experience, however often they are told about it.

Before he had experienced this new state, he had imagined that if he could ever leave his sorrow for Eva behind, it would mean his wounded soul would heal over all the more quickly, in an accelerated demonstration of the saying that time is a great healer. He had resisted this with every fibre in his body, as do all those who clearly recognise that the passing of sorrow at the death of the beloved means that the image, which they do not want to lose, will also fade.

But there was a small, flower-strewn path between these two precipices, whose existence he had not suspected, but which

now opened up before him. Eva's image had not, as he had feared it might, sunk without trace in the mists of time; no, only the pain had disappeared, and her tear-stained image had been replaced by the risen Eva herself, and at moments of inner repose he could feel her presence as clearly as if she were standing in front of him.

As he withdrew more and more from the outside world, there were times when he was overcome with such a deep happiness as he would never have thought possible. Insight followed insight as he came to see more and more clearly that there were true miracles of inner experience compared with which the events of physical existence not only appeared to be, as he had always thought, but actually were as light to shade.

The image of the phoenix as the eagle of eternal renewal impressed itself on him more and more, revealed daily ever new significance and taught him to appreciate the unsuspected wealth of difference between living and dead symbols. Everything that he sought seemed to be contained within this inexhaustible symbol. It explained things that puzzled him, like an omniscient being whom he only had to ask to learn the truth.

In all his efforts to control the comings and goings of his thoughts he had noticed that, although he sometimes had great success, when he assumed he knew precisely how it had been done, he always found the next day he had no memory of it left whatsoever. It was as if it had been erased from his mind, and he appeared to have to start from the very beginning again and think up a new method.

'The sleep of the body has robbed me of the fruit of my efforts', he told himself and decided to counter it by not going to sleep for as long as possible, until one morning he was granted the insight that this strange disappearance from his memory was nothing other than the 'burning to ashes' from which, again and again, the phoenix arose rejuvenated; he realised that it was a habit from his transient, earthly existence to create methods and try to remember them, that, as Pfeill had said in Hilversum, the valuable thing was not the completed painting, but the ability to paint.

Since he had achieved this insight, mastering his thoughts

became a source of constant delight to him, instead of an exhausting struggle, and, without noticing, he climbed from step to step until suddenly he realised to his astonishment that he already possessed the key to a mastery of which he had never even dreamed. "It is as if until now thoughts had buzzed around me like a swarm of bees, which took their nourishment from me", was how he had explained it to Swammerdam, with whom he still used to discuss his inner experiences. "Now I can send them out by my will and they return to me laden with honey – with insights. They used to plunder me, now they enrich me."

By chance, a week later he came across a similar spiritual process described in the roll of papers in almost the same words, and realised, to his joy, that he had taken the right path of development without having to be instructed.

The pages on which it was written had previously been stuck together by damp and mould; they had separated due to the heat from the sun at the window by which they were kept.

He felt that something similar had happened to his thoughts.

In the years just before and during the war he had read much about so-called mysticism and, instinctively, everything connected with it had evoked the word 'confused', for everything he read about it was characterised by vagueness and sounded like the delirium of an opium-eater. His judgment had not been wrong, because what commonly went under the name of mysticism was really nothing but groping around in the fog; but now he realised that there was a true mystical state – difficult to discover and even more difficult to attain – which was not only the equal of everyday experience, but in fact far exceeded it in vividness.

There was nothing here that reminded him of the suspicious raptures of the ecstatic 'mystics'; there was no humble whining for a selfish 'salvation' which, to appear all the more glorious, needed to be seen against the bloody background of all the sinners condemned to the eternal torments of hell; and the glutted complacency of the bestial masses, who equated a ripe belch with a firm grip on reality, had also vanished like an unpleasant dream.

Hauberrisser had switched off the light and was sitting at his desk waiting, waiting through the darkness.

Night covered the window like a dark, heavy cloth.

He felt that Eva was by him, but he could not see her.

When he closed his eyes, colours billowed like clouds behind his lids, dissolved and then formed again. He had learnt from his experiences that they were the material from which he could form pictures, if he wanted, pictures which at first seemed stiff and lifeless but then, as if some mysterious force had breathed life into them, took on an independent existence, as if they were beings like himself.

A few days ago he had managed by this method to bring Eva's face to life, and he had thought he must be on the right path to establishing a new kind of spiritual communication with her; but then he recalled the passage in the roll of papers about the hallucinations of the witches and realised that here began the boundless realm of ghosts and that once he had entered it he would never find his way back again.

The more this power of giving shape to his innermost, unconscious wishes grew, the greater, he felt, must be the danger of losing himself on a path from which there was no return.

It was with a feeling of both horror and ardent longing that he thought back to those minutes when he had succeeded in calling up the spectre of Eva. At first it had been grey and shadowy, then it had slowly taken on colour and life, until it stood before him, as clear as if it were made of flesh and blood. Even now he could still feel the icy shudder that had run through his body as, driven on by some magic instinct, he risked trying to make the vision respond to hearing and touch as well.

The desire to call up her image kept on rising unbidden from his subconscious, and each time he had to call on all his strength of will to resist the temptation.

The night was well advanced, but he could still not make up his mind to go to bed; he could not get rid of the feeling that there must be some magic means of calling up Eva so that she would come to him not as a ghostly vampire, brought to life by the breath of his own soul, but in her own true form.

He sent out his thoughts, so that they would return to him laden with new intuition as to how to set about it. He knew from the progress he had made during the last few weeks that this method of sending out questions and patiently awaiting the answer, this conscious change from an active to a passive state, could even be successful when it concerned matters which could not be determined by logical thought.

Insight upon insight buzzed through his mind, the one more grotesque and fantastic than the last; he weighed them in the balance of his feeling: each one was found wanting

Again 'wakefulness' was the key that helped him to open the hidden lock. This time, however – it came to him instinctively – it was his body, and not just his mind alone, that had to be aroused to higher activity; the magic powers were asleep within his body, and it was they he had to waken if he wanted to affect the material world.

He found an instructive example in the whirling of the Arabian dervishes, the purpose of which, he assumed, was nothing other than to whip the body up into a state of higher 'wakefulness'.

Following an intuition, he laid his hands on his knees and sat upright in the position of Egyptian idols – with their impassive expressions they suddenly seemed to him like symbols of magic power – forcing his body to maintain a corpse-like stillness, whilst at the same time sending a fiery current of will power blazing through every fibre of his body.

After only a few minutes a storm of unprecedented fury was raging inside him. A demented cacophony of voices – were they animals or humans? – the angry barking of dogs and the shrill crowing of numerous cocks all echoed in his mind; in the room an uproar broke out as if the house was about to burst; the metallic thunder of a gong reverberated through his bones, as if hell were ringing in the Day of Judgment; he felt he was about to disintegrate and his skin burnt as if he were wearing the shirt of Nessus, but he gritted his teeth and did not allow his body the slightest movement.

Unceasingly, with every heartbeat, he called for Eva.

A voice, the softest of whispers that yet pierced the racket like

a sharp needle, warned him not to play with forces whose strength he did not know, that he was not yet ready to master them, that at any moment he might be plunged into incurable madness – he ignored it.

The voice grew louder and louder, so loud that the hubbub around seemed to fade into the distance; it screamed at him to turn back: Eva would indeed come if he did not stop unleashing the dark forces of the underworld in his effort to call her, but if she should come before her time of spiritual development was finished, her life would be snuffed out like a candle flame the very moment she appeared, and that would burden him with a greater sorrow than he could bear. He gritted his teeth and ignored it. The voice then tried to reason with him: Eva would have long since come to him or sent news of where she was, if it had been allowed; and did he not have proof that she was alive and hourly sent her passionate thoughts out to him, in the certainty of her presence which he felt every day? He ignored it and called and called.

He was so consumed with longing to clasp Eva in his arms, even if it were only for a brief moment, that all other considerations had vanished.

Suddenly the pandaemonium died down and he saw that the room was as bright as day. In the middle there rose, as if it had sprouted from the floorboards, a post of rotten wood with a cross-beam at the top, like a truncated cross.

A bright-green, shimmering snake as thick as a man's arm was wrapped round the cross-beam; its head hung down and its lidless stare was fixed on him. Its face – there was a strip of black material wrapped round its forehead – resembled that of a mummified human being; the skin of its lips, dry and thin as parchment, was stretched over the decayed, yellowish teeth.

In spite of the corpse-like distortion of the features, Hauberrisser could see a distant resemblance to the face of Chidher Green, as he had stood before him in the shop in the Jodenbreetstraat.

His hair stood on end and the blood froze in his veins as he listened to the words that slowly, syllable by syllable and in a soft, whistling voice that seemed to break at each vowel, dribb-

led from the decomposing lips, "Wh-aat do-o you wa-ant fro-om meee?"

For a moment terror paralysed him; he could feel Death lurking behind him and thought he saw an obscene black spider scuttle across the gleaming table-top; then his heart screamed the name: Eva.

Immediately the room went dark again and when, dripping with sweat, he groped his way to the door and switched on the electric light, the wooden cross with the snake had disappeared.

He felt as if the air were poisoned, he could hardly breathe and the room was spinning.

He tried to persuade himself that the vision must have been the result of a feverish delirium, but in vain; he could not rid himself of the terror that was clutching at his throat and that was telling him that everything he had just seen had been an actual, physical presence here in the room.

Icy shivers ran down his spine when he remembered the warning voice; the mere thought that it might reawaken, to scream at him that his crazy magical experiments had really called Eva and had plunged her into mortal danger, was enough to scorch his brain.

He thought he was about to suffocate and bit his own hand, blocked up his ears with his fingers, grasped the chairs and shook them, to try and calm his mind; he flung open the window and sucked in the cool night air, but it was all in vain, he remained convinced that he had done some damage in the spiritual world of first causes that could not be put right again.

Like rabid beasts, the thoughts, which in his pride he believed he had conquered once and for all, fell upon him; 'sitting still' was no use against them any more, and 'awakening' failed him as well.

'It's madness, madness, madness', he repeated to himself desperately, rushing up and down in the room, his teeth clenched together. 'Nothing happened! It was a phantom, nothing more! I'm going mad! Delusions, delusions! The voice was lying, the apparition was not real. Where could the wood and the snake have come from ... and ... the spider?!'

He forced himself to laugh out loud, but his lips were twisted

into a distorted grin. 'The spider! Why isn't that here any more?' he tried to mock himself; he lit a match to light under the table, but the vague fear that the spider might really be there, as a kind of left-over from the ghostly apparition, was too strong; he did not have the courage to look.

He breathed a sigh of relief when he heard three o'clock strike from the towers. 'Thank God, the night is almost over.'

He went over to the window, leant out and gazed at the misty darkness, looking – or so he thought – for the first signs of the approach of dawn; then he suddenly realised what the real reason for doing it was: every fibre of his being was straining to see *whether Eva might still not come*.

'My longing for her has become so overpowering, that, even when I am wide awake, my imagination conjures up nightmare images.' He was pacing up and down the room again, trying to soothe the torment that was still racking him, when suddenly his eye was caught by a dark patch on the floor that he could not remember having seen before. He bent down and saw that on the spot where, as far as he could recall, the truncated cross with the snake had stood, the wood of the floorboards was rotten.

He gasped. It was impossible that the patch should have always been there!

A loud blow, like a single knock, jolted him out of his trance.

Eva?

There it was again.

No, that could not be Eva; a solid fist was hammering violently on the door of the house.

He ran to the window and called out into the darkness, asking who it was.

No answer.

Then again, after a while, the same rapid, impatient knocking.

He grasped the red silk tassel on the end of the cord that went through the wall and down the steep stairs to the latch on the door, and pulled it.

The bolts creaked.

Deathly silence.

He listened: no one.

Not the faintest creak from the stairs.

At last: a rustling, almost inaudible, as if outside a hand were feeling for the doorknob.

Immediately the door was opened and Usibepu entered, barefoot and with the bowl of hair on his head damp from the fog. He did not say a word.

Instinctively Hauberrisser looked round for a weapon, but the Zulu did not take the slightest notice of him, did not seem to see him, but prowled round the table with silent, hesitant steps, his eyes fixed to the floor and his trembling nostrils flared like a dog on the scent.

"What are you doing here?" Hauberrisser shouted at him; he gave no answer, scarcely even turned his head. His deep, stertorous breaths showed that he was sleep-walking and completely unconscious.

Suddenly he seemed to have found what he was looking for, for he changed direction and, his face bent low over the floor, went to the rotten patch of wood and stood there looking at it.

Then his eye moved slowly up, seeming to follow an invisible line, until it stopped in mid-air. The movement was so convincing, so pregnant, that for a moment Hauberrisser thought he could see the truncated cross growing out of the floor again.

He felt there was no longer any doubt that it was the snake that the negro was watching; he was gazing upwards, his eyes fixed on one single point, and his thick lips muttered, as if he were talking to it. The expression on his face was constantly changing, from burning desire to corpse-like fatigue, from wild joy to blazing jealousy and uncontrollable fury.

The inaudible conversation seemed to have finished; he turned to face the door and squatted on the ground.

He appeared to be in the grip of a convulsive fit. Hauberrisser watched as he opened his mouth wide, stuck out his tongue as far as possible then jerked it back in and, to judge by the gulping and gurgling, swallowed it. His pupils began to flutter and gradually disappeared up under the wide-open lids whilst his face turned a deathly ashen grey.

Hauberrisser wanted to rush over to him and shake him back to consciousness, but an inexplicable leaden weariness kept him paralysed in his chair. He could scarcely even lift his arm: he

seemed to have been infected by the Zulu's catalepsy.

The picture of the room with the dark, motionless figure in it hovered in front of his gaze, like a tormenting dream-image that had slipped out of time to remain forever unchanged; the only sign of life he felt was the monotonous throb of his heartbeat, even his anxiety about Eva had vanished.

Once more he heard the bells resound from the towers, but he was incapable of counting the strokes; in his dazed stupor, there seemed to be an eternity between each one.

Hours might have passed when finally the Zulu began to move. As if through a veil, Hauberrisser saw him stand up and, still in a deep trance, leave the room. Hauberrisser called up all his reserves of strength to break out of the state of lethargy, and ran down the stairs after him. But Usibepu had already disappeared: the door of the house was wide open and the thick, impenetrable fog had swallowed up any trace of him.

He was about to go back into the house, when suddenly he heard a soft footstep, and the next moment Eva was coming out of the white mist towards him.

With an exclamation of joy, he took her in his arms, but she seemed in a state of total exhaustion and only began to come to after he had carried her into the house and laid her gently in a chair. Then they held each other in a long, long embrace, unable to grasp the fullness of their joy. He was on his knees before her, mute, speechless, and she was holding his face between her hands and covering it over and over with burning kisses.

The past was like a long-forgotten dream; to ask where she had been all those long months and how it had all come about, seemed like a waste of the present. A cascade of sound streamed into the room: the church bells had woken – but they did not hear it; the pale half-light of morning crept through the windows – they did not see it, they only saw each other. He caressed her cheeks, kissed her hands, eyes, mouth, breathed in the scent of her hair: he still could not believe it was actually happening, that it was her heart he could feel beating next to his.

"Eva! Eva! Never leave me again." The words were stifled in a flood of kisses. "Tell me that you will never leave me again, Eva."

She put her arms around his neck and pressed her cheek up against his, "No, no, I'll stay with you for ever. Even in death. I am so happy, so unspeakably happy that I was allowed to come to you."

"Eva, Eva, do not talk of death", he exclaimed; her hands had suddenly gone cold.

"Eva!"

"Do not be afraid, I cannot leave you ever again, my love. Love is stronger than death. He said it. He cannot lie. I lay dead and he brought me back to life. He will keep on bringing me back to life, even if I should die." She was talking as if in a fever; he picked her up and carried her to his bed. "He nursed me when I lay ill; for weeks I was mad, I was hanging by the hands from the red strap that death wears round his neck, hanging in the air between heaven and earth. He tore death's neckthong; since then I have been free. Did you not feel that I was with you every hour? Why – why – do the hours rush past so quickly?" Her voice faltered, "Let me – let me be – your wife. I want to be a mother the next time I come to you."

They embraced each other in ecstatic, boundless love as they sank, oblivious to the world, beneath waves of happiness.

"Eva!"
"Eva!"
Not a sound.

"Eva! Can't you hear me?" – he tore open the curtains of the bed – "Eva! – Eva!" He grasped her hand – she fell back lifeless onto the pillow. He felt for her heart – it had stopped beating. Her eyes were blank.

"Eva, Eva, Eva!" With a fearful cry he leapt up and staggered to the table – "Water! Bring water!" – and collapsed as if struck on the forehead – "Eva!" – the glass splintered and cut his finger; he leapt up, tore his hair and ran to the bed – "Eva!" – tried to clasp her to him, saw the set smile of death on her rigid features and sank gibbering to his knees, his head on her shoulder.

"There – out in the street – someone clattering tin buckets – the milkwoman! – Yes, yes, of course – clattering – the milk-woman – clattering." He felt that his mind had suddenly gone

blank. He could hear a heart beating somewhere quite near, he could count the calm, regular pulse and did not know that the heart was his own. Mechanically he caressed the long silky locks in front of his eyes on the white pillow. "How beautiful they are! – Why is the clock not ticking?" He looked up. "Time is standing still. – Of course. It's not yet light. – And over there on the desk are some scissors and – and the two candlesticks beside them are lit. – Why did I light them? – I forgot to put them out when the negro left. – Of course, and afterwards there was no time to do it because – because Eva – came. – Eva?? – But – but she is – dead! Dead!" the whimper bubbled up from his breast. He was engulfed in a blaze of terrible, unbearable pain.

"Finish it all! Finish it all! – Eva! I must follow her. – Eva! Eva! Wait for me!" Gasping for breath, he flung himself at the table, seized the scissors and was about to plunge them into his breast when he stopped, "No, death is not enough. Blind I will be, before I go from this accursed world!" Mad with despair, he opened the points of the scissors to thrust them into his eyes, when a hand hit his arm with such force that the scissors clattered onto the floor.

"Do you mean to go and seek the living in the realm of the dead?" Chidher Green was standing before him, as he had so many months ago in the shop in the Jodenbreetstraat: in a black caftan with white ringlets. **"Do you believe the real world is 'over there'? It is only the land of transient joys for blind ghosts, just as the earth is the land of transient sorrows for blind dreamers. Anyone who has not learnt to 'see' here on earth, will certainly not learn to see over there. Do you think that because her body is lying as if dead"**, he pointed to Eva, **"she cannot rise again? She is alive, it is you who are still dead. Anyone who has come alive as she has, can never die; but one who is dead, as you are, can still come alive."** He picked up the two candlesticks and changed them round, the left-hand one to the right and the right-hand one to the left, and Hauberrisser could not feel his heart beating any more, it was as if it had vanished from his breast. **"As truly as you can put your hand into my side now, just so will you be united with Eva, when you have come into your new spiritual life. What**

should it matter to you that people will believe that she has died? You cannot expect sleepers to see those who are awake.

You called for transitory love", he pointed to the place where the truncated cross had stood, passed his hand over the rotten patch in the floorboards and it disappeared, "and transitory love I brought to you, for I have not remained upon earth to take, but to *give,* to give to each what he longs for. But men do not know what their souls long for; if they knew, they would be able to see.

You went into the shop where the world sells magic and asked for new eyes to see the things of this earth in a new light. Remember: did I not tell you that you would first of all have to cry your old eyes out of your head before you could have new ones?

You asked for knowledge, and I gave you the papers of one of my disciples, who lived in this house when he was still in his corruptible body.

Eva longed for everlasting love; I gave it to her, just as for her sake I now give it to you. Transitory love is a phantom love.

Wherever on earth I see a love put forth its shoots and grow beyond the love that is between phantoms, I hold my hands over it like protective branches, to shield it against Death, the Harvester; for I am not only the phantom with the green face, I am also Chidher, the Ever Green Tree."

When Vrouw Ohms, his housekeeper, came into the room in the morning with his breakfast, she saw to her horror the body of a beautiful young girl lying on the bed and Hauberrisser kneeling before it, pressing the dead girl's hand to his face.

She sent a message to his friends; when Pfeill and Sephardi came and, assuming he was unconscious, tried to lift him up, they started back in horror at the smiling expression on his face and the radiance in his eyes.

Dr. Sephardi had asked Baron Pfeill and Swammerdam to come to his house. They had already been sitting together in the library for over an hour, and night had fallen. They talked of mysticism and philosophy, of the Cabbala, of the strange Lazarus Egyolk, who had long since been released from medical custody and started running his liquor business again, but the conversation kept on returning to Hauberrisser.

Tomorrow was Eva's burial.

"It is terrible. The poor, poor man!" exclaimed Pfeill as he rose and paced restlessly up and down. "I shudder whenever I try to imagine how he must feel." He stopped and looked at Sephardi. "Should we not go and keep him company? What do *you* think, Swammerdam? Do you really think there is no possibility of him waking from his incomprehensible languor. What if he should suddenly come to and, finding himself alone with his sorrow, ... ?"

Swammerdam shook his head. "You do not need to worry about him, Baron. Despair cannot touch him ever again; Egyolk would say the lights have been changed round inside him."

"I find something fearful in your belief", said Sephardi. "Whenever I hear you talk like that I am gripped by – by fear." He hesitated for a while, uncertain whether he might not open up an old wound. "When your friend Klinkherbogk was murdered, we were all very concerned for you. We thought it might be too much for you to bear. Eva particularly asked me to go and visit you, to try to calm you down.

Where on earth did you find the courage to bear such a dreadful occurrence, that must have shaken your faith to its very foundations?"

Swammerdam interrupted, "Can you still remember Klinkherbogk's words before his death?"

"Yes. Every single one. Later I came to understand their meaning, as well. There can be no doubt that he foresaw his end, even before Usibepu entered his room. What he said about the 'King from the Land of the Moors' bringing him the 'myrrh of the life beyond' proves that."

"You see, then, Doctor Sephardi, it was precisely the fact that his prophecy was fulfilled that healed my sorrow. At first, of course, I was overwhelmed by it, but then I saw it in all its greatness, and I asked myself this question: what is more worthwhile, that words spoken in a state of spiritual rapture should become reality, or that a sick, consumptive child and a frail old shoemaker should remain in this world a little while longer? Would it have been better if the spiritual voices had lied?

Since then, the memory of that night has been a source of pure, unalloyed joy for me.

What does it matter that the two of them had to die? Believe me, they feel much better now."

"So you are convinced that there is life after death?" asked Pfeill. "Though to tell the truth", he added, "I believe in it myself now."

"Certainly I am convinced of it. Of course, paradise is not a place, but a state of being; life on earth is just a state of being, too."

"And – and you long to be there?"

"N-no." Swammerdam hesitated, as if it was something he did not want to talk about.

The old servant in his mulberry livery announced that his master was wanted on the telephone. Sephardi stood up and left the room. Immediately Swammerdam continued. Pfeill realised that what he had to say was not meant for Sephardi's ears.

"The question of paradise is a two-edged sword. Some people can be harmed beyond cure by being told that 'over there' there is nothing but images."

"Images? How do you mean?"

"I will give you an example. My wife – you know that she died years ago – had an immense love for me, and I for her; now she is 'over there', and dreaming that I am with her. She does not know that it is not really I who am with her, but only my image. If she did know, paradise would be hell for her.

Everyone who dies finds, when he crosses over, the images of those he has been longing for, and takes them for real, even the images of the objects his soul was attached to", he pointed to the rows of books on the library shelves. "My wife believed

in the Mother of God; now, 'over there', she is dreaming in her arms.

The rationalists, who want to turn the people away from religion, do not know what they are doing. Truth is only for the few and should be kept secret from the masses; anyone who has only half understood it will find himself in a paradise devoid of colour when he dies.

Klinkherbogk's longing on earth was to see God; now he is on the other side and can see 'God'. He was a man without knowledge or learning, and yet, so consumed was he with his thirst for God, that his lips spoke words of truth; and fate was merciful enough to keep their *inner* meaning hidden from him.

For a long time I could not understand why that was so; today I know the reason. He had only half understood the truth, and his desire to see God could not have been fulfilled, neither in reality, nor in the dreams of the world beyond." He stopped abruptly as he heard Sephardi returning.

Pfeill guessed intuitively why he did so: he obviously knew about Sephardi's love for the dead Eva, and also that, for all his scholarship, deep down inside Sephardi was a religious, even a pious person; Swammerdam did not want to disturb his 'paradise', the illusion he would have in the life beyond that he was united with Eva.

"As I said", Swammerdam went on, "it was my realisation that the fulfilment of Klinkherbogk's prophecy far outweighed his horrible death that turned my grief to joy. Such a 'changing-round of the lights' does exist; it is a transformation of bitter into sweet that can be brought about by the power of truth alone."

"In spite of that", Sephardi joined in the conversation again, "what still puzzles me is what gives you the strength to master your sorrow merely through such a realisation. However much I seek refuge in philosophy to overcome my sorrow at Eva's death, I still feel as if my happiness has gone for ever."

Swammerdam nodded thoughtfully. "True, true. The reason is that your insights come from rational thought and not from the 'inner voice'. Without knowing it, we distrust our own insights; that is why they are grey and dead. The insights that come to us

from the inner voice, on the other hand, are gifts of living truth, and they delight us more than we can say, whenever they are granted us.

Since I have been following the 'path', the inner voice has only spoken to me a few times, but it has still brightened my whole existence."

"And has what it told you always come to pass?" asked Sephardi, trying to conceal the scepticism in his voice. "Or did it not prophesy to you?"

"There were three prophecies concerning the distant future. The first was, that with my help a young couple would open up a spiritual path which had been blocked for thousands of years, but which would now, in the coming age, be revealed to many people. It is this path that gives life its true worth, gives meaning to existence. My whole life has come to centre round this prophecy.

I would rather not talk about the second one, you would think I was insane, if I were to tell you –"

Pfeill quickly asked, "Does it concern Eva?"

Swammerdam's only answer was a smile, "– and the third seems unimportant, although that cannot really be the case, and wouldn't interest you."

"Have you any indications that at least one of the three predictions will come true?" asked Sephardi.

"Yes. My feeling of absolute certainty. I don't care in the slightest whether I ever see them come true; I am content with the knowledge that it is impossible for me to feel the slightest doubt about them.

You cannot know what it is to feel the presence of the truth that can never err. It is something you must experience yourself.

I have never seen a so-called 'supernatural' apparition; only once in my sleep I saw the image of my wife as I was searching for a green insect. I have never desired to 'see God'; an angel has never come to me, as one did to Klinkherbogk; unlike Lazarus Egyolk, I have never met the prophet Elijah, but that does not grieve me: I find myself rewarded a thousand times because the living truth of what is said in the Bible, 'Blessed are they that have not seen, and yet have believed', has shown itself in my

life. I believed when there was no ground for belief, and have learnt to think of the impossible as possible.

Sometimes I feel there is someone next to me, immense and all-powerful; or I know he is holding his hand over this or that person; I cannot see him, nor can I hear him, but I know that he is there.

My hope is not that I shall ever see him; my hope is *in* him.

I know that a time of terrible devastation is at hand that will be ushered in by a storm, the like of which the world has never known. I care not whether I shall see that time or not, but I am glad that it will come!" Both Pfeill and Sephardi felt a shiver at the cold, calm way Swammerdam spoke those words. "This morning, you asked me where I thought Eva could have been hidden all this time. That I did not know – how could I? – but I knew that she would come, and she has come.

And I know, just as surely as I know that I am standing here, that she is not dead. His hand is over her!"

"But she is in a coffin, in the church!"

"But tomorrow she will be buried!" Exclaimed Pfeill and Sephardi together.

"Even if she were to be buried a thousand times over; even if I were to hold her skull in my hand – I know that she has not died."

"Mad. Mad!" said Pfeill to Sephardi after Swammerdam had left.

The colours of the high, arched windows of St. Nicholas' glowed out into the misty night with a dull gleam, as if a candle had been lit inside the church. The heavy, tired tread of the policeman, who, since the violent incidents on the Zeedijk, had been assigned to patrol the infamous harbour area, echoed along the churchyard wall. Unseen in its shadow, Usibepu waited motionless until he had passed, then climbed over the gate, pulled himself up by a tree onto the sacristy roof, which projected out like a small chapel, cautiously opened the round skylight and dropped to the floor like a cat.

On a silver catafalque in the centre of the nave Eva's body was

bedded on a mound of white roses, her hands folded over her breast, her eyes closed, with a smile on her rigid features. At the head and either side of the coffin red and gold candles as thick as a man's arm kept the deathwatch with a steady flame.

In a recess in the wall hung the picture of a black Madonna with the child on her arm and in front of it, suspended from the roof by a glittering wire, was the blood-red glow of the sanctuary lamp in a glass bowl like a ruby heart. Its dull light illuminated pale hands and feet made of wax behind curving bars; a pair of crutches nearby and a message, 'Mary came to my aid'; painted wooden statues of Popes on stone pedestals with white tiaras on their heads, their hands raised in blessing; columns of fluted marble disappearing into the darkness – and the Zulu slipping noiselessly from the shadow of one column to the next, eyes wide in astonishment at all the strange objects around; he nodded grimly to himself when he saw the wax limbs, assuming they came from defeated enemies, peeped through the chinks in the confessionals and suspiciously tapped the huge figures of the saints, to make sure they were not alive.

When he was certain he was alone, he crept on tiptoe to where the body was and stood there for a long time, looking at it sadly. Dazed by her beauty, he stretched out his hand and touched her soft blond hair, then pulled it back, as if afraid he might disturb her sleep.

Why had she been so terrified of him, that summer's night on the Zeedijk? He could not understand it. Until then any woman, black or white, that he had desired, had been proud to belong to him, even Antje, the waitress in the tavern, and she was white *and* had yellow hair. He had never had to resort to his Vidoo spells, they had all come of their own accord and flung themselves into his arms. One alone had not: She. She alone he had not been able to possess, she for whom he would willingly have given all the money for which he had strangled the old man with the gold paper crown.

Night after night since he had fled from the sailors he had wandered through the streets looking for her, but in vain; none of the countless women, who sought men in the darkness, could tell him where she was.

He put his hands over his eyes. Memories rushed past as in a wild dream: the torrid savannahs of his homeland; the English trader who had lured him to Cape Town with the promise of making him King of Zululand; the floating house that had brought him to Amsterdam; the circus troupe of wretched Nubian slaves, with whom he had to perform war dances every night for money which kept being taken away from him; the stone city where his heart had withered so far from home and where no-one understood his language.

With gentle fingers he stroked the dead woman's arm, and an expression of boundless desolation appeared on his face; she did not know that for her sake he had lost his God. To make her come to him, he had called the dreadful souquiant, the snake-idol with the human face; in doing so he had risked – and lost – the power to walk over red-hot stones.

Dismissed from the circus and moneyless, he was to have been sent back to Africa, to return as a beggar instead of as a king! He had leapt from the ship into the water and swum back to land; by day he had hidden in barges carrying fruit and by night prowled around the Zeedijk, looking for *her*, her whom he loved more than the savannahs of home, more than his black wives, more than the sun in the sky, more than anything.

Once, only once, since then the angry snake-god had appeared to him; in his sleep it had given him the cruel order to call Eva to the house of a rival. He was only allowed to see her again here in the church, when she was dead.

Full of grief, he let his eyes wander round the gloomy building: a man with a crown of thorns, nailed to a cross with iron nails through his hands and feet? A dove with green twigs in its beak? An old man with a large golden sphere in one hand? A young man pierced by arrows? Strange white gods; he did not know their secret names, by which to call them.

And yet, they must be able to work magic and bring the dead woman back to life. Who else gave Mister Arpád Zitter the power to push daggers through his throat, to swallow eggs and make them reappear?

He felt one last ray of hope when he saw the Madonna in the alcove. She must be a goddess, for she wore a golden diadem in

her hair; she was black, perhaps she could understand his language?

He squatted down before the picture and held his breath until he could hear in his ears the wailing of his executed foes, who had to await his arrival as slaves at the gates of the life beyond; then with a gurgle he swallowed his tongue, so that he could cross over into the realm where men can speak with the invisible ones: Nothing. Nothing but deep, deep blackness instead of the pale, green glow he was accustomed to see; he could not find the way to the foreign goddess.

Slowly, sadly he returned to the bier, huddled down at the foot of the catafalque and started the burial song of the Zulus, a wild, awful liturgy consisting of barbaric, moaning grunts answered by a breathless muttering, like the clatter of antelopes in flight, interrupted by the harsh screeching of a hawk, hoarse yelps of despair and a melancholy keening, which seemed to lose itself in distant forests, then reappear in a dull sobbing and turn into the long-drawn-out howling of a dog that has lost its master, before it finally died away.

Then he stood up, reached inside his shirt and brought out a small, white chain made of the vertebrae of kings' wives that he had strangled: the symbol of his status as King of the Zulus, which grants immortality to anyone who takes it to the grave with them. He twisted it, like a gruesome rosary, round the dead woman's hands, which had been folded together in prayer.

It was the most precious thing he possessed on earth, but what was immortality to him now? He was homeless, here and on the other side; Eva could not enter the paradise of the black people, nor he the paradise of the whites.

A slight noise startled him.

He tensed, like a predator about to strike.

Nothing.

It must have been a rustling from the wreaths as the foliage withered.

Then his eye noticed the candle at the head of the bier, and he saw the flame flicker and then lean to one side, as if struck by a current of air – someone must have come into the church!

In a single movement he was in the shadow of the pillar,

looking towards the sacristy to see if the door was opening: nothing!

When he looked back towards the body, he saw a high, stone seat had replaced the flickering candle. On it throned an Egyptian god, slim, taller than a man, motionless and naked apart from a red and blue cloth about his loins, holding the crook and scourge in his hands and with the feather crown on his head: the Judge of the Dead. On a chain around his neck hung a golden tablet. Facing him at the foot of the coffin was a brown man with the head of an ibis, holding in his right hand the green ankh, the T-shaped cross with a loop at the top, the symbol of eternal life. On either side of the bier were two further figures, one with the head of a sparrowhawk, the other with the head of a jackal.

The Zulu realised that they had come to pronounce judgment on the dead woman.

Wearing a close-fitting dress and a vulture-head cap, the Goddess of Truth approached down the central isle, went up to Eva, who sat up stiffly, took her heart out of her breast and laid it on a balance. The man with the jackal's head came up and threw a tiny bronze statuette into the other pan.

The sparrowhawk checked the weight.

The pan with Eva's heart in sank down low.

The man with the ibis head silently wrote on a wax tablet.

Then the Judge of the Dead spoke:

"She has been weighed and not found wanting; devout was her life on earth and heedful of the Lord of the Gods, therefore she has reached the land of truth and justification.

She will wake as a living god and shine in the choir of the gods which are in heaven, for she is of our stock.

Thus it is written in the Book of the Hidden Abode."

He sank into the ground.

Eva, her eyes closed, stepped down from the bier. Placed between the two gods, she silently followed the man with the head of a sparrowhawk through the walls of the church. All three disappeared.

Then the candles changed into brown figures with flames blazing up over their heads who lifted the lid onto the empty coffin.

A rasping sound echoed through the church as the screws bit into the wood.

Holland had been visited by an icy, sombre winter, which had cast its white shroud over the plains and then slowly, very slowly receded. But still spring did not come: it was as if the earth were never going to wake again; May came with a pallid yellow light, and went again, and still there was no new growth in the meadows.

The trees were withered and bare, without buds and frozen to their roots. Everywhere was black, dead earth, the grass brown and sere, and the air unnaturally calm; the sea was as motionless as if it were glass, for months there had been not a drop of rain and the sun peered dimly through a veil of dust; the nights were close and the morning brought no refreshing dew.

The cycle of nature seemed to have ground to a halt.

As in the terrible days of the Anabaptists, the population was seized with the fear of an imminent cataclysm which was whipped up by frenzied priests, who roamed the streets of the city, bellowing psalms and calling for repentance.

There were rumours of a great famine and the end of the world.

Hauberrisser had moved from his apartment in the Hooigracht out to the flat land in the south-east of Amsterdam. He was living alone in a house about which a legend ran that it had once been a so-called druid's stone. It stood by itself, with its back to a low hill in the middle of the ditches of the Slotermeer polder.

He had seen it on his way back from Eva's funeral and, as it had been standing empty for some time, taken it on the spot and moved in on the very same day; in the course of the winter he had had it refurbished so that it was tolerably comfortable. He wanted to be alone with himself and far from the throng, which seemed to consist of shades without substance.

From his window he could see the city; with its gloomy buildings and the forest of ships' masts in the background it lay before him like a spiny monster breathing out smoke.

At times he viewed the city through his binoculars, and the

sight of the two spires of St. Nicholas' and the countless other towers and gables close before his eyes gave him a strange feeling: as if what he was seeing were not solid objects, but tormenting memories that had taken on visible form and were stretching out their cruel arms to grasp him. Then they would dissolve again and drain back into the silhouette of the houses and roofs in the hazy distance.

At first he had occasionally visited Eva's grave in the nearby cemetery, but it was always just a mechanical, mindless walk. Whenever he tried to tell himself that she was there, under the earth, and that he ought to feel sorrow, the thought seemed so absurd that he often forgot to place the flowers he had brought on the mound, and took them back home with him.

The whole idea of sorrow had become an empty word for him and had lost all power over his emotions. Sometimes, when he pondered on this strange transformation within him, he felt almost a horror of himself.

In such a mood he was sitting one evening at the window, his eyes fixed on the setting sun. In front of the house a tall poplar towered up from a desert of dry, brown grass. The only sign of life far and wide was a tiny patch of green, like an oasis, where there grew an apple-tree covered in blossom; sometimes the farmers came to see it, as if they were on a pilgrimage to the site of a miracle.

As he gazed out over the desolate landscape, a thought came to him, "Mankind, that eternal phoenix, has burnt itself to ashes in the course of the centuries; but will it rise again?"

He remembered the apparition of Chidher Green, and his words came back to him that he had stayed on earth in order to 'give'.

"And what am I doing?" he asked himself. "I have become a walking corpse, a withered tree like that poplar over there. Who, apart from myself, knows there is a second, secret life? Swammerdam set me on the path, and the unknown writer showed me the way, but I keep all these fruits that destiny has dropped in my lap for myself. Not even my best friends, Pfeill and Sephardi, suspect what is going on inside me; they imagine I have withdrawn to solitude to grieve for Eva. People seem to

me like ghosts making their way blindly through life, or like caterpillars, crawling along the ground, unaware that they have the seeds of a butterfly inside them; but does that give me the right to avoid them?"

He leapt up as he felt a sudden violent urge to set off for the city that very moment, to stand at some street corner, like one of the many itinerant prophets who were announcing the Day of Judgment, and scream to the multitude that there was a bridge linking life on earth with the world beyond. The next moment he sat down again. "I would only be casting pearls before swine", he reflected. "The masses would not understand me; they snivel and whine for a god to come down from heaven to them, only to betray him and crucify him. And the few people of true worth, the few who are seeking a way of redemption for themselves, would they listen to me? No. Those who have truth to give away have fallen into disrepute." Pfeill came to mind, who in Hilversum had said he would have to be asked first whether he was prepared to accept a gift.

"No, no, that wouldn't work", he told himself, and thought hard. "Strange; the richer you become in inner wealth, the less you can give to others. My path is taking me farther and farther away from mankind, soon the time will come when they cannot hear my voice at all."

He realised he had almost reached that point.

He thought of the roll of papers, and the strange manner in which it had come into his possession. "I will continue it with a description of my own life", he decided, "and leave it to fate to decide what will happen to it. It shall be my testament, and I shall leave it in the care of him who said, 'I have remained to give, to each what he desires'; he shall see that it comes into the hands of people who can make use of it, of people who thirst for an inner awakening. If it leads to only one person awakening to immortality, it will give meaning to my life."

He went to his desk and sat down, to illustrate the teachings of the roll of papers with his own experiences. His intention was to take them back to his former apartment and place them in the hole in the panelling, from which they had fallen on his face that fateful night. He started:

"TO THE UNKNOWN PERSON WHO SHALL INHERIT THESE PAPERS

The hand that wrote these papers you are holding may well have long ago decayed.

Something tells me that they will come to you at a time when you need them, as a ship with torn sails that is being driven onto the rocks needs its anchor.

In the writings that accompany mine, you will find set down a teaching, which contains all we need to know to cross over, as by a bridge, to a new world full of marvels.

I have nothing to add, apart from a description of my life and the spiritual states I achieved with the help of the teaching. If all these lines do is to strengthen you in your belief that there truly is a secret path leading beyond mortal humanity, then they will have achieved their purpose.

The night, in which I am writing these lines for you, is filled with the stench of horrors to come, horrors not for me, but for the multitude of those who have not ripened on the tree of life. I do not know whether I shall see the 'first hour' of the new age, that you will find mentioned by my predecessor, perhaps this night will be my last, but: whether I part from this earth tomorrow or in a few years' time, I am stretching out my hand into the future to touch yours. Grasp it, just as I grasped the hand of my predecessor, so that the chain of the 'doctrine of wakefulness' shall not be broken, and pass on your legacy, when your time comes."

It was long past midnight when his narrative had reached the point in his life when Chidher Green had saved him from committing suicide. He paced up and down, deep in thought. He felt that here began the great gulf separating the comprehension of a normal person, however imaginative, however ready to believe, from that of one who had been spiritually wakened. Were there words at all to give even an approximate impression of what he had experienced continually from that point onward?

For a long time he was uncertain whether or not to finish his description with Eva's funeral. He went into the next room to take the silver holder he had had made for the roll of papers out

of his suitcase. While he was looking for it, he happened upon the papier-maché skull he had bought a year ago in the Hall of Riddles. Deep in thought, he examined it by the light of the lamp, and the same thoughts that he had had a year ago came into his head.

'It is more difficult to master the eternal smile than to find the skull one bore on one's neck in a previous existence.' It sounded like the promise of a joyful future, in which the serene smile would be mastered.

His past life, with all the pain of his designs and desires, now seemed unbelievably distant, alien, as if it really had all taken place in this ridiculous and yet so prophetic object made of papier-maché, and not in his own head. An involuntary smile greeted the thought that here he was holding his own skull in his hand. The world he had left behind seemed like a magicians' shop, full of worthless junk.

He picked up his pen and wrote,

"When Chidher Green left me, and, in some way I could not understand, seemed to take all my grief for Eva with him, I turned back to the bed to kiss her hand; but I saw a man kneeling there with his head on her arm, and in astonishment I recognised my own body. Myself I could not see any more; when I looked down at myself there was nothing but empty air. But the man by the bed had stood up and was looking down at his feet, just as I believed I was doing. It was as if he were my shadow, and had to carry out every movement I ordered him to.

I bent over the dead body – he did so as well. I presume that as he looked at her he suffered and felt pain; I presume so, but I do not *know*. For me the woman who was lying there, motionless, with a smile frozen on her face, was the corpse of a divinely beautiful, unknown girl, like a wax model that left my heart cold, a statue that was a perfect likeness of Eva, but only a likeness.

I felt so incredibly happy that it was an unknown woman, and not Eva, who had died, that I could not speak for joy.

Then three figures entered the room. In them I recognised my friends and saw them go over to my body to comfort it, but it was only my 'shadow'; it smiled and answered not a word. How

could it have? It could not open its mouth itself, it was incapable of doing anything other than what I ordered it to do. To me, my friends and all the other people I saw later in the church and at the funeral had become phantoms, just like my own body: the hearse, the horses, the torchbearers, the wreaths, the houses we passed, the graveyard, the sky, the soil and the sun, they were all images without an inner life of their own, like a colourful dreamworld I was observing, glad that it did not concern me any more.

Since then my freedom has expanded more and more, and I know that I have grown beyond the threshold of death. Occasionally at night I see my body lying there asleep, I hear its regular breathing, and yet all the time I am awake. Its eyes are closed, and yet I can look around and be anywhere I want to. When it is roaming around, I can rest, and when it is resting, I can roam around. But I can also see with its eyes and hear with its ears whenever I want to, only when I do that, everything about me is dull and joyless, I am like other men again, a ghost in the realm of ghosts. But when I am freed from my body and observe it as a shadow that automatically carries out my orders in the shadow-world it inhabits, my condition is so strange that I do not know how to describe it.

Imagine you are sitting in a cinema, full of happiness because of some great joy you have just experienced, and on the film you see your own figure rushing from one sorrow to the next, collapsing at the death-bed of a woman whom you know is not dead, but waiting at home for you; imagine you hear your own image on the screen utter cries of grief and despair with your own voice, produced by a machine – would you be moved by such a film?

It is only a feeble example I can give you; I hope that one day you will experience it. Then you will know, as I know now, that it is possible to escape death.

The stage I have never succeeded in reaching is the great solitude, of which my predecessor speaks. That would, perhaps, be even more cruel for me than earthly life, if the ladder that leads up to it should stop there; but the glorious certainty that Eva is not dead takes me beyond it.

Even though I cannot yet see Eva, I know that after only one more short step along the path of awakening, I will be with her, and be with her in a much more real sense than would ever have been possible in my earlier existence. All that separates us is a thin wall, through which we can already sense each other. How much deeper and calmer is my hope of finding her than in the days when every hour I called for her. Then I was devoured with expectancy, now I am filled with joyful confidence. There is an invisible world which pervades the visible, and I am sure that Eva is living there, waiting for me.

If you should suffer a like destiny and lose the one you love on earth, then know that there is no other way of finding your love again than by the 'Path of Awakening'. Remember Chidher Green's words to me, 'anyone who does not learn to see on earth will certainly not learn to do so on the other side'.

Beware of the doctrine of the spiritualists, it is a poison, it is the most dreadful plague that has ever been visited upon humanity. The spiritualists also claim to be able to converse with the dead, they believe the dead come to them: they deceive themselves. It is good that they do not know who they are that come to them. If they knew, terror would strike them to the bone.

First you must learn to become invisible yourself, before you can find the path that leads to the invisible ones, and learn to live both here and on the other side, just as I have become invisible, even to the eyes of my own body.

I have not yet reached the stage when my eyes are open to the world beyond, and yet I know that those who were blind when they left the world are not there; they are like melodies that fade away and float through the cosmos until they come across strings on which they can sound once more; where they think they are is not a place, it is far less real than the earth, it is a dream island of phantoms without a spatial dimension.

Only human beings who have *awakened* are truly immortal; suns and gods pass, only they remain, and can accomplish whatever they will. There is no god above them.

It is not for nothing that our path is called a heathen path. What pious people call their god is only a *state*, which they could achieve if they had the ability to believe in themselves. In their

incurable blindness they create for themselves a barrier they dare not cross; they create an image for them to worship, instead of transforming themselves into it.

If you must pray, then pray to your invisible self; it is the only god that answers your prayers, other gods give you stones instead of bread.

Unhappy are they who pray to an idol and their prayers are heard: they lose their own selves, since they are no longer capable of believing that it was they themselves that answered their prayers.

If your invisible self should appear within you as an essence, you will be able to recognise it by the fact that it casts a shadow; I did not know who I was until I saw my own body as a shadow.

A new age is dawning in which mankind will cast radiant shadows instead of dark blemishes onto the earth, and new stars are rising. There will be light and you, too, have your part to play."

Hauberrisser stood up, hurriedly rolled up the sheets of paper and pushed them into the silver container. He had a distinct feeling that someone was urging him to act with all haste.

The sky already bore the first signs of the coming day; the air was leaden and made the withered grass outside look like a huge woollen carpet with the grey waterways appearing as lighter stripes.

He left the house and set off for Amsterdam, but after only a few steps he abandoned his plan of taking the document back to his old house in the Hooigracht, turned back and went to fetch a spade. He felt sure, now, that he was to bury it somewhere nearby.

But where?

In the graveyard, perhaps? He looked in that direction. No, not there.

His eye was caught by the blossoming apple tree. He went over to it, dug a hole and placed the container with the documents in it.

Then, as fast as he could, he hurried across the meadows and over the footbridges through the half-light towards the city. He

had suddenly been gripped by a deep anxiety for his friends, as if there was some danger threatening them of which he had to warn them. In spite of the early hour, the air was hot and dry, like the atmosphere before a storm, and so still it was stifling. There was something uncanny about the whole landscape, it lay before him like a huge corpse; the sun, a disc of dull yellow metal, hung in the sky behind a veil of thick haze; far away in the west, over the Zuiderzee, a bank of clouds blazed red, as if it were evening instead of morning.

Fearful, lest he should arrive too late, he took short cuts wherever possible, through the fields and along the empty roads, but the city did not seem to come any nearer.

As daylight grew the sky gradually began to change: against the pallid background, great whorls of whitish cloud twisted and turned, like gigantic worms whipped to and fro by invisible eddies, but always remaining above the same spot: a battle of aerial monsters sent down from space. High up in the air cones of cloud spun round like immense inverted goblets; the faces of wild beasts with grinning jaws fell upon each other and wound themselves into a seething tangle; below, on the ground, was the same lowering, deathly stillness as before.

As if borne along by the hurricane, a long black triangle appeared from the south and passed below the sun, blocking out its light so that for some minutes the land was plunged into night, before it settled on the ground in the distance: a swarm of locusts blown over from the coasts of Africa.

All the time he had been hurrying towards the town Hauberrisser had not met a single living being. Now he caught sight of a strange, dark figure, larger than man-size, which seemed to emerge from a clump of gnarled willows at a bend in the road, head bent low and clothed in a long robe.

At that distance he could not make out its features, but the dress, posture and outline of the head with the long side locks immediately told him that it was an old Jew who was approaching.

The nearer the man came, the less real he seemed to become. He was at least seven feet tall and did not move his feet at all as he walked; there was something slack and hazy about his shape.

Hauberrisser even thought he saw one or other of his limbs – the arm or the shoulder – separate from the body, to rejoin it immediately. A few minutes later the Jew had become transparent, as if his body were not a solid mass, but a sparse collection of black dots.

Immediately after that, the figure glided silently past him and Hauberrisser saw that it was a cloud of flying ants which, remarkably, had taken on the shape of a human body and maintained it, an incomprehensible freak of nature, like the swarm of bees he had seen so long ago in the convent garden in Amsterdam. Shaking his head in disbelief, he watched the strange phenomenon for some time as it sped faster and faster towards the south-west, towards the sea, until it disappeared like a puff of smoke on the horizon.

He did not know what to make of it. Was it some mysterious portent or merely a meaningless quirk of nature? It seemed unlikely to him that Chidher Green would choose to appear in such a fantastic form.

To get to Sephardi's house as quickly as possible Hauberrisser, still brooding on what he had seen, cut across the Westerpark and was heading towards the Damrak when a wild commotion in the distance told him something must have happened to arouse the crowd. Soon the broad streets were so jam-packed with a seething mass of excited people that progress was impossible, he decided to see if he could get round by cutting through the narrow streets of the Jewish Ghetto.

Hordes of believers from the Salvation Army were milling about in the squares, praying out loud or bellowing the psalm, "There is a river, the streams whereof shall make glad the city of God"; in a frenzy of religious mania, both men and women were tearing the clothes from each others' bodies; foaming at the mouth, they sank to their knees, directing a mixture of obscenities and hallelujahs at the heavens above; amid horrible fits of hysterical laughter, fanatical monks scourged their bare backs until the blood ran; here and there epileptics collapsed with shrill screams and rolled twitching over the cobblestones; others, followers of some insane creed, 'humbled themselves before the Lord' by squatting down in the midst of the mesmer-

ised crowd and hopping around like frogs as they croaked, "Jesu, Lover of my soul, Let me to thy bosom fly."

Filled with horror and disgust, Hauberrisser wandered through a maze of twisting alleyways, constantly forced out of his way by the throng until he found he was boxed in and could move neither forwards nor back; he was opposite the skull-like house in the Jodenbreetstraat.

The blinds were down and the sign announcing the Hall of Riddles had vanished. In front of the building was a wooden scaffolding painted gold with a throne on top of it; on the throne, wearing an ermine cloak and a diadem so thickly encrusted with diamonds it looked like a halo, sat 'Professor' Arpád Zitter throwing copper coins with his head on to the ecstatic crowd; he was also making a speech which, because of the incessant hallelujahs, was scarcely audible, apart from the repeated bloodthirsty call to, "Cast the whores into the flames and bring me their ill-gotten gold."

With great difficulty Hauberrisser managed to push his way to a street corner. He was trying to work out where he was, when someone grasped his arm and pulled him into an entrance. He recognised Pfeill. They were immediately separated again by the milling throng; they shouted to each other over the heads of the crowd and realised that the same impulse had brought both of them into the city. "Come to Swammerdam's", shouted Pfeill.

It was impossible to stand still. Even the tiniest of courtyards and the narrowest of alleyways was overflowing with people; occasional gaps in the crowd allowed them to make some progress, but conversation was reduced to hurried scraps. Sometimes next to him, now in front, now behind, now separated by the crush, Pfeill told Hauberrisser about Zitter, "A monster, that man ... terrible ... the police have given up ... can't do anything about him. ... Claims to be the Prophet Elijah; people believe him and worship him. ... Terrible bloodbath in the circus the other day ... he incited them to it. ... Mob took over the circus and dragged in some ladies, elegant but demi-monde, of course ... and then set the tigers on them. Megalomania ... thinks he's

Nero. ... First of all he married Madame Rukstinat and then, to get at her money, poisoned ..."

A procession of robed figures carrying burning torches and wearing pointed hoods that came down over their faces, like the judges of the *Vehmgericht,* came between Pfeill and Hauberrisser, and their muffled, monotone chorale – "O sanctissima, o pi--issima, dulcis virgo Maa--rii--aaa" – drowned his last words.

Pfeill reappeared, his face blackened by the smoke from the torches. "... and then he gambled away her money in poker clubs. After that he was a spiritualist medium for several months ... incredibly popular ... the whole of Amsterdam flocked to his seances."

"What about Sephardi?" Hauberrisser shouted over to him.

"In Brazil, arrived three weeks ago. Sends his best wishes. ... Was a changed man before he left, completely changed. I don't know that much about it ... but I do know one thing: the man with the green face appeared to him and told him he was to found a Jewish state in Brazil ... and he told him that the Jews were the people chosen to create an international language that would gradually come to be used by all peoples as a means of communication and would bring them closer together ... a modernised Hebrew, I assume, I don't know. Overnight Sephardi was a changed man, had a mission, he said. Anyway, he seems to have hit the jackpot with his Zionist state, almost all the Jews in Holland have followed him ... and now thousands of others are arriving from all sorts of places to emigrate to South America, the city's teeming like an anthill."

They were separated for a while by a group of caterwauling, hymn-singing women. When Pfeill had used the expression 'teeming like an anthill' Hauberrisser had immediately remembered the strange phenomenon he had seen on his way to the city.

"In the last weeks before he left, Sephardi spent a lot of time with a person called Lazarus Egyolk", Pfeill went on. "I've got to know him myself – he's an old Jew, a kind of prophet, in an almost permanent trance – but everything he prophesies comes true, every time! Just recently he predicted that Europe would

suffer a terrible catastrophe to prepare for the coming of a new age. He said he is happy that he is going to be destroyed in it, because that means he can lead all the dead who cross over into the realm of abundance. As for the catastrophe, he's probably not far wrong about that, you can see what's going on here today. Amsterdam is expecting the flood. Humanity has gone mad, the railways stopped running long ago, or I would have come out to see you out in your hermitage. Today the unrest seems to have reached its climax. There's so much I would like to tell you ... I wish to God there wasn't this constant crush around us, you can hardly finish a sentence in peace ... so much has happened to me too since we last met."

"And Swammerdam? How is he?" Hauberrisser had to yell to be heard above a pack of flagellants shuffling along on their knees.

"He sent a messenger to me", Pfeill screamed back, "to tell me to come and see him straightaway, and to go and fetch you too. Good that we met on the way. He's worried about us, the messenger said, he thinks we will only be safe with him. He claims that his inner voice prophesied three things to him; one was that he will outlive St. Nicholas' Church. He probably takes that as a sign that he will survive the coming catastrophe, and wants us to stay with him in order to keep us safe until the new age has come."

Those were the last words Hauberrisser could understand. The air was shattered by a sudden, deafening roar, that started in the open square they were heading for and echoed across the roofs from skylight to skylight to the farthest corners of the city, growing louder and louder with shrill cries of "The New Jerusalem has appeared in the sky!" – "A miracle, a miracle!" – "God have mercy on our souls!"

He saw Pfeill's lips moving, as if he was using every last ounce of his lung-power to scream something to him, but then he felt his feet lifted from the ground by the crowd, whose excitement had now reached fever pitch. It was useless to resist, he was swept along by the current into a large square where the people were so tightly packed together that his arms were pressed to his sides and he could hardly move his hands.

Everyone was staring upwards. High in the sky, the battle between those strange, twisting formations like gigantic winged fish, was still going on, but below them snow-capped mountains of cloud had formed, and there, in a valley illuminated by the slanting rays of the sun, was the mirage: an exotic, southern city with flat, white roofs and Moorish arches.

Through its clay-coloured streets strode men in flowing burnouses; so close and frighteningly distinct they were, that one could see their eyes move when they turned their heads to cast an indifferent glance, as it seemed, on the terrified throng in Amsterdam. Beyond the ramparts of this celestial city stretched a reddish desert, the edges of which merged into the clouds; a caravan of camels was making its spectral way through the shimmering air.

For a good hour this fata Morgana stood in the sky in all the splendour of its magic colours, then it gradually faded, leaving only one tall, slender minaret, that shone dazzling white for a while, as if it were made of glistening sugar, and then suddenly vanished in the mists.

Hauberrisser was carried inch by inch along the house-fronts by the sea of bodies, and it was late in the afternoon before he found the opportunity of escaping the press over a canal bridge.

It was completely impossible to reach Swammerdam's house; apart from the many crowded streets, he would have had to cross the square again, so he decided to return to his lonely cottage and try again another day.

Soon he was back in the deathly hush of the polder. The lower sky had become an impenetrable, dusty mass. So deep was the solitude, that the hiss of the withered grass as it was crushed beneath his hurrying feet was like the singing of the blood in his own ears.

Behind him, the black shape of Amsterdam against the red of the setting sun looked like a huge lump of burning pitch.

There was not a breath of air and the ditches reflected the sunset in their glassy surface; only now and then the stillness was broken by a faint splash as a fish jumped.

As the twilight deepened, large, murky grey patches rose from the earth and flitted over the meadows like moving sheets;

he saw that it was countless hordes of mice that had come out of their holes and were now scurrying all over each other, squeaking excitedly.

The more the darkness increased, the more uneasy the natural world seemed to become; yet still not a blade of grass moved. The water had turned peaty brown and occasionally small, round craters appeared, although not the slightest breeze had crossed the surface, or a plume of water would splash up, as if an invisible stone had been dropped in, and then immediately disappear without trace.

Hauberrisser had just caught sight of the bare poplar outside his cottage when, suddenly, whitish cylindrical shapes shot up into the sky from the ground before him, blocking his view of the tree.

Like silent ghosts, they came towards him, tearing up the grass where they went, leaving broad, black marks: whirlwinds travelling towards the city. They made not the slightest sound as they passed him, mute, treacherous ghosts of the atmosphere.

Bathed in sweat, Hauberrisser reached his cottage.

The gardener's wife from the nearby cemetery who looked after him had put his dinner on the table, but in his overwrought state he could not touch it. Plagued by unease, he threw himself fully-clothed onto his bed and lay there, sleepless, awaiting what the coming day would bring.

Conclusion

The hours crept by unbearably slowly, the night seemed unending.

Finally the sun rose; the sky remained inky black, but around the horizon there was a vivid, sulphurous gleam, as if a dark bowl with glowing edges had descended over the earth.

There was an all-pervading, matt half-light; the poplar outside the window, the distant bushes and the towers of Amsterdam were faintly illuminated, as if by dim floodlights. Beneath them lay the plain like a huge, blind mirror.

Hauberrisser scanned the city with his binoculars; in the wan light it stood out from the shadowy background as if frozen in fear and expecting the death-blow at any moment.

A ringing of bells washed over the countryside in tremulous, breathless waves and then came to an abrupt halt; a dull roar filled the air and the poplar was bent groaning to the ground. Gusts of wind swept over the meadows like the crack of a whip, flattening the withered grass and tearing the sparse, low bushes up by the roots.

A few minutes later the whole landscape vanished in an immense dust-cloud, and when it reappeared it was scarcely recognisable: the ditches had been whipped into white foam, the windmills were transformed into blunt stumps squatting on the brown earth, as their torn-off sails whirled through the air high in the sky. The pauses between blasts became shorter and shorter, until eventually nothing could be heard but the constant roaring of the wind. Its fury redoubled by the second. The wiry poplar was bent at right angles a few feet above the ground; branches gone, it was little more than a smooth stem, fixed motionless in that position by the immense force of the mass of air rushing over it.

Only the apple tree stood still, as if protected by some unseen hand in a haven of stillness, not one single leaf moving.

A never-ending shower of missiles flew past the window: beams and stones, clods of earth and tangles of brushwood, lumps of brickwork, even complete walls.

Then suddenly the sky turned light grey, and the darkness

dissolved into a cold, silvery glitter.

Hauberrisser assumed the fury of the tornado was subsiding, then noticed to his horror that the bark of the poplar was being stripped off in fibrous scraps, which disappeared instantly. The next moment, before he could really grasp what was happening, the tall factory chimneys towering over the south-west part of the docks were snapped off at the roots and transformed into thin spears of white dust which the hurricane carried off at lightning speed. They were followed by one church tower after another: for a second they would appear as black shapes, whirled up in a vortex, the next they were lines on the horizon, then dots, then – nothing.

The vegetation torn up by the storm flew past the window at such a speed that soon all that could be seen through it was a pattern of horizontal lines. Even the graveyard must have been ripped open, for now tombstones, coffins, crosses and grave-lamps flew past the house, never deviating, never rising, never falling, always horizontal, as if they were weightless.

Hauberrisser could hear the cross beams in the roof groaning, every moment he expected it to be torn apart; he was about to run downstairs to bolt the front door so that it would not be blown off its hinges but, with his hand on the knob of the bed-room door, he stopped, warned by an inner voice that if he opened it the draught would smash the windowpanes, allowing the storm that was sweeping past the front of the house to rush in and transform it into a maelstrom of rubble. It could only avoid destruction as long as the hill behind protected it from the full blast of the hurricane and the rooms remained shut off from each other, like cells in a honeycomb.

The air in the room had turned icy cold and thin, as if in a vacuum; a sheet of paper fluttered round the room, then pressed against the keyhole and stuck there, held fast by the suction.

Hauberrisser went back to look out of the window. The gale was blowing the water out of the ditches so that it spattered through the air like fine rain; the meadows gleamed like smooth grey velvet and where the poplar had stood there was now a stump crowned by a flapping shock of splinters.

The roar of the wind was so constant, so deafening, that

Hauberrisser began to think that all around was shrouded in a deathly hush. It was only when he went to nail back the trembling shutters, so that they would not be blown against the glass, and found he could not hear the hammering, that he realised how great the din outside must be.

For a long time he did not dare look out again, for fear that he might see that St. Nicholas' had been blown away, and with it the nearby house on the Zeedijk harbouring Swammerdam and Pfeill; when he did risk a tentative glance, he saw it still towering up undamaged, but it was an island in a sea of rubble: the rest of the frieze of spires, roofs and gables had been almost completely flattened.

'How many cities are there left standing in Europe?' he wondered with a shudder. 'The whole of Amsterdam has been ground to dust like crumbling rock; nothing left of a rotten civilisation but a scatter of rubbish.' He was gripped with awe as he suddenly comprehended the magnitude of the cataclysm. His experiences the previous day, his exhaustion and the sudden eruption of the storm had kept him in a state of constant numbness, from which he only now awoke to clear consciousness.

He clutched his forehead. 'Have I been sleeping?'

His glance fell on the apple tree: as if by a miracle, the splendour of its blossom was completely untouched. He remembered that yesterday he had buried the roll of papers by its roots; it seemed as if an eternity had passed since then. Had he not written in them that he had the ability to leave his body? Then why had he not done so – yesterday, through the night or this morning, when the storm had broken?

Why did he not do it now?

For a brief second, he managed it. He saw his body as a foreign, shadowy creature leaning at the window, but in spite of the devastation, the world outside was no longer the dead, ghostly landscape of his previous experiences: a new earth was spread out before him, quivering with life, spring hovered on the air, full of glory, like a visible manifestation of the future, his breast trembled with the presentiment of nameless raptures; the world around seemed to be a vision that was gradually taking on lasting clarity – and the apple tree in blossom, was that not

Chidher, the 'ever green tree'?

The next moment Hauberrisser was back in his body gazing out on the howling storm, but he knew now that the picture of destruction concealed within it the promise of the new land that he had just seen with the eyes of his soul.

His heart beat in wild, joyous anticipation, he felt that he was on the threshold of the last, highest awakening, that the phoenix within him was stretching its wings for its flight into the ether. His sense of the approach of an event far beyond any earthly experience was so strong, that he almost choked with the intensity of emotion; it was almost the same as in the park in Hilversum, when he had kissed Eva, the same gust of icy air from the wings of the Angel of Death, but now it was permeated with the fragrance of flowers, like a presentiment of the approach of life imperishable. He heard the words of Chidher, "For Eva's sake I will give you never-ending love", as if it was the blossoming apple tree that was calling them to him.

He thought of the countless dead who lay beneath the ruins of the destroyed city on the horizon, but he could not feel sorrow. 'They will rise again, if in a different form, until they find the last, the highest form, that of the 'awakened man' who will die no more. Nature, too, is ever renewed, like the phoenix.'

He was suddenly gripped by an emotion so powerful, that he felt he must choke; was that not Eva standing close beside him? He had felt a breath on his cheek, and whose heart was beating so close to his, if not hers?

He felt new senses ripening within him to reveal the invisible realm that permeates our earthly world. Any second the last veil that kept it from his eyes might fall.

"Give me a sign that you are near, Eva", he quietly implored. "Let my faith that you will come to me not be disappointed."

"It would be a poor love that could not overcome time and space", he heard her voice whisper, and his scalp tingled at the intensity of his emotion. "Here in this room I recovered from the torments of the earth and here I am waiting with you until the hour of your awakening has come."

A quiet, peaceful calm settled over him. He looked around; the whole room was filled with the same joyful, patient expec-

tancy, like the half-stifled call of spring; each object seemed about to undergo the miracle of a transformation beyond comprehension.

His heart beat audibly.

The room, the walls, the objects around him were, he sensed, only delusory, external forms for his earthly eyes, projecting into the world of bodies like shadows from an invisible realm; any minute the door might open behind which lay the land of the immortals.

He tried to imagine what it would be like when his spiritual senses were awakened. 'Will Eva be with me? Will I go to her and see her and talk to her? Will it be just as beings of this earth meet each other? Or will we become formless, colours or sounds that blend together? Will we be surrounded by objects, as we are here, will we be rays of light, soaring through the infinite cosmos, or will the material world be transformed and ourselves transformed along with it?' He surmised that, although it would be completely new and something he could not at the moment grasp, it would also be a quite natural process, perhaps not unlike the formation of the whirlwinds which he had seen yesterday arise from nothing – from thin air – and take on shapes perceptible to all the senses of the body; yet he still had no clear idea of what it involved.

He was quivering with the presentiment of such indescribable rapture that he knew that the reality of the miraculous experience awaiting him would far surpass anything he could imagine.

The hours slipped by.

It seemed to be midday: high in the sky a gleaming disc hung in the haze.

Was the storm still raging?

Hauberrisser listened.

There was nothing by which he might tell: the ditches were empty, blown away; there was no water, no hint of any movement in them; no bushes as far as the eye could see; the grass flattened; not a single cloud crossing the sky – nothing but empty space.

He took the hammer and dropped it, heard it hit the floor with a crash and concluded that it was quiet outside.

Through his binoculars he could see that the city was still suffering the fury of the cyclone; huge blocks of stone were thrown up into the air, waterspouts appeared from the harbour, collapsed, towered up again and danced out towards the open sea.

And there! Was it a delusion? Were not the twin towers of St. Nicholas' swaying?

One collapsed suddenly; the other whirled up into the air and exploded like a rocket; for a moment the huge bell hovered free between heaven and earth. Then it plunged silently to the ground. Hauberrisser's heart stopped still. Swammerdam! Pfe-ill!

No, no, no, nothing could have happened to them. 'Chidher, the eternal tree of mankind, will shield them with his branches.' Had Swammerdam not prophesied he would outlive the church?

And were there not islands, like the blossoming apple tree there in its patch of green grass, where life was kept safe from destruction and preserved for the coming age?

Only now did the thunder from the crash of the bell reach the house. The walls vibrated under the impact of the airwaves on one single, terrifying note, a note so piercing that Hauberrisser felt as if the bones in his body had shattered like glass; for a brief moment he felt consciousness fade.

"The walls of Jericho have fallen", he heard the quivering voice of Chidher Green say aloud in the room. **"He has awakened from the dead."**

A breathless hush ...

Then the cry of a baby ...

Hauberrisser looked around, disorientated.

Finally he found his bearings

He clearly recognised the plain, bare walls of his room, and yet at the same time they were the walls of a temple decorated with a fresco of Egyptian deities. He was standing in the middle, and both were reality: he saw the wooden floorboards and at the same time they were the stone flags of the temple, two worlds

that interpenetrated before his very eyes, fused together and yet separate. It was as if he were awake and dreaming in one and the same moment. He touched the whitewashed wall with his hand, could feel its rough surface and yet at the same time knew without mistake that his fingers were stroking a tall, gold statue, which he believed he recognised as the Goddess Isis sitting on a throne.

In addition to his previous, familiar human consciousness, he had acquired a new consciousness, which had enriched him with the perception of a new world, which touched the old world, enveloped and transformed it, and yet in some miraculous way let it continue the same.

Each sense awoke doubled within him, like blooms bursting from their buds.

Scales fell from his eyes. Like someone who for his whole life has only known two dimensions and suddenly finds he is seeing rounded forms, he could for a long time not grasp what had happened.

Gradually he realised that he had reached his goal, the end of the path that is the hidden purpose of every human being. His goal was to be an inhabitant of two worlds.

Once more a baby cried.

Had Eva not said she wanted to be a mother when she came to him again? The thought was a sudden shock to him.

Did not the Goddess Isis have a naked, living child in her arm?

He lifted his eyes to her and saw that she was smiling.

She moved.

The frescos were becoming sharper, clearer, more colourful, and all around were sacred vessels. Everything was so distinct that Hauberrisser forgot the sight of his room and only had eyes for the temple and the red and gold paintings round the walls.

Lost in thought, he gazed at the face of the goddess and slowly, slowly a dull memory rose to the surface: Eva! That was Eva and not a statue of the Egyptian goddess, the Mother of the World!

He pressed his hands against the sides of his head, he could not believe it.

"Eva! Eva!" he cried out loud.

Again the bare walls of his bedroom appeared through the temple walls; the goddess was still there on her throne, still smiling, but close in front of him was her earthly likeness, a young woman, the picture of living beauty.

"Eva! Eva!" with an ecstatic cry of boundless rapture, he clasped her to him and covered her face with kisses: "Eva!"

For a long time they stood entwined at the window, looking out at the dead city.

He felt a thought speak within him, as if it were the voice of Chidher, "You are united to help the generations to come, as I do, to build a new realm from the ruins of the old, so that the time may come when I, too, may smile."

The room and the temple were equally distinct.

As if he had the double head of Janus, Hauberrisser could see both the earthly world and the world beyond at the same time, and clearly distinguish all details, all objects:

>He was a living man
>Both here and beyond.

AFTERWORD

by Franz Rottensteiner

The locale of Gustav Meyrink's second novel *The Green Face* (*Das grüne Gesicht*, 1916) is Amsterdam, but this Amsterdam is Prague by another name. The place of the Jewish ghetto of his first novel *The Golem* has been taken over by Amsterdam's disreputable harbour quarter and is populated by a blend of grotesque, mysterious and sinister characters; disaffected Austro-Hungarian emigrants waiting, bored and without hope, to be transported to a new world.

Meyrink's *The Green Face* is second in visionary power only to *The Golem* and while it was not quite as successful as the latter, it nevertheless sold some 90,000 copies in its first year. Indeed the structure of the novel is very similar to his earlier masterpiece. This should come as no surprise since the two novels were written in parallel during the years 1910 to 1916 and its tentative title *Der ewige Jude* is sometimes mistaken for an alternate title for *The Golem*. Meyrink had employed a myth from the Jewish-Christian tradition to powerful effect in his first novel and he does so again in his second. This time the central motif is that of The Wandering Jew; but just as the legend of the Golem that dominates his first novel is not a mere faithful re-telling of lore from the Cabala but freely incorporates Buddhist and Hinduistic elements, so Chidher Grün, the Green Face, is a vision that is unmistakably Meyrink's own. Chidher Green, who never appears in person, visible as he is only in fragments of old manuscripts, visions and fevered dreams, is an amalgam derived from various immortal beings and symbols of re-birth, including but certainly not exhausted by, Ahasverus, John the Baptist and the Phoenix.

According to Christian lore Ahasverus was a cobbler who refused Christ a rest on his way to Golgotha, and for this was damned to wander over the Earth until he was redeemed by the second coming of Christ. The English term *wandering* stresses

the homelessness and restlessness that is the curse of this figure. In German the emphasis is on the *ewige*, the Eternal Jew. It is this aspect that is stressed by Meyrink's symbolic use of the figure: his Wandering Jew is not a soul in need of redemption, but a being that has already been redeemed, and one who can therefore act as a spiritual guide for others; a sort of mid-wife in the spiritual re-birth that is the mystic theme of Meyrink's novel.

The Wandering Jew, who became a folktale in the German countries in the 16th century, has been preserved and kept alive in the fantastic literature of many countries. He makes a brief and somewhat more traditional appearance in Leo Perutz's fantasy novel *The Marques de Bolibar,* written four years after *The Green Face.* Perutz and Meyrink were contemporaries; both Jewish writers from Prague who wrote in German, they were two of the most potent writers of the German fantastic revival that flourished from the turn of the century until the late twenties (or, more precisely, the Nazi take-over in 1933, when the real world caught up with fantasy).

Indeed, there was a whole movement of German fantasy writers after the turn of the century. Among the first of these were the 'three musketeers' of German fantasy, Hanns Heinz Ewers (1871-1943), Karl Hans Strobl (1877-1946) and Meyrink himself. Although not quite in Meyrink's league, Ewers and Strobl did enjoy wide popularity for a time. Also circulating at this time was a beautifully illustrated and well produced magazine of fantasy literature, *Der Orchideengarten* (1919-1921), edited by Karl Hans Strobl. Its famous illustrator, Albert Kubin (1877-1959), also wrote the classic fantasy *The Other Side (Die andere Seite,* 1909), a novel of apocalyptic vision for which he used some of the pictures originally intended for Meyrink's *The Golem.*

In the opinion of Herman Hesse, what distinguished Meyrink from other fantasy writers of the time was the power of his personality. Other commentators have not always been so generous. It has been said that after the visionary power of *The Golem*, Meyrink's later novels deteriorated into the quagmire of occult indoctrination, and served more as a vehicle for the

exposition of secret doctrines than as literature. This argument is given credence by the fact that Meyrink is widely read in esoteric circles and studied more as a teacher than a novelist. On the other hand, this same belief may have contributed, in part, to Meyrink's success. For some, Meyrink's work was itself a 'higher truth', it transcended the realm of 'mere' literature, and conveyed insights that were hidden to the multitude. Certainly this was the aspect that his enthusiastic biographer, critic, and sometimes editor Paul Frank chose to emphasize; for him, Meyrink's art was far removed from the school of *l'art pour l'art,* not for him the aesthetic games that other writers engaged in, rather his books are 'eruptive blocks, thrown up from depths in which seldom a human eye dares to penetrate'. A recent biography (Frans Smit, *Gustav Meyrink, In Search of the Extra-Sensory,* 1988) also stresses this image of Meyrink as the seeker after the paranormal.

Meyrink did nothing to discourage the belief that he had mastered the paranormal and had access to hidden knowledge. In the introduction to his novel, *Der weiße Dominikaner* (1921, *The White Dominican*) Meyrink's claim that his was 'inspired literature' and that his book had been dictated to him from other spheres further intensified the legend that had grown around him. The story of the alleged suicide attempt, from which he was saved when a bookseller's apprentice threw some occult advertisements and the sample issue of an occult magazine through his door and thus set him on his occult path, has all the features of a conveniently apocryphal story. His failure as a banker in Prague in the 1890s may owe as much to the airs of occult experimentation that he liked to give himself than to the plottings of his enemies: for this is a quality not exactly trust-inspiring in a banker! and if he was accused of using spiritual guidance in his banking business, this sounds exactly like a Meyrink satire.

Meyrink's contacts with various occult orders and organizations are fairly well documented. As early as 1891 a theosophical brotherhood of 'The Blue Star' was founded in Prague. Among Meyrink's acquaintances were various mystics in

Vienna and Prague, such as the Viennese polyhistor Friedrich Eckstein. He read H. P. Blavatsky (whom he later despised) and corresponded for three months with Annie Besant, met Rudolf Steiner (but didn't get along with him, although Steiner later wrote favourably of Meyrink's work). Meyrink also had contacts with French and British Freemasons, various circles with grandiose sounding names such as 'Ancient and Primitive Rite of Masonry', and was acquainted with the German guru of the occult J. Schneiderfranken, who called himself 'Bo Yin Ra'. In 1897 he became a member of the Order of Illumination, as well as a 'Brotherhood of the Old Rites of the Holy Grail in the Great Orient of Patmos'. In 1923 he wanted to become a member of the 'Old Gnostic Church of Eleusis', and in 1926 he became a member of an 'Aquarian Foundation' and a 'White Lodge'. Eduard Frank quotes a document that Meyrink received from 'Mandale of the Lord of the Perfect Circle' which reads:

'It is ordered, that Brother Gustav Meyer of Prague be constituted one of the seven Arch-censors. And in virtue of this Mandale Gustav Meyer receives the Spiritual and Mystic name Kama.'

And in 1895 he received a letter from a member of a brotherhood in Manchester, in which Meyrink is given his new name: 'Theravel. This Name, when translated into English, would be expressed thus: I go; I seek; I find. This is therefore the Motto of your future life.' Whether or not this was indeed the motto of Meyrink's personal life it is certainly the theme that dominates all of his major texts.

It is interesting to note that Meyrink, who translated Charles Dickens (a translation praised by Arno Schmidt), and also some supernatural stories of Lafacadio Hearn and Rudyard Kipling, apparently had no knowledge of English fiction of the supernatural; he was not familiar with Algernon Blackwood or Arthur Machen, to say nothing of Aleister Crowley who might conceivably have been of interest to him.

All this testifies to a considerable interest in the occult, but what did Meyrink actually believe? His fictional works are not so much eruptions of the unconscious but literary works with a strong ludistic component that is not absent even in his occult

novels. Meyrink first made a name for himself as a writer of the sharply satirical, irreverent tales (later collected in *The German Philistine's Wonder*) that bitterly attacked the shibboleths of the German bourgeoisie and the pillars of the state, the bureaucracy, the military, patriotism and the church. These stories derive their special impact from an often savage satirical distortion and exaggeration of specific features of German life. Some stories are biting parodies of nationalist writers. Typical of these early stories is 'Wetherglobin', in which apes are inoculated with a new serum and begin to exhibit all the behaviour of fanatically patriotic soldiers. His story 'Die Ersturmung von Serajewo' ('The Storming of Sarajevo') was forbidden in Austria-Hungary during the First World War, for in this broad satire the Austro-Hungarian army, whose officers are described as cretins, heroically conquer the wrong city (one of their own), and in 1917 in Germany there raged a press campaign against the unpatriotic Meyrink. In other stories Meyrink showed a preference for the occult, for Indian mysteries and the wisdom of the East, and for frightening and grotesque happenings. The great Austrian satirist Karl Kraus summed him up as combining 'Buddhism with a dislike for the infantry'.

It would appear that there was a certain dichotomy in Meyrink, that can, perhaps, be reconciled: on the one hand there was the satirist, the scoffer, the sceptic, the liberal writer with a preference for the eccentric and the bizarre, for whom little was sacred, and under whose scrutiny not even the occult was spared; on the other the believer in occult wisdom, the seeker after hidden knowledge, the propagator of occult doctrines. But how to make sense of these different selves? His occult essays are as polemical and ambiguous as his fictions, with elements of playfulness and strategic opposition ever present. At times Meyrink gives the distinct impression that he was better at formulating what to dislike than what he believed in. He especially raged against astrology which he considered a baleful poison, and while he believed in ghosts, he considered spiritualism a poor cousin of genuine insight, and expended much energy trying to debunk mediums. He believed in parapsychological phenomena, but considered them extremely rare, and the

whole field fraught with swindlers and charlatans; perhaps there were four true yogi in all of India, he once declared. In the descriptions of spiritual voyages of his novels, his heroes are beset at every turn by pitfalls, traps, false paths of which they must constantly be wary. While debunking charlatans he continued to believe in the existence of a deep and true occult knowledge.

What emerges from the plethora of contradictory evidence that exists by and about him is the image of a man who longed to believe in a realm of higher spiritual reality that opposed the petty materialism of the everyday world. But a man who at the same time was too much of a sceptic, perhaps not a *thorough* sceptic, but certainly a *methodical* one, whose strong bent for the grotesque and the playful led him to probe even that in which he wanted to believe. So he tried one system after another, one teacher of wisdom after another, always willing to invest a good deal of enthusiasm, but again and again he came away disappointed, finding only fraud, showmanship and false pretences. And on he went with his search.

This sceptical attitude, combined with his ability to laugh at himself and a penchant for polemics and satire, proved an advantage in his fiction, where ambiguity is a virtue, giving the impression of manifold meanings, leaving the reader room for his own interpretations, and providing the dialectical interplay and tension on which intellectual drama thrives. Nor is the satiric component incompatible with Meyrink's mystic goals, they are rather supplementary. An essential element of Meyrink's novel is dualism; a conflict between a material world of appearances, and a higher, spiritual world of true causes. The world of appearances is one of alienation, spiritual decline and despair; an eccentric world of the criminal demi-monde: a kind of gigantic curiosity shop enlarged to city-size and populated by the rejects of mankind. This world has to be rejected, and like Athanius Pernath in *The Golem,* the engineer Hauberrisser, the nominal hero of *The Green Face* has to be educated for and initiated into a higher world, helped along by various colourful figures who offer him assistance (like Swammerdam or Sephardi). But the rejection of the material world is not total,

rather he has to become a citizen of both worlds, truly alive in this world and the other. This goal is to be achieved not after death, but in this world; only citizens of both worlds may survive the fall of this one and help create the real one.

Who is to say of this labyrinthine structure where fictional reality ends and dream and vision begins? What is sanity and what madness? The hero has to experience both, he is forced to split and to double his ego and meet himself. By creating an all-pervading atmosphere of kafkaesque mystery and uncertainty, Meyrink succeeds in suggesting inexhaustible depths and heights of meaning.